# Dreaming Their Way

AUSTRALIAN
ABORIGINAL
WOMEN
PAINTERS

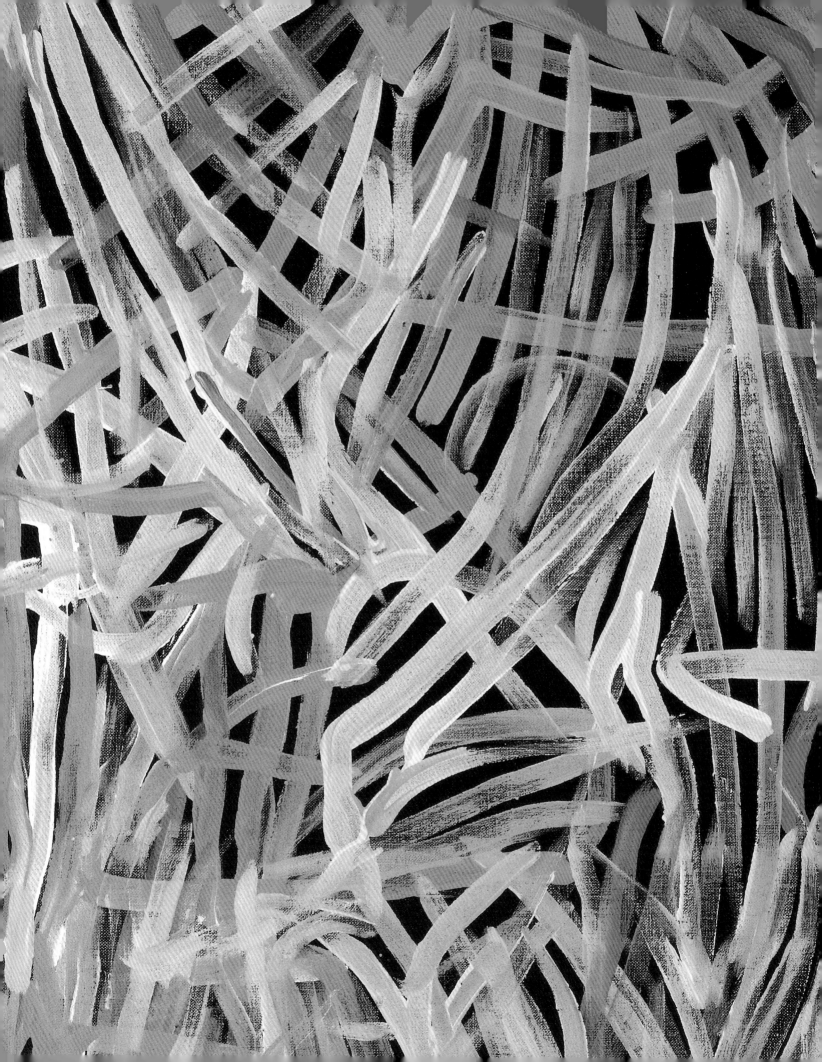

# Dreaming Their Way

AUSTRALIAN
ABORIGINAL
WOMEN
PAINTERS

NATIONAL MUSEUM OF WOMEN IN THE ARTS

Published on the occasion of the exhibition *Dreaming Their Way: Australian Aboriginal Women Painters*, organized by the National Museum of Women in the Arts (NMWA) and curated by Britta Konau, Associate Curator of Modern and Contemporary Art, NMWA, in collaboration with Margo W. Smith, Director and Curator of the Kluge-Ruhe Aboriginal Art Collection of the University of Virginia, Charlottesville.

The exhibition and book are made possible through the valuable assistance of the Embassy of Australia, the Australian Department of Foreign Affairs and Trade, and the Kluge-Ruhe Aboriginal Art Collection of the University of Virginia, Charlottesville.

Generous support is provided by the Macquarie Group; Chevron; Qantas; The Boeing Company; Marriott Metro Center; Ann Lewis, AM; Raymond Garcia and Fruzsina Harsanyi, and one anonymous donor.

Special recognition goes to the NMWA Business and Professional Women's Council for providing essential funding for this exhibition.

June 30–September 24, 2006
National Museum of Women in the Arts
1250 New York Avenue, NW
Washington, D.C. 20005–3970
www.nmwa.org

October 7–December 10, 2006
Hood Museum of Art
Dartmouth College
Wheelock Street
Hanover, NH 03755–3591
www.hoodmuseum.dartmouth.edu

First published in 2006 by
Scala Publishers Ltd.
Northburgh House
10 Northburgh Street
London EC1V 0AT, UK
www.scalapublishers.com

ISBN 1 85759 442 8

Designed by Karin Kuzniar
Project managed by Amanda Freymann
Edited by Rebecca Price and Elizabeth S. G. Nicholson, NMWA
Copyedited by Elizabeth Stepina
Printed in China
10 9 8 7 6 5 4 3 2 1

Frontispiece: Detail of cat. 23.
Page 5: Detail of cat. 55.
Page 6: Detail of cat. 7.
Page 8: Detail of cat. 63.
Page 12: Detail of cat. 75.
Page 18: Detail of cat. 50.

Page 30: Detail of cat. 13.
Page 38: Detail of cat. 19.
Page 100: Detail of cat. 64.
Page 132: Detail of cat. 61.
Page 150: Detail of cat. 46.
Page 156: Detail of cat. 38.

# Contents

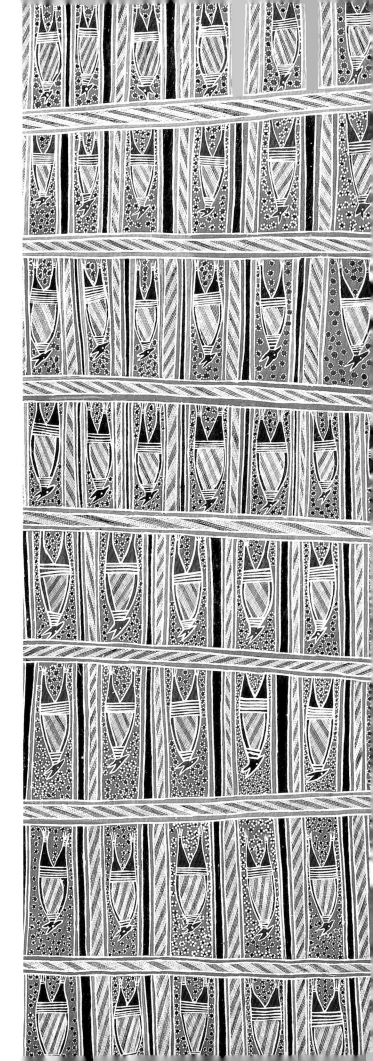

# Note to the Reader

In Australian Aboriginal communities it is common practice neither to name nor reproduce images of recently deceased persons. In producing this book all care has been taken to comply with appropriate Indigenous protocols. Discretion and care should nevertheless be exercised when displaying the book in Australia. Also, to the authors' knowledge, no restricted or secret/sacred images or information have been included in this book.

The term Indigenous Australians refers to Aboriginal as well as Torres Strait Islander peoples. These indigenous peoples are ethnically and culturally distinct, and *Dreaming Their Way* focuses on Aboriginal culture only. For purposes of clarity, the artists are grouped with the communities with which they are predominantly associated or to which they attribute the greatest influence on their work, including those places of which they are traditional owners. However, many are highly mobile and often move between communities and outstations.

When Europeans first arrived in Australia, approximately 650 dialects of over two hundred Aboriginal languages were in use. Today, at least one hundred of these languages are still spoken to varying degrees. Because Aboriginal languages are verbal, various orthographies were used in attempts to write them down, resulting in different spellings of the same word. Some examples of this include the terms *Jukurrpa*, and *Tjukurrpa*, for which the English approximation is "Dreaming," and *Wagilag*, which is also spelled *Wagilak*. Wherever possible, we have maintained consistency in the spelling of Aboriginal terms. However, we have occasionally allowed for variations, especially in the titles of the artworks or in direct quotations.

## Britta Konau
Curator, *Dreaming Their Way: Australian Aboriginal Women Painters*
National Museum of Women in the Arts, Washington, D.C.

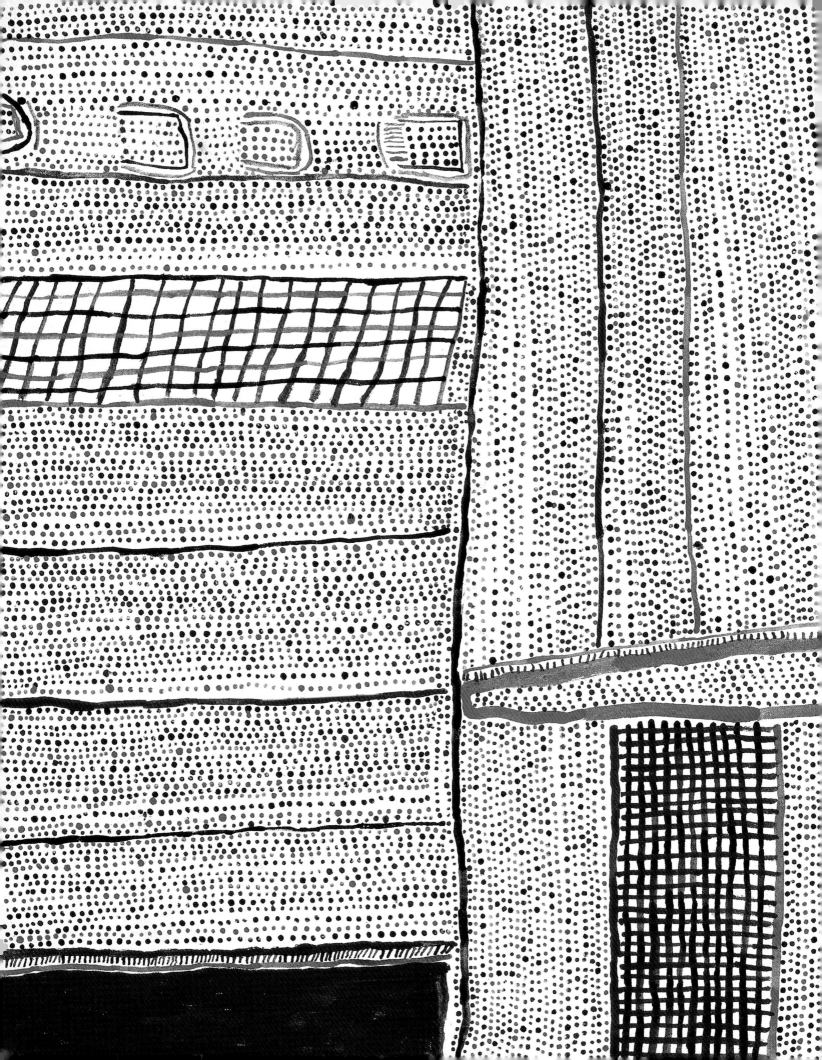

# Foreword

Aboriginal peoples are the indigenous peoples of Australia, here from the very beginning, from the Dreaming. Archaeologists generally agree that Aboriginal peoples have been in Australia for more than fifty thousand years; some speculate that the figure may be as high as 120,000 years. These estimates are not important to Aboriginal peoples: we have simply always been here—this is our land.

At the time of the British invasion of Australia in 1788, every part of Australia was named, owned, and occupied by Aboriginal peoples. Estimates of the Aboriginal population at the time have varied from 750,000 to upwards of one million people, including over six hundred separate language groups. Aboriginal peoples were culturally diverse but shared a common heritage—often referred to in European terms as the Dreaming (or, more correctly, Dreamings)—and a common value system dominated by spirituality, land, and family.

The Dreaming tells of how, in the creation period, the landscape was formed by ancestral beings, and of how Aboriginal peoples became human. The Dreaming gave Aboriginal peoples the Law, the rules by which we should live. The Dreaming holds past, present, and future as one. It encompasses and connects the human and physical (or natural) realms with the spiritual. Aboriginal society sees all things as living and interrelated under a strong system of kinship. Responsibilities and roles are clearly defined: kinship incorporates everyone.

Aboriginal culture enjoys a rich oral tradition. History is living—not stored. The land itself can be read as text. Art is a means of telling the story, as is dance, as is ceremony, as is song. All live in the land; all are equally old.

Aboriginal art is recognised as the oldest continuous living art tradition in the world. Expressed in myriad forms, Aboriginal art used all available materials and surfaces from the relative stability of rock, bark, and wood, to the more ephemeral sand paintings and body decoration. More recently (at least in Aboriginal terms), have been added canvas and paper, oils and acrylics. The forms change, but in many ways the tradition and the stories do not.

Aboriginal art, though not always valued in Australia and for many years consigned exclusively to the realm of anthropologists, is now recognised worldwide as a unique and exciting art heritage.

<div style="text-align: right;">

## Jill Milroy
Dean of Indigenous Studies
University of Western Australia

</div>

# AUSTRALIA

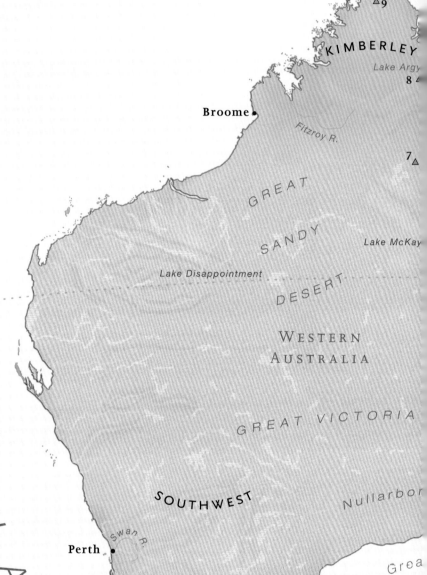

KILOMETERS
0  100  200  300  400

MILES
0  100  200  300  400

Tropical   Semi-arid   Desert   Agricultural   Forest

Intermittent Lake

Intermittent River

ABORIGINAL COMMUNITIES
REPRESENTED IN
*DREAMING THEIR WAY*

△ CENTRAL AUSTRALIA
1  Papunya
2  Yuendumu
3  Ikuntji (Haasts Bluff)
4  Lajamanu
5  Utopia
6  Walungurru (Kintore)

▲ KIMBERLEY
7  Balgo Hills (Wirrimanu)
8  Warmun (Turkey Creek)
9  Kalumburu

△ ARNHEM LAND/NORTH AUSTRALIA
10  Maningrida
11  Ramingining
12  Yirrkala
13  Bathurst Island
14  Melville Island
15  Ngukurr
16  Peppimenarti

▲ NORTHEAST
17  Lockhart River

Timor Sea

KIMBERLEY
Lake Argyle
Broome
Fitzroy R.

GREAT
SANDY
Lake McKay
Lake Disappointment
DESERT
WESTERN
AUSTRALIA

GREAT VICTORIA
SOUTHWEST
Nullarbor
Perth
Swan R.
Grea
Frankland R.

INDIAN OCEAN

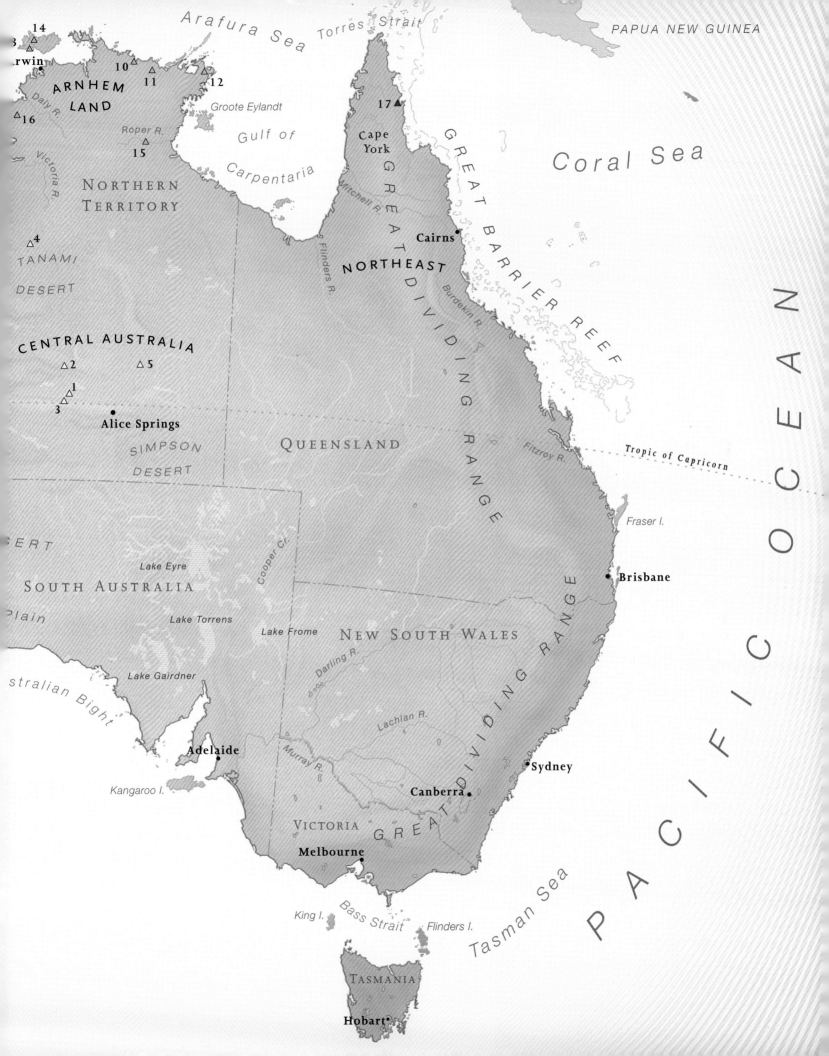

# Introduction

Over the last thirty years one of the most exciting developments in the Australian cultural arena has been the emergence of Australian Aboriginal painting as a contemporary art form. To say the indigenous people of Australia have always been artistic is to understate the fact that artistic expression has been part of their everyday lives over the fifty thousand years in which they have inhabited Australia. It was in the early 1970s, however, that an opportunity to use modern art materials—and to commit designs and stories to something more permanent than the sand, rock, and body paintings of the past—enabled this sensational new movement to begin.

In recent decades there have been some key opportunities for Americans to view Australian Indigenous art in the United States through exhibitions such as *Dreamings* in 1988 and *Native Born: Contemporary Aboriginal Art* in 2002. Whilst there have been many major international Aboriginal art exhibitions in cities such as London, New York, Paris, St. Petersburg, Tokyo, and Basel that have focussed on various themes, media, and sites, *Dreaming Their Way: Australian Aboriginal Women Painters* is particularly important because it documents

the substantial contributions of Indigenous Australian women in a field once dominated by men. As the title suggests, this exhibition focuses on the Dreaming stories of Aboriginal peoples. Simply interpreted, the Dreamtime is the period when the physical features of the land and the life upon it were created by spiritual ancestors. It can refer to both the past and the present. Over thousands of years Dreamings have been communicated through painting, dance, and storytelling. This exhibition brings together some of the best modern interpretations of Dreaming stories by women artists.

Aboriginal art is represented in the collections of most Australian public art institutions—the largest of which is held by the National Gallery of Australia, Canberra. American collectors have also been quick to recognise the unique qualities of this distinctive genre and have purchased broad-ranging works from various communities. Many of the works in this exhibition are the result of astute collecting by American and Australian collectors and public institutions.

I would like to acknowledge my appreciation for the support of the exhibition by National Museum of Women in the Arts chair and founder, Wilhelmina Cole Holladay; the ongoing commitment to the project of the museum's director, Judy L. Larson; and especially Britta Konau, curator of the exhibition, who travelled to Australia to visit Aboriginal centres and important collections in order to select the excellent works for display. Initiated by the National Museum of Women in the Arts in Washington, D.C., the exhibition is touring to the Hood Museum of Art at Dartmouth College, where the director, Brian P. Kennedy, former director of the National Gallery of Australia, Canberra, is a great advocate of Aboriginal art.

These paintings will not only introduce many visitors—some for the first time—to the diversity and richness of contemporary Australian Aboriginal art but will also provide evidence of the enduring creativity of Indigenous Australian women.

## Dennis Richardson
Australian Ambassador to the United States
Embassy of Australia
Washington, D.C.

# Acknowledgments

*Dreaming Their Way: Australian Aboriginal Women Painters* is the first major presentation of works by Aboriginal women artists in the United States. This exhibition is special for its specific focus on women painters, who comprise the majority of the artists painting in Aboriginal communities today. In addition to focusing on art by these talented women, the exhibition also illustrates the clear separation of female and male roles and activities that are customary to Aboriginal societies and are still practiced today.

The exhibition and catalogue *Dreaming Their Way* would not have been possible without the help of many individuals and institutions to whom we are enormously grateful. The Embassy of Australia provided constant support for this project and we would like to acknowledge the help of Ambassador Dennis Richardson and Mrs. Betty Richardson. Ron Ramsey, Director of Cultural Relations at the embassy, has been a great adviser and has kept us laughing with his wonderful sense of humor.

The implementation of *Dreaming Their Way* has been a multiyear effort, and several individuals involved in the process have moved on to other positions, including former Ambassador Michael Thawley and Mrs. Deborah Thawley. It was Mrs. Thawley's keen interest in Australian Aboriginal art that sparked our enthusiasm for presenting this exciting new work to American audiences. Britta Konau, Associate Curator of Modern and Contemporary Art at the National Museum of Women in the Arts, received a research grant from the Australian Department of Foreign Affairs and Trade under its Cultural Awards Scheme for a two-week planning trip to Australia. Instrumental in facilitating this trip were Teresa Keleher, former Director of Cultural Relations, and Trevlyn Gilmour, former Cultural Projects Manager, at the embassy. Many thanks go to them for this early encouragement.

Raymond Garcia and Fruzsina Harsanyi have been involved with the project from the beginning, and we gratefully acknowledge their manifold efforts on behalf of the exhibition. The National Museum of Women in the Arts greatly depended on the generosity of other institutions and private collectors who lent their remarkable works to us. Our thanks go to Gerard Vaughan, Director and CEO of the National Gallery of Victoria; Ron Radford, Director of the National Gallery of Australia; Edmund Capon, Director of the Art Gallery of New South Wales; Margo W. Smith, Director and Curator of the Kluge-Ruhe Aboriginal Art Collection of the University of Virginia, Charlottesville; Mimi Gardner Gates, Illsley Ball Nordstrom Director of the Seattle Art Museum; Brent Benjamin, Director of the Saint Louis Art Museum; Margaret Levi and Robert Kaplan in Seattle; Will Owen and Harvey Wagner in North Carolina; Elizabeth and Colin Laverty in Sydney; Richard Kelton, President of The Kelton Foundation, Los Angeles; Ann Lewis, AM,

in Sydney; Richard Klingler in Virginia; The Wolfensohn Family Foundation, Washington, D.C.; and The LeWitt Collection in Connecticut. We are pleased to present the works of thirty-three remarkable artists in *Dreaming Their Way*, and we congratulate and thank each woman represented in the exhibition.

The exhibition was organized by Britta Konau, whom we thank for her vision and tenacity in pursuing this project. Margo Smith has been an enthusiastic collaborator as well as a friend, making valuable introductions and being just a phone call away with her informed opinions. Hetti Perkins, Curator of Aboriginal and Torres Strait Islander Art at the Art Gallery of New South Wales, offered additional and much welcomed advice, as did Brenda L. Croft, Senior Curator of Aboriginal and Torres Strait Islander Art at the National Gallery of Australia. Their support of this project is especially meaningful to us. Judith Ryan, Senior Curator of Indigenous Art at the National Gallery of Victoria, has also freely lent her expertise, which is much appreciated. We would further like to thank Brian P. Kennedy, Director of the Hood Museum of Art at Dartmouth College, for contributing an essay to this catalogue. We are delighted that *Dreaming Their Way* will be presented at the Hood Museum in the fall of 2006.

Many staff members at the National Museum of Women in the Arts have contributed their efforts to the success of *Dreaming Their Way*, including Susan Fisher Sterling, Deputy Director and Chief Curator; Darcy Honker, Chief Development Officer; Erin Harms, Associate Director of Corporate, Foundation, and Government Support;

Elizabeth S.G. Nicholson, Managing Editor; Catherine Bade, Registrar; Greg Angelone, Chief Preparator, and Quint Marshall, Preparator. We especially thank Curatorial Assistant Rebecca Price for her invaluable work on the exhibition and catalogue. We would also like to acknowledge the wonderful cooperation of everyone involved in producing this splendid publication. At Scala Publishers, these were Jennifer Wright, Director of Publications, and Oliver Craske, Editorial Director. Thank you also to Amanda Freymann, Project Manager; Elizabeth Stepina, Copyeditor; and Karin Kuzniar, Designer. Our thanks also go to independent curator Susan Jenkins and editor Janis Johnston for their crucial assistance with the publication.

An exhibition of this magnitude requires the commitment and financial support of many corporations, foundations, and individuals. We gratefully acknowledge the contributions of Macquarie Group; Chevron; Qantas; The Boeing Company; Marriott Metro Center; Ann Lewis, AM; Raymond Garcia and Fruzsina Harsanyi; and other anonymous donors. Our special thanks go to National Museum of Women in the Arts' Business and Professional Women's Council, especially Sheila Shaffer, Arlene Fine Klepper, Angela Brock, and Diane Casey-Landry, for their generous support of *Dreaming Their Way*.

Finally, in keeping with Indigenous tradition, we would like to thank the Piscataway People and the Powhatan People for our ability to present this important Australian Aboriginal work in this area.

Judy L. Larson
Director
National Museum of Women in the Arts, Washington, D.C.

# Art as Life and Identity

## by Brian P. Kennedy

Very few exhibitions of contemporary Aboriginal art have been organized or hosted by civic museums in the United States. While admirable private collections have been established, most public museums have struggled to understand how contemporary Aboriginal art fits in to the story of world art. For museums with an emphasis on social and cultural history, Indigenous Australian art can be considered too aesthetically based and market focused. Conversely, art museums often categorize the work as ethnographic and anthropological. Moving ahead of museum curators, a small number of American collectors have been especially active in their pursuit of the best contemporary Indigenous Australian art. *Dreaming Their Way: Australian Aboriginal Women Painters*, organized by the National Museum of Women in the Arts, is significant in that it demonstrates the strength of several American private collections, while also including works lent by Australian public institutions and private collections. Dartmouth College in Hanover, New Hampshire, which has a well-established interest in Indigenous Australian culture, welcomes the opportunity to present this exhibition at its Hood Museum of Art. The Hood Museum has long celebrated the role of art in historical and cultural heritage.

"For Indigenous peoples, art expresses all aspects of life and identity. Art is a major way of passing on culture to future Indigenous generations," explained Indigenous rights lawyer Terri Janke. The contemporary Australian Aboriginal art movement of painting for the general public began around 1971 at Papunya in central Australia and now embraces a network of art-producing communities across the country's vast expanse. The government subsidy of Aboriginal art centers began in 1973 and has expanded to support a great number of centers across Australia today. A web portal (www.aboriginalart.org) links many of these centers and provides access to information about them and their artists. All over Australia, Indigenous culture continues to be a cause for celebrating the power of human creativity and imagination despite poverty and adversity. It is, however, a matter of deep concern when people are pleased to own wonderful works of art but fail to associate them with the circumstances of those who made them. Indigenous peoples in Australia will remain in relative poverty until there is a nationwide realization that their situation is simply unacceptable. The challenges for Australian Aboriginal artists in isolated communities include avoiding

commercial exploitation; protecting individual and community copyrights and moral rights to their stories, designs, and other intellectual property; and maintaining their culture for succeeding generations. At the same time, these artists are the major and often only nongovernmental source of income for their families.

Huge tracts of land, mostly in remote regions, have been returned to Aboriginal people and carry importance as tribal lands, native country, and home. According to the last Australian census (2001), there are 458,000 Indigenous people, 2.4 percent of the total population. There are 1,216 self-managed Indigenous communities in Australia, and 1,139 of them are located in isolated and very remote regions. Many of the painters represented in *Dreaming Their Way* live in communities with populations of only a few hundred people. While the relative isolation of many Aboriginal communities offers a buffer to some outside influences, it also increases the cost of the provision of basic infrastructure and services. This creates a huge governmental challenge to break the cycle of extreme poverty. Of course, it should not be thought that remote Aboriginal communities live immune from international media and popular culture. There has been a major effort in the past decade to "network Australia" with digital communication services, and Indigenous people are exposed to television, film, and international music culture. The youth in remote communities are more likely to be found playing instruments or listening to contemporary, popular, rap, rock, or techno music than they are to be painting in an arts center.

Women painters from Aboriginal communities have worked hard to win their much-deserved acclaim within the international art market. These women have shown tremendous resilience and courage in the face of challenging circumstances. It has been an honor and a privilege to travel to their communities throughout Australia, to witness their traditions, to speak out publicly on their behalf, and to acquire their works of art for the national art collection in Canberra.

There is a growing awareness in Australia of the political imperative to address the situation of its Indigenous people. The exhibition *Dreaming Their Way*, with its splendid range of magnificent works by many of the most admired women painters, is as eloquent a proclamation of the importance of land, story, and tradition as its viewers are ever likely to see. It focuses attention on one of the most remarkable art movements of the late twentieth century, one that continues to thrive and to renew itself. May these works provide a source for visual delight, transmission of stories, and recognition of the strength of these women and their culture.

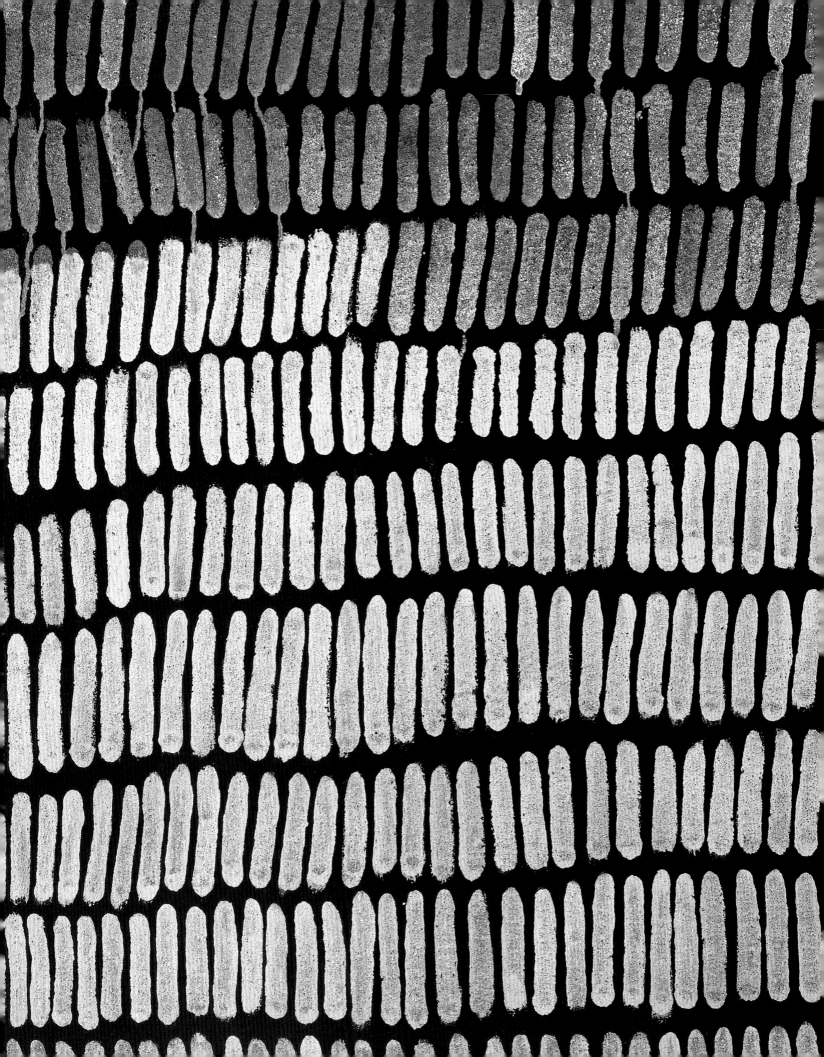

# "The Enchantment of Being What We Are" Diversity and Change in Aboriginal Art by Margo W. Smith

The winners of the 2005 Telstra National Aboriginal and Torres Strait Islander Art Awards (NATSIAA)[1] in each category, including bark painting, general painting, work on paper, and three-dimensional art, were all women. This marked the first time in the twenty-two-year history of the awards that the entire field of winners comprised one gender. Similarly unprecedented was the award of the top prize to a group of Ngannyatjarra women from the Papulankutja (Blackstone) community in Western Australia for their life-size spinifex sculpture of a Toyota, complete with steel tire rims and a woman behind the steering wheel (fig. 1). The creation of sculptural works from grass is a recent development in Aboriginal art. It represents both the innovative spirit that women have brought to their work and the community-based movement intended to generate independent revenue for women. Over the past two decades, women have taken a steadily increasing role in art production, often supporting their families and communities through art sales, and they have become major figures in Australia's contemporary art scene.

In 1991, when the Art Gallery of New South Wales presented the *Aboriginal Women's Exhibition*, curated by Hetti Perkins, women artists were still struggling for recognition in a field dominated by men. As Perkins noted in her introductory essay in the exhibition catalogue, the long-held identification of women's art as "craft" had diminished its value.[2] The *Aboriginal Women's Exhibition* presented paintings alongside sculpture, woven works of art, batik, photography, and fine-art prints. At that time, women comprised fifty-four percent of artists represented by community art centers, yet few of the women had exhibited their works prior to 1986. Since then, a noticeable shift has taken place within the Aboriginal art world. Individual artists, such as Emily Kame Kngwarreye, have achieved record sales and international recognition outside the commercial arena for their work. New art movements driven by women, such as the one that began in Kintore/Haasts Bluff in 1993, were welcomed for their fresh and innovative styles. Women artists began appearing more regularly in exhibitions, gallery collections, and publications. The raised status of Aboriginal women artists reflects both the social and cultural changes that have taken place within Aboriginal society, and the growing significance of Indigenous art within Australia and globally.

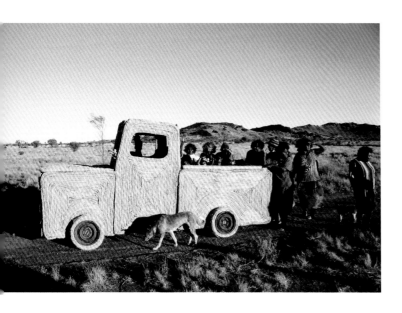

Fig. 1 *Tjanpi Toyota*, 2004. Desert grass, aviary wire, steel, jute twine, recycled floorboards, steering wheel, and hubcaps; life-size. This remarkable sculpture was a collaborative project made by twenty women weavers from the remote desert community of Papulankutja in Western Australia. The project was facilitated by Tjanpi Aboriginal Baskets, a social enterprise organization within the NPY Women's Council, Alice Springs.

Exhibitions of Aboriginal women's art have typically been very broad, demonstrating the impressive range of art forms produced by women. In this exhibition, the National Museum of Women in the Arts focuses on paintings by Australian Aboriginal women to reveal the variety that exists within one genre and to highlight the individual styles of major artists. The diversity found within Aboriginal women's paintings is a product of tightly interwoven cultural, historical, and personal factors. It is difficult to make generalizations about the work because different circumstances have contributed to each woman's development as an artist. Geography does not necessarily determine an artist's style, yet it is possible to see continuities in the art from each region. The artists of Arnhem Land paint with natural pigment on bark and are thus distinguished from the artists of central Australia, who work in acrylic paint on canvas. Thematically, however, they have more in common with one another than they do with artists from Queensland or the west coast of Australia.

Distinctions such as "traditional" or "urban" do not reflect the way Aboriginal artists typically conceive their work. Each artist reflects her experience as an Aboriginal woman. Some of the art in this exhibition has been inspired by gendered cultural practices regarded as "women's business." Other paintings reflect the artist's personal history or response to social and political challenges faced by Aboriginal people today. Although Aboriginality means different things to different people, it is the thread that ties these diverse artists together. Carol Dowling, the twin sister of artist Julie Dowling, remarked, "When Indigenous people are asked the meaning of being human, there are ten thousand different responses. It is in this diversity of knowledge and practice, of intuition and interpretation, of promise and hope, that we will all rediscover the enchantment of being what we are."[3]

Traditional Aboriginal cultural practices, such as ceremonial body painting and sand drawing, have inspired a variety of art forms in different locations, including contemporary bark painting from Arnhem Land and central Australian paintings in acrylic on canvas. In the Kimberley region of western Australia, Lily Karedada's paintings of spirit ancestors known as

Wandjina bear a striking resemblance to ancient rock art (fig. 2). While the influences of body paint, rock art, and sand drawing tie Aboriginal art to traditional and perhaps ancient practices, its production for a global fine-art market has profoundly influenced painting styles. The size of paintings, the materials used, the styles associated with one locality or an individual artist, and the demand for work in a specific style reflect the art market's considerable power. That is not to say that Aboriginal art has lost its authenticity; rather, complex social and cultural changes have influenced Aboriginal artists. For this reason, Aboriginal art is considered contemporary art.

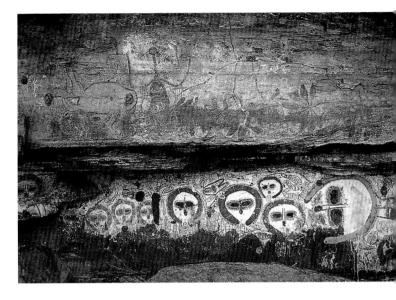

Fig. 2  Image of Wandjina Wojin, Wanalirri, Gibb River, northwestern Australia.

Nevertheless, a large proportion of Aboriginal art relates to traditional beliefs about the Dreaming. These stories constitute an oral history, recounting the creation of all that is and the transmission of human culture. In the Dreaming, ancestors traveled the Australian countryside, engaging in activities that formed the natural features of the land, gave birth to humans, and established the code of moral behavior known to Aboriginal people as the Law. Dreaming ancestors are often associated with a species of animal. Yet they have many human qualities, like emotions, as well as superhuman capabilities, such as the power to travel underground or transform themselves into different beings. Dreaming stories provide moral and social lessons. Ancestors who broke the Law were severely punished, and today they serve as a cautionary example for modern Aboriginal people. The stories also encode information about

the landscape, such as where to find food and water. They serve as mental maps, providing hunting-and-gathering people with information on the resources available in a specific location. Tales of the Dreaming are multireferential—body paint, dance, painting, rock art, sand sculpture, and song are all used to convey the stories. Together they form some of the most fundamental and enduring expressions of Aboriginal culture.

The bark paintings made by Yolngu people from central and northeast Arnhem Land depict the ancestral stories that are owned by individual clans. Pictorial elements and design features are highly conventionalized and relate to closely held knowledge of ancestral activities that have been passed down through generations. Seventy years ago, such paintings were produced solely by initiated men in ceremonial contexts.[4]

Fig. 3  Wolpa Wanambi with Gambali Ngurruwuthun and Dundiwuy Wanambi at Yirrkala, 1996.

For the most part, these paintings were made on the bodies of initiates or on sacred objects, including barks, used in ceremonies. Women and uninitiated men were not allowed to view the paintings until they were revealed in public portions of a ceremony. During the period of increasing contact with European Australians in the early twentieth century, Yolngu artists began producing bark paintings, initially for explorers and anthropologists, and later for an outside market. From the 1930s onward, missionaries encouraged art production both to draw Aboriginal people into their settlements and to promote a work ethic among them. Bark paintings and crafts were traded for rations at the mission and later sold at church-run shops in urban centers where they raised money and support for remote missions. For the most part, paintings produced at missions had no ceremonial significance. However, on some occasions sacred works were publicly painted and displayed. For example, in 1962 a pair of large bark paintings depicting the major Yolngu clan stories of each moiety—Dhuwa and Yirritja—was commissioned by Reverand Edgar Wells for the church in Yirrkala.

Paintings of more substantive themes were created for the art market as Yolngu began to "open up" styles that were previously restricted to ceremonial contexts. At first, these paintings were produced in seclusion from women and were covered before they were taken to the mission for sale.[5] Women became involved in the process by the early 1960s, initially as apprentices to their fathers and later producing their own work. In Milingimbi, Dorothy Djukulul was taught the Ganalbingu designs related to the Flying Fox and Magpie Goose Dreamings by her father, Nhulmarmar. Daisy Manybunharrawuy learned the Wagilag Sisters creation story from her father, Dawidi, and she inherited full rights to reproduce this painting after his death.[6] Women from Yirrkala also began painting in the 1960s, most notably Banygul, Dhuwarrwarr, and Banduk Marika, who learned from their legendary father, Mawalan. Also from Yirrkala, Galuma Maymuru and Wolpa Wanambi began painting with their fathers, Narritjin and Dundiwuy, and they now produce their own works (fig. 3). According to anthropologist Howard Morphy, "the increased participation of women was viewed by Yolngu as an enrichment of community life and a recognition of the important role played by women in holding the

community together in times of social stress."[7] As Yolngu artists adjusted to the social and cultural disruptions that accompanied increased contact with Europeans, they made choices, collectively or individually, to pass on traditional bark painting to their daughters.

Galuma Maymuru's 1996 painting *Djarrakpi Landscape* (fig. 4, also cat. 59) depicts ancestral stories associated with Djarrakpi (Cape Shield) and contains many of the same elements found in her father's paintings. The composition comprises three horizontal panels. In the top section, two ancestral men are shown with their canoe. In this particular Dreaming, they went out to fish, and one man was swept overboard. His body later washed up on shore. The central canoe-shaped motif represents a *yingapungapu*, which is a ground sculpture made of earth and used in Manggalili clan mortuary ceremonies. Relatives of the deceased who have been "contaminated" through contact with the body must eat their meals within the *yingapungapu*. The ancestor who initiated this practice buried pieces of fish in the sculpture. The food became infested with maggots, indicated by the hatch marks in the *yingapungapu*, and a crab later dug up the pieces and scurried away with them.

In the central panel, an ancestral woman known as Nyapililngu travels up and down the sand hills making string from possum fur and fashioning it into a decorative breast girdle, indicated by the X on her torso. This symbol is reiterated in the triangular border of this

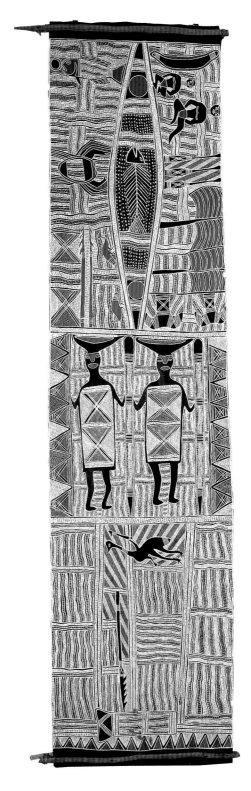

Fig. 4  Galuma Maymuru, *Djarrakpi Landscape (Manggalili Dhawu)*, 1996. Natural pigment on eucalyptus bark; 116 1/4 x 30 1/4 in. (295.3 x 76.9 cm). Kluge-Ruhe Aboriginal Art Collection, University of Virginia, Charlottesville. Cat. 59.

panel, and in the anvil-shaped clouds in the upper panel. Featured twice, Nyapililngu balances a dish on her head and carries a digging stick in one hand. In the lower panel, an emu attempts to dig for fresh water in the dry lake bed. Finding only salt water, he flings his spear into the sea, hitting a sacred rock and causing fresh water to spew forth.

Many of the referents in this painting relate to actual landscape features.[8] The Manggalili clan design of wavy rectangular lines filled with cross-hatching represents the marks left by the ebb and flow of the tide on the beach at Djarrakpi. The painting acts as a map of the Manggalili homelands and contains key symbols that serve as a kind of mnemonic for the detailed ancestral stories associated with this specific area. Although the figurative elements in Galuma Maymuru's painting are Manggalili clan designs also found in works by her father, uncle, and brother, no two paintings of Djarrakpi appear exactly alike (compare fig. 4 and fig. 5). Each artist exercises quite a bit of freedom in the design and execution of circumscribed elements.

Despite tremendous social and cultural changes that have affected their production and use, Yolngu bark paintings maintain a great deal of cultural continuity. In comparison, the style of painting that sprang up in the 1970s in central Australia represents innovation in media and technique. Traditional forms of art in the desert region, such as body painting, ground design, and sand drawing, were mostly ephemeral. After their use, they were rubbed off of

the body or wiped away from the surface of the sand. When these traditional designs were applied to two-dimensional surfaces in a settlement called Papunya in 1971, the Western Desert art movement was born.

Other painting styles had originated in desert communities prior to this time, most notably the watercolor landscapes produced at the Hermannsburg mission in the 1930s and 1940s. Although very few women took up the Hermannsburg style, which was based on European models, Cordula Ebatarinja (1919–1973) achieved some success as a painter. At the Ernabella mission in the 1950s, women were encouraged to draw or paint decorative abstract designs on paper. These designs stimulated craft production in other media, including hooked rugs made with wool from the mission and later batik. Interestingly, batik was taken up by women in other desert communities, such as Utopia, where it served as a precursor to acrylic painting.

The history of the Western Desert art movement is well documented.[9] The first Papunya painters were initiated men from the Pintupi, Warlpiri, and Luritja language groups. Their paintings replicate some aspects of ritual life, where men and women operate in separate spheres. Like the Yolngu bark painters, men worked together in secluded locations, where they could discuss and sing the stories associated with their work without being overheard by women or uninitiated men. Completed paintings were hidden under sheets of corrugated iron and revealed

to the art advisor and other men in the same manner that one would present sacred objects. Even so, Papunya paintings were intended for sale and were well received by the art market, initially in Alice Springs and later in urban centers throughout Australia and abroad. The success of the Papunya art movement encouraged similar enterprises in other desert communities such as Yuendumu, where women constituted the majority of artists.

Although some Papunya women showed an early interest in acrylic painting, the budding art movement did not support their efforts. It was feared that the resources would be spread too thin if they were shared among men and women. Painters like Pansy Napangati thus worked independently, selling their work to galleries in Alice Springs. In Yuendumu, a very different situation developed. Françoise Dussart, a French anthropologist working in the community in the early 1980s, encouraged art production among Warlpiri women by providing crucial logistical support. What began as a project to raise money to purchase a Toyota so that the women could visit their sacred sites evolved into one of the most successful community-run art centers in central Australia.

Although it was the promise of commercial success that caused many desert communities to develop their own painting programs, art production has strengthened Aboriginal society by providing a focal point for cultural reproduction. Both the content of the art and its execution conform to traditional Aboriginal law.

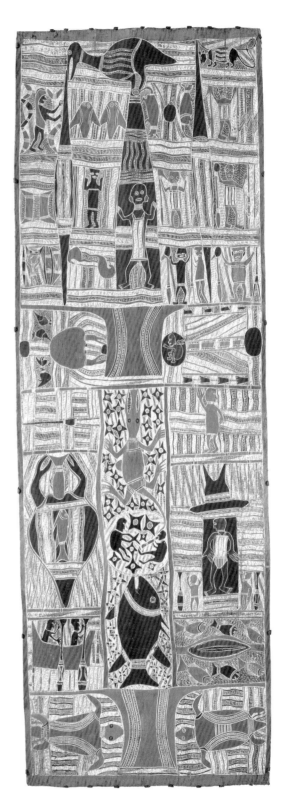

Fig. 5 Narritjin Maymuru, *Creation Stories of the Manggalili Clan*, c. 1965. Natural pigment on eucalyptus bark; 88 1/5 x 30 in. (224 x 77.5 cm). National Museum of Australia, Canberra.

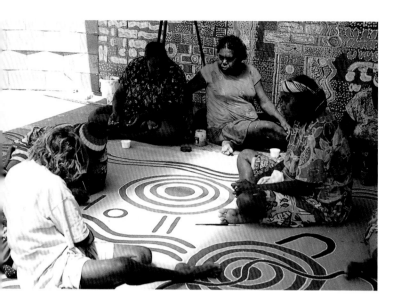

Fig. 6  Women painting *Karrku Jukurrpa* canvas commissioned by John W. Kluge in 1996 at
Warlukurlangu Artists Aboriginal Association in Yuendumu, North Australia.

The first Warlpiri painters from Yuendumu were women
who, in that particular community, had considerable
knowledge and ritual power.[10] They directed younger
artists and ensured that the designs were executed
properly. Painting, like ritual, provided an occasion to
discuss and transmit cultural knowledge. Furthermore,
art production echoed the traditional pattern of respon-
sibilities for land involving ritual "owners," who inherit
rights to the Dreaming stories through their father's
line, and "managers," whose rights are matrilineal.
Members of these groups enact complementary roles
in Warlpiri rituals, in order to preserve the integrity
of the land and the Dreaming. Artistic collaborations
between "owners" and "managers" also reinforce the
link between art production and ritual life. Yuendumu
artists have taken collaboration to an extreme level,
developing a form of large, communally produced
painting that may involve over thirty artists (fig. 6).

Such projects begin with a bush trip to the site that is
the focus of the work. After spending days there singing
and dancing the major stories associated with the site,
the artists return to Yuendumu to begin work on a large
canvas stretched out behind the art center. Dussart has
reported that the complex negotiations characteristic
of Warlpiri ritual production play an important role in
the execution of such paintings.[11]

Gender played a large role in the development of
central Australian Aboriginal painting. Although
Warlpiri women initiated the production of art in
Yuendumu, they were soon joined by the men, who
gained equal recognition as artists. The historical
circumstances in each community dictated whether
men or women became painters. In some areas,
such as the Balgo community in the Kimberley region,
the women's art movement developed after the men
had been painting for some time. Women appealed
to the men for permission to paint and to use the dot
motifs that were associated with men's ceremonies.[12]
Although the desert art movement began with Pintupi
men, their female counterparts were among the last
desert women to take up the painting program in the
1990s. These senior women, many of whom had been
married to the original Papunya painters, introduced a
fresh, spontaneous style that diverged significantly
from men's art.

The seemingly abstract symbols used in central
Australian painting originated in sand drawing and
other traditional art forms. Anthropologist Nancy Munn

began studying these symbols in the 1950s, and they have remained consistent except for the addition of several representational icons in recent years. Concentric circles denote named places or sites created by ancestral beings. Often these places are waterholes, hills, or rocks. U shapes indicate ancestors who are seated or camped at sites, where they may be engaged in daily activities, such as hunting and gathering bush foods, or enacting a ceremony. Lines connecting concentric circles can represent the ancestral paths linking sites, while animal tracks or human footprints indicate the presence of ancestral beings who assumed different forms in the Dreaming. Although early desert painters used dots of color sparingly to outline important symbols, later desert paintings display a wealth of colorful dots, which often fill entire canvases.

In some desert art, symbols can be read as a narrative or mythical map relating to a particular Dreaming story. Bessie Nakamarra Sims' 1996 painting *Yarla Jukurrpa* (*Bush Potato Dreaming*) (cat. 9) depicts the story associated with a site called Yumurrpa, northwest of Yuendumu. Women of the Nakamarra and Napurrula skin groups, who traveled around the area looking for *yarla*, are indicated by U-shaped symbols. Desert iconography is multivalent; each symbol refers to many things. The circles in the center of the canvas represent both the site itself and the *yarla* plant, while the lines between them indicate both the ancestors' paths and the roots of the plant. While desert paintings appear to share many qualities with Western maps, they are not strictly topographical. The relationships between places refer more to their associations in Dreaming stories than to their physical placement on the landscape.

As the painting movement grew throughout central Australia, artists developed local and personal styles. Variations in palette, dotting techniques, the use of symbols, and themes served to distinguish the art produced in different communities. Paintings from Balgo, for example, contain bold colors and dots so closely applied that they form bands or solid fields of color, as is demonstrated in the work of Eubena Nampitjin and Lucy Yukenbarri Napanangka. Utopia artists such as Kathleen Petyarre eschewed the traditional desert symbols, using only dots and lines to convey ancestral landscapes. This gives their paintings a more abstract appearance, although they still refer to Dreaming stories. Individual artists also developed signature styles that are easily identifiable. Utopia artist Emily Kame Kngwarreye is known for her underlying networks of lines covered with splotchy dots in soft, complementary colors. Kngwarreye's style has many of the qualities of modernist painting. Her amazing success as an artist is most likely attributed to the dual appeal of her work as both traditional Aboriginal art and contemporary painting.

While most desert artists continue to paint Dreaming stories, Linda Syddick (Tjungkaya Napaltjarri) is considered the first Pintupi modernist painter.[13] Syddick was taught to paint by her father, Shorty Lungkarta, who was one of the early Papunya painters.

Fig. 7  Julie Dowling, *Didn't you know you were Aboriginal?*, 2004. Acrylic and red ochre on canvas; 47 1/5 x 59 in. (120 x 150 cm). Collection National Gallery of Australia, Canberra.

Inspired by Steven Spielberg's film *ET*, Syddick produced a series of paintings depicting the alien whose primary desire was to return home. Syddick's work reflects her personal story of loss, estrangement, and alienation.[14] While she incorporates the iconography of Western Desert paintings, her themes relate to place in a substantially different way compared to other desert artists who express their connection to the land and knowledge of the Dreaming stories.

Personal and historical themes also dominate the work of Western Australian artist Julie Dowling. Dowling is best known for her portraiture, although she embellishes figurative work with hidden symbols, Christian iconography, and jewel-like sequins. Dowling has drawn on her family history as the basis for much of her work, which also addresses political and social themes, such as the dispossession of traditional country

and the separation of Aboriginal children from their parents. As a fair-skinned Aboriginal woman, Dowling has experienced both the historical processes aimed at destroying Aboriginal people and the incredible resilience of family and culture.

While her identity as an Indigenous woman is foremost in her work, Dowling has struggled with feeling like an outsider in both Aboriginal and white societies.[15] A poignant work from her exhibition *Warridah Sovereignty* entitled *Didn't you know you were Aboriginal?* (2004; fig. 7) refers to Dowling's first realization at age four that her family was different from others. In *Self-portrait: in our country* (2002; cat. 77) Dowling grapples with the loss of her traditional lands and her aspirations to regain access to her country through a Native Title claim. Her body encompasses her female ancestor, as if she is propelled forward by the woman's spirit within her. Like the other artists in the exhibition, Dowling focuses on land as a source of inspiration and identity.

As a genre of Aboriginal art, women's painting includes many varied styles that reflect Aboriginal cultural diversity, historical processes and the changes they effected within Aboriginal cultures, and personal visions that inspire individual artists. Through their art, Aboriginal women express their relationships to their country, their understandings of the world and how it came into being, and their responsibilities for maintaining and reproducing their culture.

Notes

[1] Sometimes called the Telstra awards, the NATSIAA are held annually in Darwin, NT, at the Museum and Art Gallery of the Northern Territory.

[2] Hetti Perkins, *Aboriginal Women's Exhibition*, exh. cat. (Sydney: Art Gallery of New South Wales, 1991), p. 7.

[3] Carol Moorditj Djurapin Dowling, "Strong Love," in *Winyarn Budjarri (Sorry Birth): Birth's End*, exh. cat. (Perth: Artplace, 2005), p. 3.

[4] Howard Morphy, *Ancestral Connections: Art and an Aboriginal System of Knowledge* (Chicago: University of Chicago Press, 1991), p. 185.

[5] Ibid., p. 201.

[6] Wally Caruana, Djon Mundine, and Nigel Lendon, *The Wagilag Sisters Story*, exh. cat. (Canberra: National Gallery of Australia, 1998), p. 28.

[7] Howard Morphy, *Aboriginal Art* (London: Phaidon, 1998), p. 252.

[8] Morphy (note 4), p. 223.

[9] See Geoffrey Bardon, *Papunya: A Place Made after the Story: Beginnings of the Western Desert Painting Movement* (Carlton, Vic.: Miegunyah Press, 2004); and Hetti Perkins, *Papunya: Genesis and Genius*, exh. cat. (Sydney: Art Gallery of New South Wales, 2000).

[10] Françoise Dussart, "Women's Acrylic Paintings from Yuendumu," in *The Inspired Dream: Life as Art in Aboriginal Australia*, ed. Margie K. C. West, exh. cat. (South Brisbane: The Gallery, 1988), p. 37.

[11] Françoise Dussart, "What an Acrylic Can Mean: On the Meta-ritualistic Resonances of a Central Desert Painting," in *Art From the Land: Dialogues with the Kluge-Ruhe Collection of Australian Aboriginal Art*, eds. Howard Morphy and Margo Smith Boles (Charlottesville: University of Virginia, 1999), p. 212.

[12] Christine Watson, *Piercing the Ground: Balgo Women's Image Making and Relationships to Country* (Fremantle: Fremantle Arts Centre Press, 2003), p. 149.

[13] Fred Myers, *Painting Culture: The Making of an Aboriginal High Art* (Durham: Duke University Press, 2002), p. 304.

[14] Ibid., p. 309.

[15] Julie Dowling, "Moorditj Marbarn (Strong Magic)," in *Colour Power: Aboriginal Art Post 1984*, ed. Judith Ryan, exh. cat. (Melbourne: National Gallery of Victoria, 2004), p. 137.

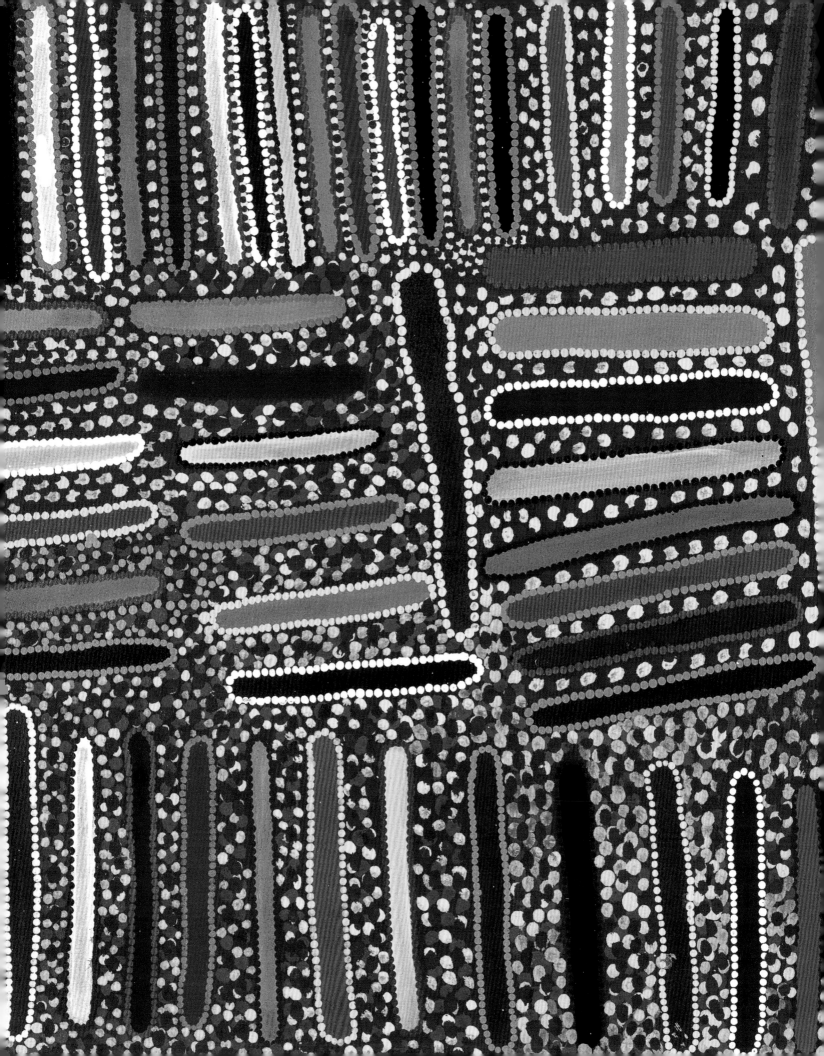

# Dreaming *Their* Way

by Britta Konau

I was first introduced to Australian Aboriginal art more than three years ago by Washington-area collector Raymond Garcia, who became an indefatigable supporter of my efforts to organize the exhibition *Dreaming Their Way: Australian Aboriginal Women Painters*. As a curator of contemporary art and a newcomer to the field, there were certain aspects of Australian Aboriginal art and culture that particularly intrigued me and have sustained my enthusiasm for this project over the years; namely, the concept of the Dreamings, the idea of maps underlying desert paintings, and the sheer exuberance of acrylic paintings from certain central Australian communities. Organizing *Dreaming Their Way* has been an ongoing learning experience that led me to refine certain ideas about the art and to appreciate its great diversity. It has also reinforced my awareness of the need for an exhibition of this kind. As Margo Smith elucidates in her preceding essay, the recent predominance of women artists in the field, as well as the clear separation of male and female spheres in Aboriginal communities, are compelling reasons for this exhibition.

Dreamings can be conceived of as a narrative structure that defines actual geographic space and relationships.

At the same time, they overlay the land with mythical significance and create a strong bond between Aboriginal people and their land. Through continuous reiterations of Dreamings in ceremonial activities, including art, dance, and song, participants transcend time by connecting the Creation Era to the present. This strong link, which is alive and not just a thing of the past, is the basis of much Aboriginal art and makes it unique among contemporary art.

In desert painting, Dreamings are often represented through symbols that retell an ancestor's journey over the land and connect it to specific locations. Although these works may thus evoke associations with geographical maps, this notion does not accurately reflect the complexity and spirituality of these paintings. Rather, these works can be considered maps of moral and religious import, which are also topographical.

Another concept that actually struck me as quite postmodern is the fluidity of meaning in desert painting. The same symbols can take on different meanings depending on their context and on the artist who painted them. A circle, for instance, can represent a campsite, a rock hole, or a breast, among other possibilities, depending upon

Fig. 1 Yvonne Koolmatrie, *Basket, eel trap*, 1993. Sedge rushes (Lepidosperma canescens);
22 2/5 x 38 1/5 in. (57 x 97 cm). Collection: Power House Museum, Sydney, Australia.

through apprenticeship with senior painters and owners of Dreamings who ensured the correct depiction of their stories. While Western eyes may be more accustomed to the colorful and expressive canvases from central Australia, I learned to appreciate the bark paintings from Arnhem Land and north Australia for their narrative complexity and compositional structure. Every one of them richly rewards closer scrutiny. With minute strokes of paint, the artists narrate Dreamings, relating features of their environment in a nonlinear fashion. Instead, individual motifs are repeated across a bark, or scenes are compartmentalized into different fields with no regard for spatial orientation or sequential order.

*Dreaming Their Way: Australian Aboriginal Women Painters* provides an introduction to both paintings on canvas as well as on bark. The exhibition approaches the works represented as art objects, with the full understanding that art history and anthropology or ethnography should not be differentiated when viewing Australian Aboriginal art. Although the paintings in *Dreaming Their Way* can be enjoyed and appreciated for their visual power alone, knowing something of their underlying meaning and circumstance of production adds a deeper layer of significance and commands a higher respect for the artists.

*Dreaming Their Way* focuses on painting because it is presently the most widespread medium in use. There

which Dreaming is depicted. In turn, the right to represent a Dreaming is dependent on who holds legal guardianship over it.

Much of desert painting is simply exhilarating, marked by complex compositions and confident color choices. The bright colors, together with the exuberance and sheer joy that seems to emanate from these canvases, stand in stark contrast to the severe conditions and circumstances under which many of them were produced, including poverty in many communities. With few exceptions, the artists included in the exhibition have not attended formal art schools in the Western sense but were trained

are, however, many other media in which Aboriginal women artists work: the central desert community of Ntaria (Hermannsburg) specializes in pottery; women in Pukatja (Ernabella) work predominantly with textiles; and the Maningrida community east of Darwin is best known for its weavings. In more urban environments, many Aboriginal artists employ nontraditional media other than painting, including photography, printmaking, sculpture, and video. Sculptor and weaver Yvonne Koolmatrie (fig. 1) was one of three Aboriginal women artists to represent Australia at the 1997 Venice Biennale. Photographer and filmmaker Tracey Moffatt (fig. 2) has gained international recognition with her perceptive commentary on contemporary society, Western or Australian Aboriginal. Other photographers who use the medium to explore Aboriginality are artist/curator Brenda L. Croft (fig. 3) and Leah King-Smith. Although many people know Sally Morgan as the author of *My Place*, a personal account of her search for her Aboriginal roots that received great public acclaim, she is also a printmaker and painter (fig. 4). Other artists, including Fiona Foley (fig. 5), use a variety of media to address the current situation of Aboriginal people in often highly provocative terms and as a route to social activism.

In discussing art produced by Australian Aboriginal people it is vital to understand that there is no single "Australian Aboriginal Art." Immense diversity exists within the cultures, languages, and traditions of Aboriginal people, as well as in their environments.

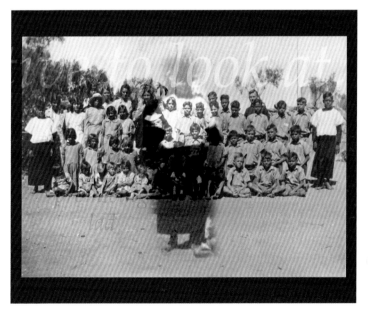

Fig. 2  Tracey Moffatt, *Adventure Series 7*, 2004. Color print on paper; 60 x 45 in. (132 x 114 cm).
Fig. 3  Brenda L. Croft, *Attractive to look at, a promising lad*, from the *Colour b(l)ind series* of *In My Father's House*, 1998. Color Ilfachrome print; 30 x 36 3/5 in. (66 x 93 cm).

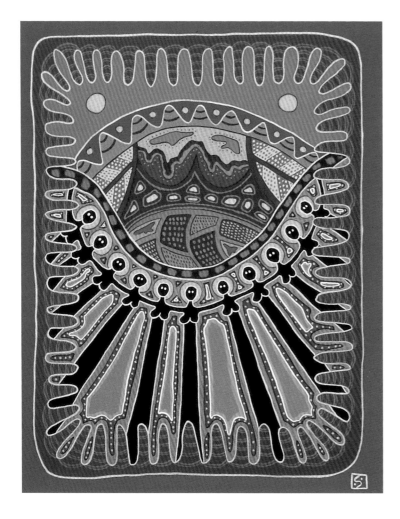

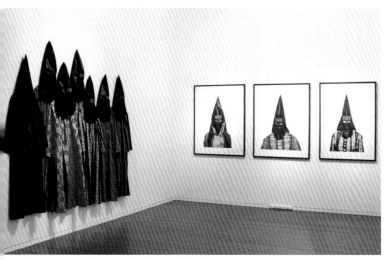

Likewise, a multitude of different visual expressions have evolved using media not traditionally associated with Aboriginal culture. While it remains difficult to generalize Aboriginal art, some similarities in material, style, and subject are recognizable in certain geographic areas. The paintings in this exhibition and catalogue are laid out following a journey from the center of Australia to the north, and then eastward and around south to the west.

When looking at these images, some readers may question the validity of this work as contemporary art, aside from its recent creation. I hope that this concern will be partially resolved simply by the works them-selves. Yet there are other reasons that these paintings can be considered contemporary. Like so much of today's art, Aboriginal works cover a diverse range and are never the product of one single factor. Besides an artist's talent and training, issues that play important roles are individual life experience, critical and monetary success, encouragement and availability of materials, age and position within a community, as well as the artistic tradition of a community. However, what distinguishes Australian Aboriginal art from other contemporary work is its basis in ancient tradition and the artists' relationship to the land. In their depiction of Dreamings, artists are stating their position in the world using a prescribed repertoire of imagery. Within these well-defined regulations, women artists have proved to be extremely resourceful and imaginative in creating new ways to represent ancient stories.

Fig. 4   Sally Morgan, *Sisters*, 1989. Screenprint; 16 x 20 in. (41 x 51 cm).
Fig. 5   Fiona Foley, *No Shades of White*, 2005. Installation view at Roslyn Oxley9 Gallery, Sydney.

Although quite a few artists included in this exhibition have had the opportunity to travel widely and may be aware of what other artists are currently producing, this exposure does not always influence their own style. Only some artists, usually but not exclusively those who are based in urban areas, participate in the international contemporary art dialogue. Using a more representational style and a wider variety of painting materials, their work may be considered more accessible to the Western eye. Urban-based artists are here represented by the work of Judy Watson and Julie Dowling, whose subjects remain deeply rooted in Aboriginality.

The main reason, however, to consider Australian Aboriginal art a contemporary art form is the fact that the artists' responses to the Dreamings are continuously evolving. These individual expressions of cultural beliefs constantly incorporate new ideas, thus reflecting the adaptability and flexibility that has allowed Aboriginal people to survive and thrive for more than fifty thousand years. The women's artistic innovations are bold and experimental, but the artists never give up their art's link to ancient tradition and essentially spiritual character. In that sense, Australian Aboriginal art invites us to broaden our concept of contemporary art as a whole. First and foremost, however, painting is a political act for Australian Aboriginal people. It states their rights to the land and asserts their strong cultural presence.

Fitzroy R.

Margaret R.

Christmas Cr.

Sturt Cr.

# WESTERN AUSTRALIA

GREAT SANDY
DESERT

△
**Balgo Hills
(Wirrimanu)**

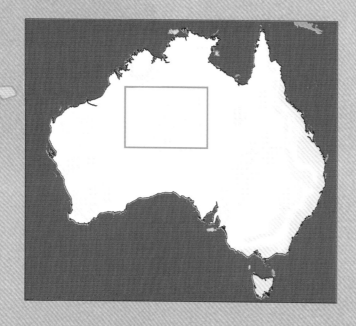

*Lake MacKay*

Kiwirrkura    ⊙ Mt. Webb
        ●

Mantati Outstation
            ●

**Walungurru
(Kintore)**
△

# CENTRAL
# AUSTRALIA

*Lake MacDonald*

KILOMETERS

| 0 | 20 | 40 | 60 | 80 | 100 | | 200 |

MILES

| 0 | 20 | 40 | 60 | 80 | 100 | 200 |

● Docker Creek

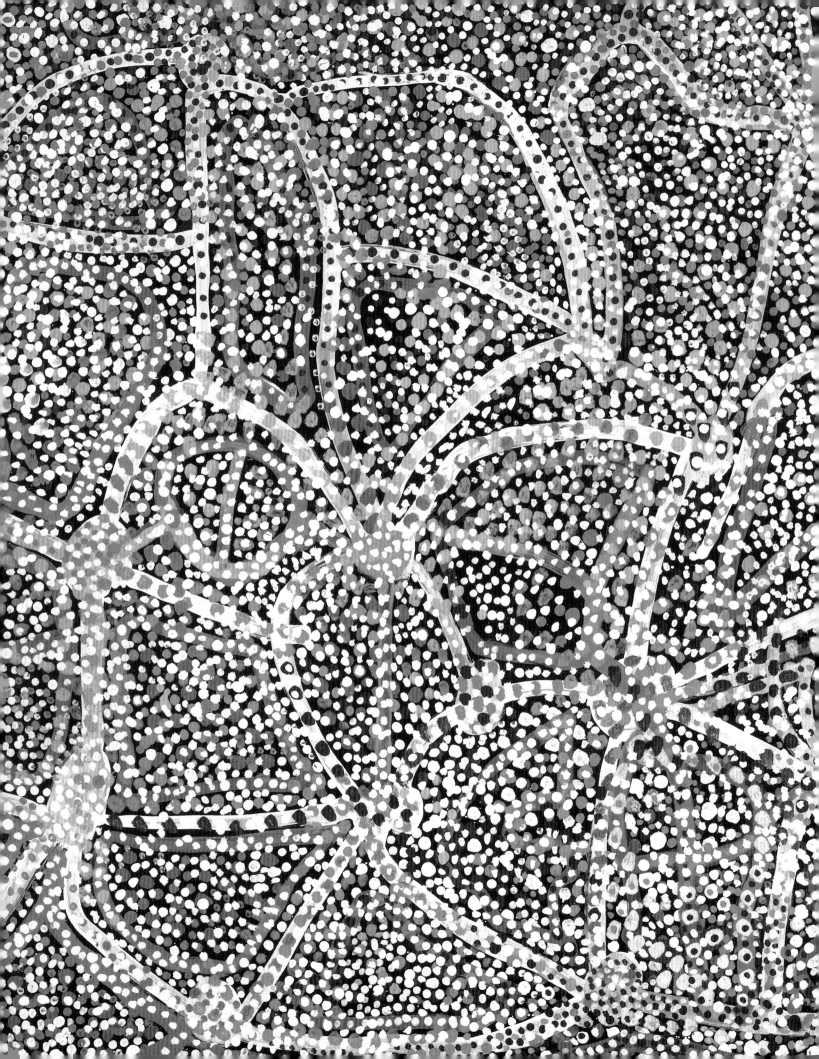

# CENTRAL AUSTRALIA

The majority of Aboriginal art-producing communities are located in Central Australia. Contemporary Aboriginal painting intended for public display began in 1971, when Geoffrey Bardon, a nonindigenous teacher, encouraged Papunya elders to use boards and acrylics to record designs that were previously represented in ephemeral media in ceremonial contexts. Best known for visualizing the travels of Dreaming ancestors and depicting specific land formations, works from this region serve as translations of ceremonial designs for uninitiated eyes. **Papunya** is also the birthplace of the so-called dot-and-circle style, which uses a range of graphic symbols and employs a restricted color palette of white, yellow, red, and black hues that reflect the rocks and earth of the landscape. Initially only Papunya men painted with modern materials; however, they eventually asked their wives and daughters to assist them by filling in the backgrounds of paintings. One exception is Pansy Napangati, who began painting on her own in the early 1970s rather than assisting male relatives. She was born in Haasts Bluff but has lived in Papunya since 1960.

Although deeply rooted in ancient tradition, Australian Aboriginal art is very open to new cultural influences, which is particularly apparent in the work of desert painter Linda Syddick (Tjungkaya Napaltjarri). Since the late 1980s, Syddick has fused aspects of Christianity with ancient religion in her paintings. In 1992 she began a series of works inspired by Steven Spielberg's film *ET*. The artist found herself captivated by the film, feeling that it resonated with her own experience of dislocation. In her very personal and contemporary works, Dreamings are understood as an ongoing process of revelation of new experiences of all types.

In contrast to the development of acrylic painting in Papunya, the new painting movement in **Yuendumu** had women at its forefront. Early compositions are based on body painting and designs on small dancing boards, and are therefore relatively small and meticulous. They have since increased in size and boldness of design.[1] By 1977 a women's museum had already been founded in Yuendumu, which is home to early examples of women's painting on boards, music sticks, and food carriers. With its dense, intricate patterns of exuberantly colored dots, Dorothy Napangardi Robinson's *Bush Plum Dreaming* (1996; cat. 6) is an excellent example of the style of early Yuendumu art. The painting's surface layer of feathery brushstrokes and the fields of small flowers follow an underlying design of sacred significance. Since 1998 the artist has developed a range of individualistic marks that she applies in very intricate patterns using subtle variations of black, white, and earth colors. The resulting canvases shimmer with the illusion of movement. Napangardi paints the story of the Women Ancestors from Mina Mina, an important site west of Yuendumu where digging sticks emerged from the ground. Carrying these digging sticks, the women visited many significant sites, walking and dancing along the way. While Napangardi maps the paths of her ancestors with the same quasi-aerial view

employed by other Aboriginal artists, her style of representation is individualistic and experimental in its sweeping and delicate patterning.

Also included in this section is Bessie Nakamarra Sims, a senior painter whose work is fairly typical of Yuendumu in its style and iconography. She led a long, traditional life in the bush before coming into contact with white people. Sims has been painting since the mid-1980s and is also active in her community's efforts to control alcohol and drug abuse.

Painters in **Ikuntji** (Haasts Bluff) use a wide variety of styles, often with strong coloration, to uniquely depict their Dreamings. Alice Nampitjinpa's early paintings resemble those from Papunya; however, she soon developed her own style of bold, simplified abstractions. Nampitjinpa represents the sand hills around her birthplace, Talaalpi, a swamp west of Ikuntji. Shades of red and yellow represent the natural ochres used in body painting.

Coming from a family of well-respected artists, including her brother Turkey Tolson Tjupurrula (c. 1942–2001), Mitjili Napurrula is one of the most innovative desert painters. She confidently uses vivid colors in stark contrasts to represent her father's land as well as his Dreaming, Uwalki, which tells of the spear-straightening ceremony. Napurrula often depicts Uwalki trees, which are used to make the spears, as symbolic patterns on a dotted background, creating a certain visual vibrancy in her paintings. In contrast to Napurrula's highly individualistic works, Gabriella Possum Nungurrayi paints in a manner that is relatively typical of desert art. She is predominantly associated with **Alice Springs**, although

she now lives in the southeastern city of Victoria. Nungurrayi is the daughter of renowned artist Clifford Possum Tjapaltjarri (c. 1932–2002) and began painting alongside him at an early age, which is still reflected in the style of her paintings. She is best known for depicting the Milky Way Seven Sisters Dreaming. It tells of seven women who fled from an unwanted Tjakamarra suitor by turning themselves into stars. Now known as the Pleiades, they are still pursued by the man in the form of a star in Orion's belt.[2]

The community of **Lajamanu**, located north of the Tanami Desert, is known for producing bold, simple works in a restrained color palette. Lorna Napurrula Fencer spent many years painting ceremonial body designs, and she did not begin to produce works on canvas until she was in her sixties. *Ngapa* (1996; cat. 17) is associated with body designs used for women's ceremonies related to fertility and *yawalyu* (regeneration). *Bush Potato* (1998; cat. 18) represents the root system of the potato and signals Napurrula's departure from the typical Lajamanu palette toward more striking color choices. Furthermore, the artist's application of paint is quite sensual and her imagery displays great freshness.

The collection of communities called **Utopia** is recognized as one of the first areas where women artists flourished. In 1977 Utopia women learned the art of batik, essentially an Indonesian textile craft. At least initially this experience influenced the fluidity and spontaneity of their designs on canvas, and flora and fauna remain the basis of their abstract images. Utopia is host to a veritable dynasty of women artists, beginning with Emily Kame Kngwarreye. As a senior member of the Anmatyerre language group, and

after decades of ritualistic artistic activity, Kngwarreye began to paint on canvas in her late seventies, but her work received immediate attention from critics, collectors, and fellow artists alike. Unlike most desert painters at the time, she did not use stylized representations of animal tracks or concentric circles in her designs, but employed richly layered brushstrokes or dabs throughout her abstract compositions. The Dreamings of her country, Alhalkere, northeast of Alice Springs, inform her work through the geographical contours, seasons, plant and animal life, and natural and spiritual forces of the land. Her free handling of paint using various implements, a keen sense of color, and dynamic compositions have earned her international fame; she was represented posthumously in the 1997 Venice Biennale.

Kngwarreye was prodigiously creative, and it is estimated that she executed around three thousand works in an eight-year period. The artist worked in series using diverse styles and almost always on a large scale. Her compositions range from the energetic to the lyrical, from overabundance to sparseness. Among Kngwarreye's nieces are seven skin group sisters who are all artists. Two of them, Gloria and Kathleen Petyarre, use a multitude of dots to create a sense of movement in their paintings. Gloria Tamerre Petyarre's country, Anungara, serves as her inspiration as she turns traditional motifs, such as leaves, into abstract patterns. Similarly, Kathleen Petyarre evokes the subtlety and drama of the desert landscape with all-over patterns of intricate marks that relate to her Dreamings and land. Her paintings have been described as "magisterial works that can be likened to symphonic compositions."[3] In a display of technical brilliance and painstaking execution, Petyarre applies many layers of paint, which combine to suggest depth. A younger generation of Utopia artists is represented by Abie Loy Kemarre, granddaughter of Kathleen Petyarre. Loy has already demonstrated a sure command of her gestural vocabulary and an eagerness to experiment with form and color.

While individual mark making is of major importance to artists in Utopia, paintings from **Walungurru** (Kintore) are characterized by rich, tactile surfaces. Using line as her predominant compositional device, Ningura Napurrula layers paint heavily on her canvases. The stark black-and-white palette the artist sometimes employs is more commonly associated with men's painting, however, Napurrula depicts the travels of her female ancestors and the mythological significance of the food they collected.

Inyuwa Nampitjinpa further abstracts and simplifies the basic symbolic elements of desert painting. In her loose and energetic compositions, circles, lines, and the typical U shapes become apparent only upon close scrutiny. Similarly, Makinti Napanangka's work may appear as abstract interplays of yellow, orange, and white circles and lines, however, her paintings are still based on the *Kungka Kutjarra* (Two Women) Dreaming. The wandering lines in Napanangka's compositions relate to the hair-string skirts that women wear during Pintupi ceremonies; the songs and dances performed at these rites are suggested in the repetitive clusters of lines. In typical Walungurru style, the paintings are freely executed and are often enlivened by a stray line or a patch of a different color. A cousin of Napanangka, Tatali Nangala, is also represented in this section.

[1] Margie West, "Aboriginal Women as Artists," in *Karnta: Aboriginal Women's Art*, ed. Chris McGuigan (Adelaide: Association of Northern and Central Australian Aboriginal Artists, 1987), p. 7.
[2] www.contemporaryaboriginalart.weiv.com.au/gallery/gabrielle/ACAAGPN0508 (accessed January 25, 2006).
[3] *Paintings by Kathleen Petyarre*, gallery brochure (Adelaide: Gallerie Australis, 1999), p. 2.

# Pansy Napangati

(born c. 1948)

PAPUNYA

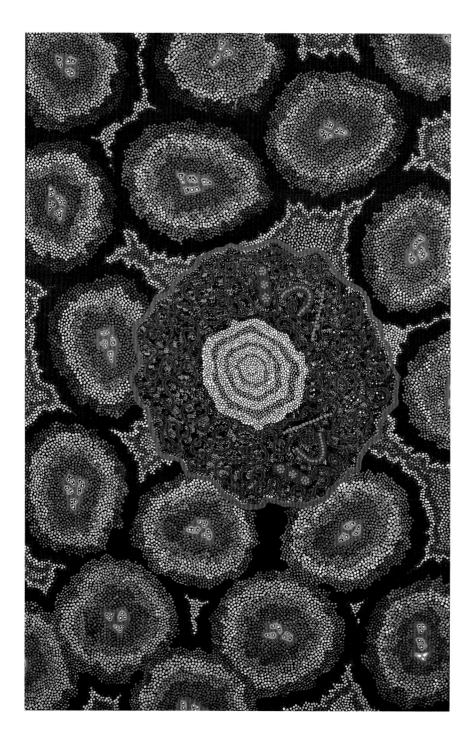

*Kungka Kutjarra* (Two Women) is a prominent Dreaming in Aboriginal ancestry. Here, the artist has depicted the Two Women resting at Kampurarrpa during their travels as they created the land and life forms of the region. Kampurarrpa is a site located north of the Ilpilli water hole, between Mount Liebig and Kintore.

In this aerial depiction of the site, the concentric circles in the center represent the site and the sinuous lines are ceremonial hair string made by the women. The U shapes are indentations of the seated women, with their coolamon dishes and digging sticks. The clusters of dots throughout the painting are the *kampurarrpa* (bush raisin), which is an edible berry.

1

**Pansy Napangati**

*Kungka Kutjarra at Kampurarrpa*
(Two Women at Kampurarrpa), 1991
Acrylic on canvas
54 x 36 in. (137 x 91.5 cm)
The Kelton Foundation

CENTRAL AUSTRALIA

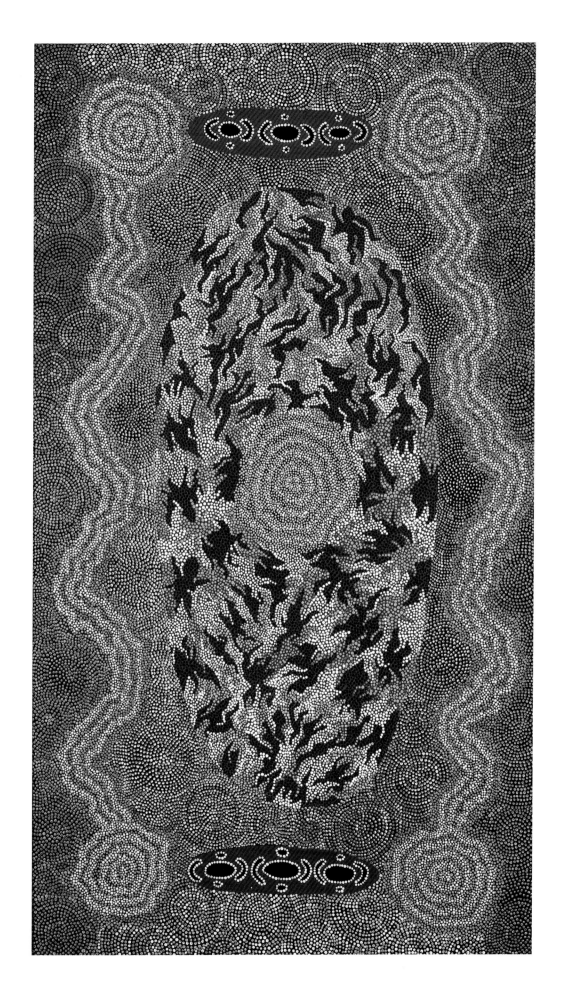

2
**Pansy Napangati**

*Women's Ceremony at Pikilyi*, 1991
Acrylic on canvas
63 x 36 in. (160 x 91.5 cm)
The Kelton Foundation

3
**Pansy Napangati**

*Winbaree*, 2001
Acrylic on canvas
48 x 35 4/5 in. (122 x 91 cm)
Private North Carolina Collection

# Linda Syddick (Tjungkaya Napaltjarri)

(born 1941)

PAPUNYA

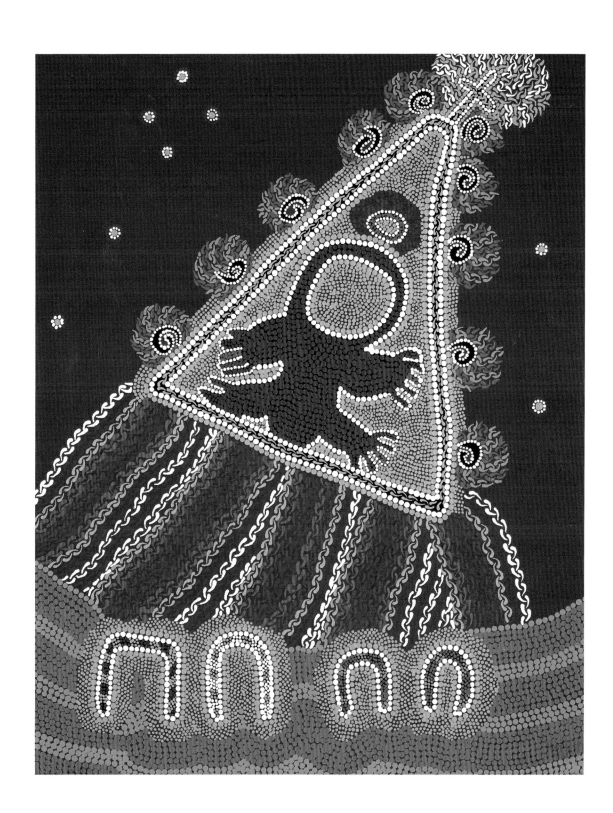

4
**Linda Syddick
(Tjungkaya Napaltjarri)**

*ET Going Home*, 1995
Acrylic on canvas
22 1/2 x 18 in. (57.2 x 45.7 cm)
The Kelton Foundation

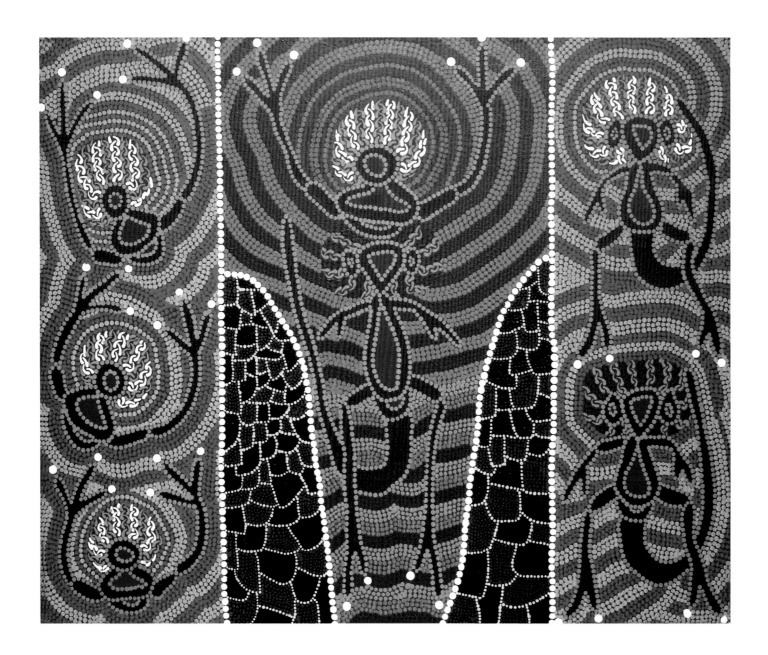

The Gap is a well-known, rocky gorge in the hills surrounding Alice Springs that is an important gathering place. *Spirits at the Gap* shows the Kangaroo (right) and Emu (left) ancestors who created Lake Mackay, a large salt lake in the desert where the artist was born. They are shown together in the center panel at the Gap.

5

**Linda Syddick (Tjungkaya Napaltjarri)**

*Spirits at the Gap*, 1999
Acrylic on canvas
26 x 30 in. (66 x 76.2 cm)
The Kelton Foundation

# Dorothy Napangardi Robinson
## (born c. 1956)
### YUENDUMU

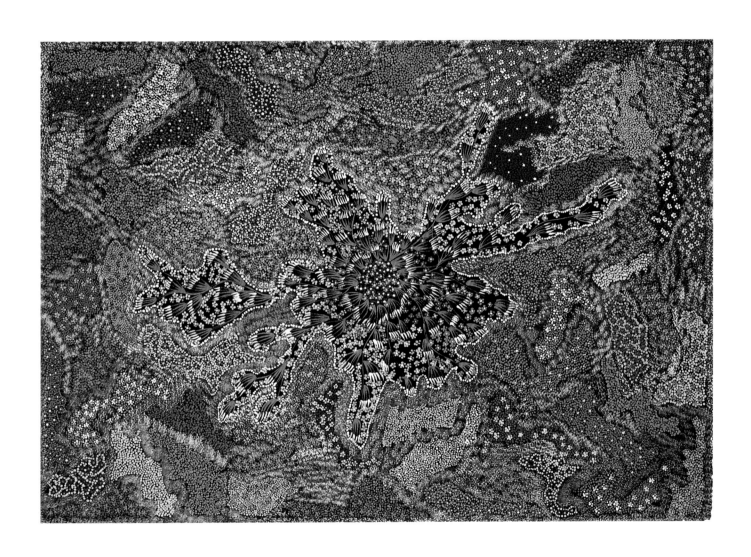

6

**Dorothy Napangardi Robinson**

*Bush Plum Dreaming*, 1996
Acrylic on canvas
34 1/4 x 49 1/4 in. (80 x 125.1 cm)
The Kelton Foundation

7
**Dorothy Napangardi Robinson**

*Salt on Mina Mina*, 2002
Acrylic on linen
79 x 48 1/8 in. (200.7 x 122.2 cm)
The LeWitt Collection,
Chester, Connecticut

8
**Dorothy Napangardi Robinson**

*Mina Mina*, 2005
Acrylic on canvas
78 x 48 in. (198 x 122 cm)
Collection of Margaret Levi and Robert Kaplan

This painting depicts the ceremonial site of origin for the *Jukurrpa* (Dreaming) known as Mina Mina, the artist's custodial country located near Lake Mackay in the desert. During the Creation Era, ancestral women of the Napangardi and Napanangka subsection groups gathered to perform the ceremonies and take up ceremonial *karlangu* (digging sticks), which emerged from the ground at a point that is now home to a large belt of eucalyptus trees. The area is made up of two enormous water soakages lined with clay. As water sinks into the ground, small areas of earth dry and lift up, with salt around the edges. In this striking new interpretation, Napangardi depicts the crustations of salt stretching infinitely onward, etched with the tracks of the women as they continue on their paths, crossing and merging, telling their stories.

# Bessie Nakamarra Sims

(born c. 1932)

YUENDUMU

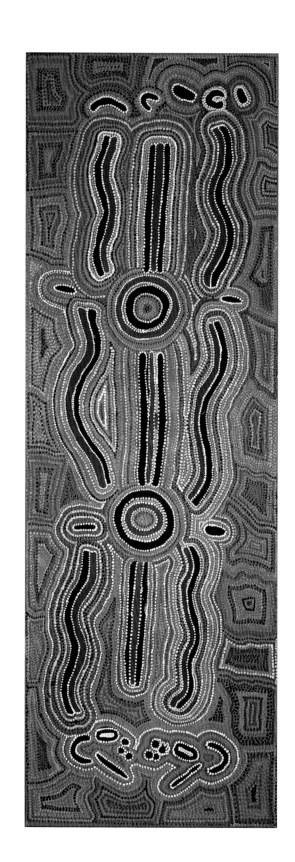

9
**Bessie Nakamarra Sims**

*Yarla Jukurrpa* (Bush Potato Dreaming), 1996
Acrylic on canvas
71 3/5 x 23 3/5 in. (182 x 60 cm)
Private North Carolina Collection

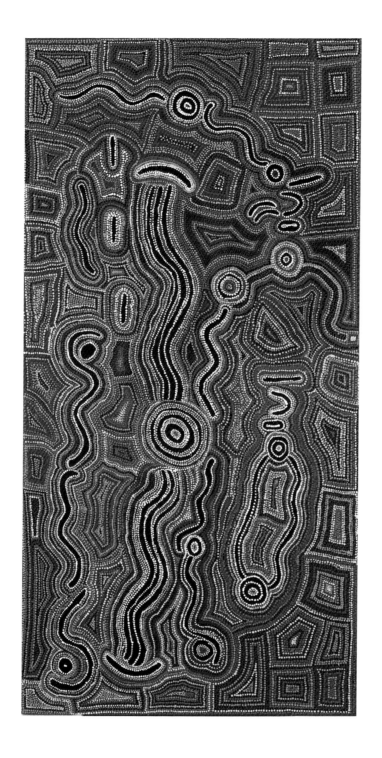

10
**Bessie Nakamarra Sims**

*Yarla Jukurrpa* (Bush Potato Dreaming), 2000
Acrylic on linen
72 x 36 1/5 in. (183 x 92 cm)
Collection of Margaret Levi and Robert Kaplan

The artist's *Jukurrpa* (Dreaming) country is Yumurrpa, northwest of Yuendumu. The story, designs, and land of this area belong to Jupurrurla and Jakamarra men and Napurrurla and Nakamarra women. In this painting, Nakamarra and Napurrurla *karnta* (women) are seated at Yumurrpa. They are gathering *yarla* (bush potatoes) with *karlangu* (digging sticks) and *parraja* (wooden carrying dishes). The U shapes represent the women; the concentric circles in the middle of the painting depict the *yarla* plant; and throughout the painting the *ngarna* (roots of the bush potatoes) are represented by meandering lines.

# Alice Nampitjinpa

(born c. 1943)

IKUNTJI (HAASTS BLUFF)

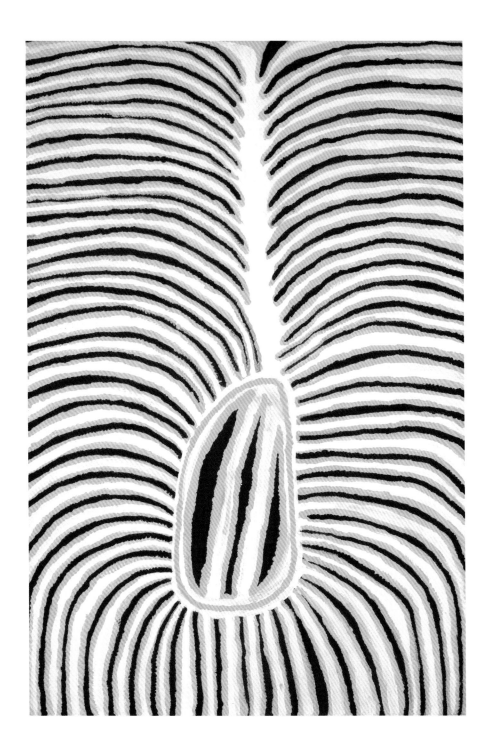

11

**Alice Nampitjinpa**

*Tali at Talaapi* (Sand hills at Talaapi), 2001
Synthetic polymer paint on canvas
54 x 36 1/5 in. (137 x 92 cm)
National Gallery of Victoria, Melbourne

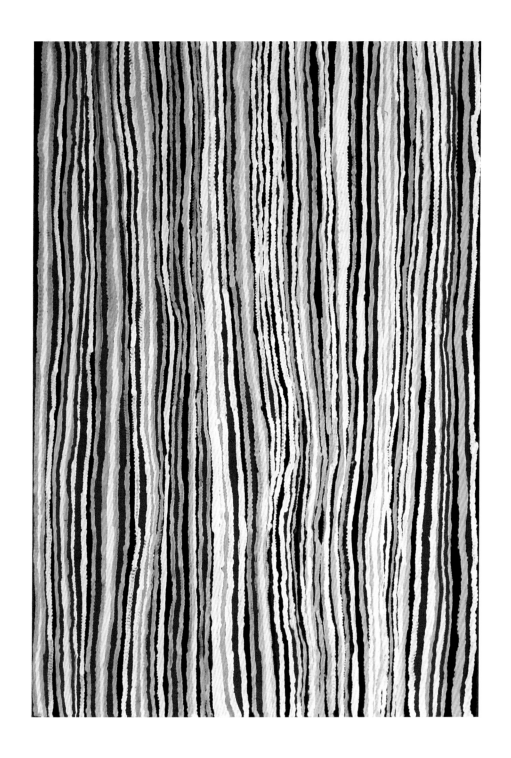

12
**Alice Nampitjinpa**
*Tali at Talaalpi* (Sand hills at Talaalpi), 2001
Acrylic on linen
54 1/2 x 36 in. (138.5 x 91.5 cm)
Private North Carolina Collection

Talaalpi is a swamp east of Walungurru (Kintore). *Tali* (sand hills) are the source of red and yellow ochres, which lend their colors to this painting. Women paint themselves with these ochres during ceremonies. In the Dreamtime, the echidna (native mammal) ancestor, *Tjilkamata*, traveled through these sand hills, passing near two carpet snakes, which were living under the water of the swamp.

# Mitjili Napurrula

(born c. 1945)

IKUNTJI (HAASTS BLUFF)

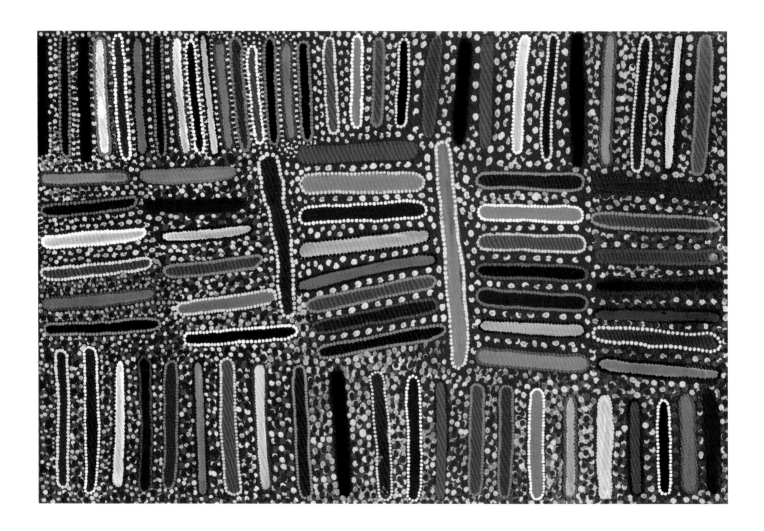

13
**Mitjili Napurrula**

*Nullanulla and alcatjari, Ualki*
(Spear grass and bush sultanas), 1994
Synthetic polymer paint on canvas
35 4/5 x 54 in. (91 x 137 cm)
Art Gallery of New South Wales, Sydney

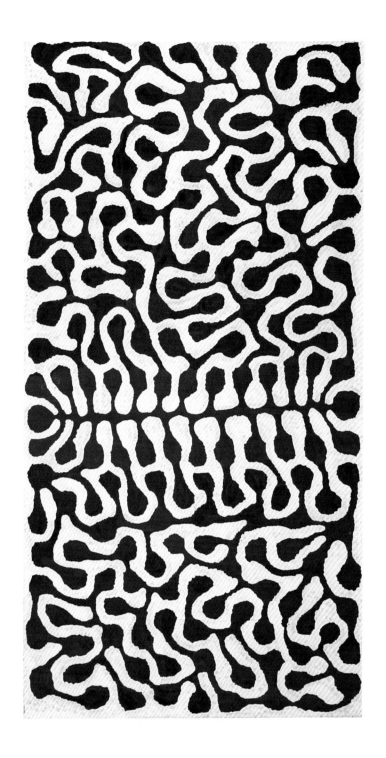

14
**Mitjili Napurrula**
*Uwalki: Watiya Tjuta* (Trees), 2000
Acrylic on canvas
48 x 24 in. (122 x 61 cm)
Private North Carolina Collection

*Watiya Tjuta* (Trees) is a common motif for the artist. The Dreaming of these paintings concerns the making of spears from trees, an important aspect of men's business. The country where the trees are found is called Uwalki, the artist's father's country. She was taught his *Tjukurrpa* (Dreaming) by her mother, who drew images in the sand of Uwalki. Napurrula has said, "My mother taught me my father's *Tjukurrpa*, that's what I'm painting on the canvas." Her brother, Turkey Tolson Tjupurrula, frequently depicts the straightening of spears in his work.

# Gabriella
# Possum
# Nungurrayi

(born 1967)

ALICE SPRINGS

"I was born in 1967 in Alice Springs and attended the Aboriginal schools there, where I studied traditional Aboriginal culture, art and the basic requirements. I have painted Aboriginal paintings with my father, Clifford Possum Tjapaltjarri, since I was fourteen years old. I sold paintings in Alice Springs for many years and I have now relocated to Warrandyte, Victoria, with my husband and two small children."

— Gabriella Possum Nungurrayi

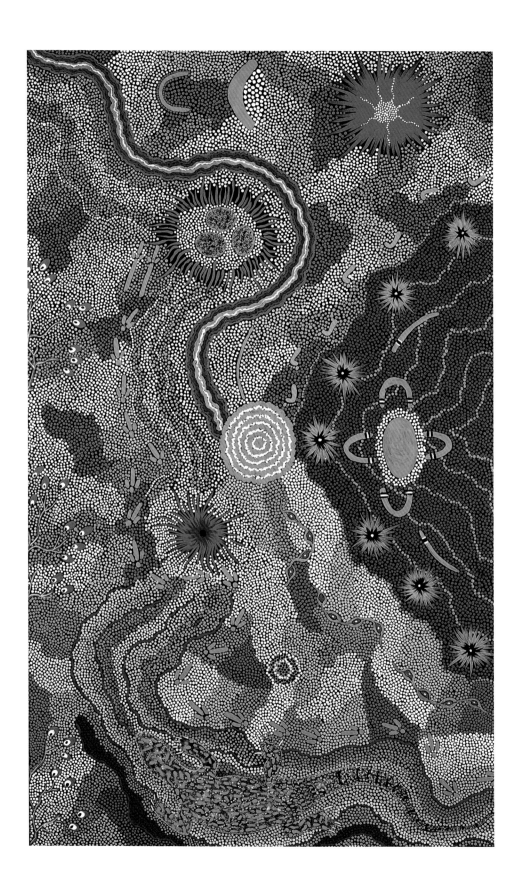

15
**Gabriella Possum Nungurrayi**

*Goanna Dreaming*, 1991
Acrylic on canvas
57 x 35 in. (144.8 x 88.9 cm)
The Kelton Foundation

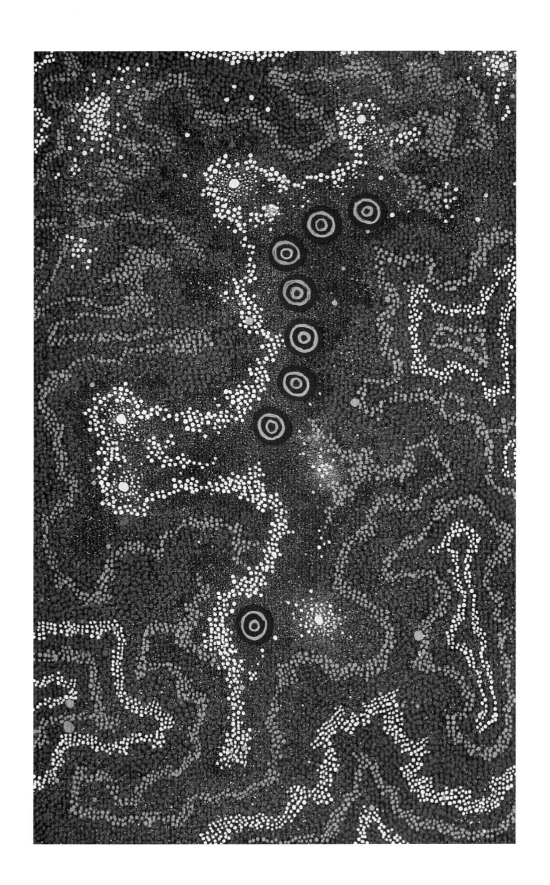

16
**Gabriella Possum Nungurrayi**

*Milky Way Seven Sisters Dreaming*, 1998
Acrylic on canvas
39 4/5 x 25 4/5 in. (101 x 65.5 cm)
Private North Carolina Collection

# Lorna Napurrula
# Fencer

(born c. 1925)

LAJAMANU

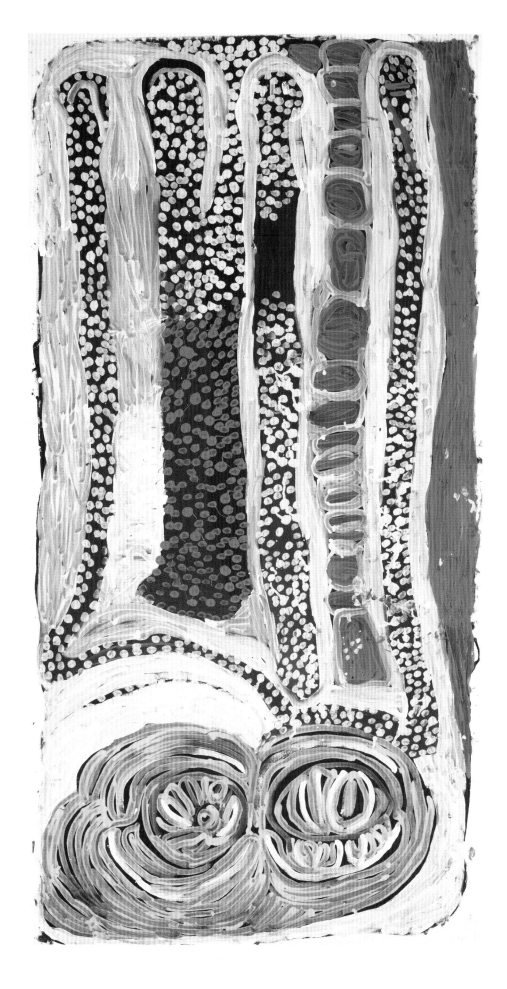

17
**Lorna Napurrula Fencer**

*Ngapa, Warna Manu Ngurlu Jukurrpa*
(Water, Snake, and Seeds Dreaming), 1996
Synthetic polymer paint on canvas
76 1/8 x 39 7/8 in. (193.4 x 101.2 cm)
National Gallery of Victoria, Melbourne

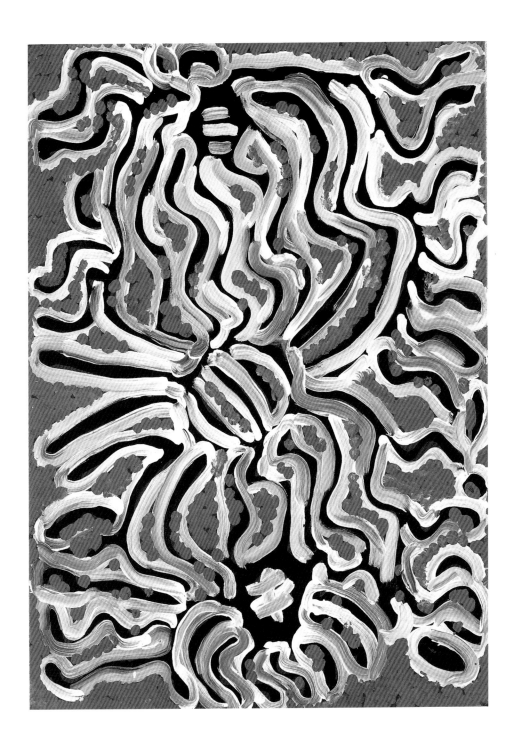

18
**Lorna Napurrula Fencer**

*Bush Potato*, 1998
Acrylic on canvas
39 1/5 x 29 3/5 in. (99.5 x 75.5 cm)
Collection of Margaret Levi and Robert Kaplan

This painting tells the Dreamtime story of the Two Women of the Napurrula and Nakamarra skin groups who search the countryside for bush potatoes. The women use basic hunting equipment, coolamon dishes and digging sticks, to look for food. Bush potatoes grow as roots underground, so the women must use the digging sticks to find them. The potatoes are collected in the coolamon dishes and carried back to camp to be cooked in hot coals.

The circle in the center of the composition represents the hole that the women dig to find the potatoes. The meandering lines signify the complex root system and branches of the bush potato plant. Dispersed throughout are small orange dots, indicating the blooming flowers of the bush potatoes, which are different colors depending on the conditions under which they grow. This Dreaming takes place at Duck Ponds in the Northern Territory.

# Emily Kame Kngwarreye

(1916–1996)

UTOPIA

19

**Emily Kame Kngwarreye**

*Hungry Emus*, 1990
Acrylic on canvas
47 1/4 x 70 1/2 in. (120 x 179 cm)
Kluge-Ruhe Aboriginal Art Collection,
University of Virginia, Charlottesville

20
**Emily Kame Kngwarreye**
*Untitled (Wild Tomato and Yam II)*, 1991
Acrylic on canvas
47 3/5 x 23 3/5 in. (121 x 60 cm)
Laverty Collection, Sydney

"Whole lot, that's whole lot, *Awelye* [my Dreaming], *Arlatyeye* [pencil yam], *Arkerrthe* [mountain devil lizard], *Ntange* [grass seed], *Tingu* [a Dreamtime pup], *Ankerre* [emu], *Intekwe* [a favorite food of emus, a small plant], *Atnwerle* [green bean] and *Kame* [yam seed]. That's what I paint, whole lot."

**—Emily Kame Kngwarreye**

21
**Emily Kame Kngwarreye**

*Alhalkere* (*My Country*), 1991
Synthetic polymer paint on canvas
47 3/5 x 118 in. (121 x 300 cm)
Ann Lewis, AM, Sydney

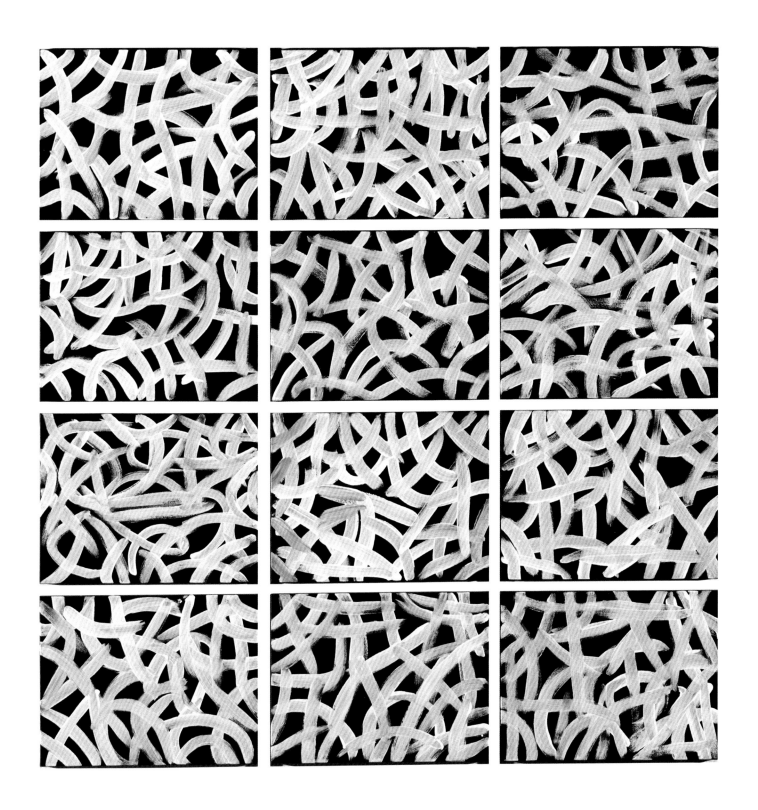

22

**Emily Kame Kngwarreye**

*Soakage Bore*, 1995
Acrylic on canvas
12 panels; each 15 x 20 in. (38 x 50.8 cm)
The Wolfensohn Family Foundation

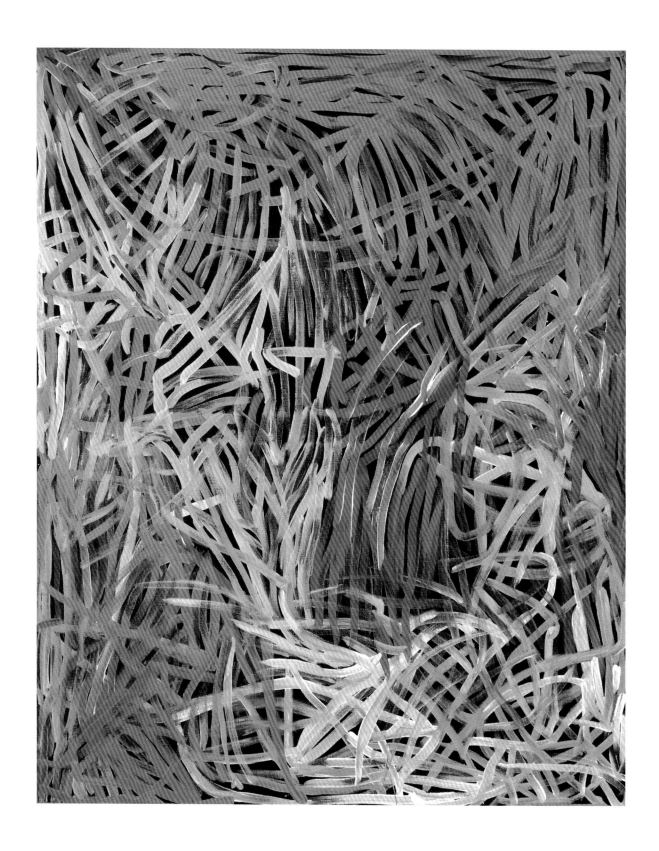

23
**Emily Kame Kngwarreye**

*Anooralya* (Wild Yam Dreaming), 1995
Acrylic on canvas
59 4/5 x 48 in. (152 x 122 cm)
Seattle Art Museum, gift of Margaret Levi and Robert Kaplan

24
**Emily Kame Kngwarreye**

Untitled, 1996
Acrylic on canvas
5 panels; each 47 3/5 x 35 4/5 in. (121 x 91 cm)
Ann Lewis, AM, Sydney

# Gloria Tamerre Petyarre

(born c. 1948)

UTOPIA

"I paint *awelye* [women's designs and ceremonies] . . .
People have to use their imagination."

—Gloria Tamerre Petyarre

25
**Gloria Tamerre Petyarre**
*Emu Ancestor*, 1992–93
Acrylic on canvas
67 1/2 x 149 1/2 in. (171.5 x 379.7 cm)
Kluge-Ruhe Aboriginal Art Collection,
University of Virginia, Charlottesville

The women's Emu ceremony takes weeks to prepare. The enactment begins at dusk and ends at sunrise. The seeds of native green beans are used to make a type of damper for the ceremonial feast. Colored ochres are gathered for ceremonial body paint, while stones, charcoal, feathers, and other items are used to execute the ceremonial ground design.

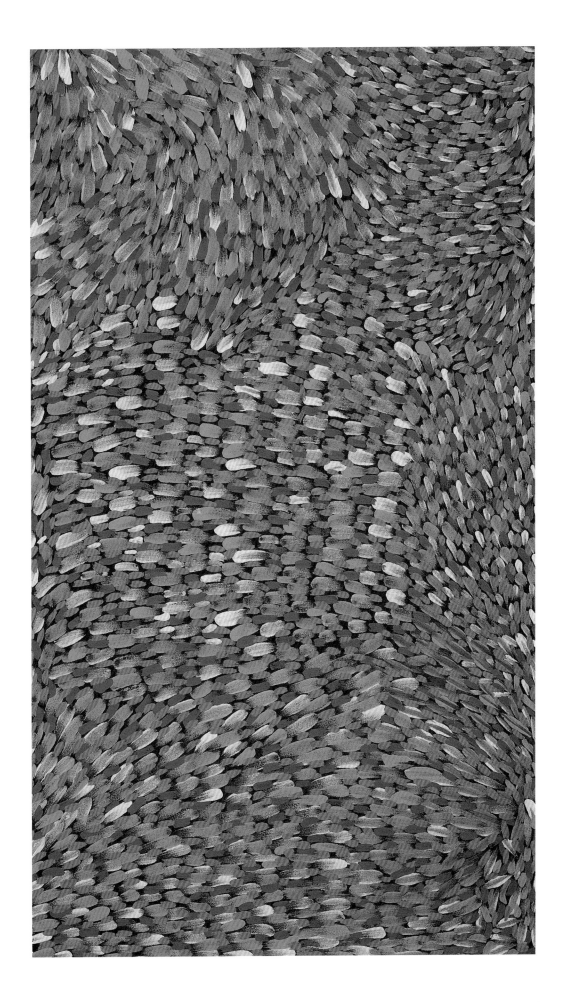

26
**Gloria Tamerre Petyarre**

*Untitled (Leaves)*, 1996
Acrylic on canvas
40 1/2 x 22 1/2 in. (102.9 x 57.2 cm)
The Wolfensohn Family Foundation

27
**Gloria Tamerre Petyarre**

*Leaves*, 2002
Acrylic on canvas
70 4/5 x 157 1/2 in. (180 x 400 cm)
Collection of Margaret Levi and Robert Kaplan, pledged to
Seattle Art Museum in honor of Virginia and Bagley Wright

# Kathleen Petyarre

(born c. 1930)

UTOPIA

"We all of us do our *awelye* ceremonies to hold onto our country."

**–Kathleen Petyarre**

28
**Kathleen Petyarre**
*Thorny Devil Lizard Dreaming (after Sandstorm)*, 1995
Acrylic on canvas
60 x 120 in. (152.4 x 304.8 cm)
Kluge-Ruhe Aboriginal Art Collection, University of Virginia, Charlottesville

*My Country–Bush Seeds* represents an aerial view of the artist's homeland. The overall dotting depicts the sand plains and sand hill country with spinifex and a variety of summer bush flowers. The prominent parallel lines at the top of the composition represent *awenth* (dogwood), a small, shrublike tree that grows on the desert savannah. The *awenth* is a valuable food source for desert dwellers, and its timber is especially favored by the Anmatyerre people for making fine boomerangs and small spears.

29
**Kathleen Petyarre**
*My Country–Bush Seeds*, 1998
Synthetic polymer on linen
60 x 60 in. (152.4 x 152.4 cm)
Collection of Margaret Levi and Robert Kaplan

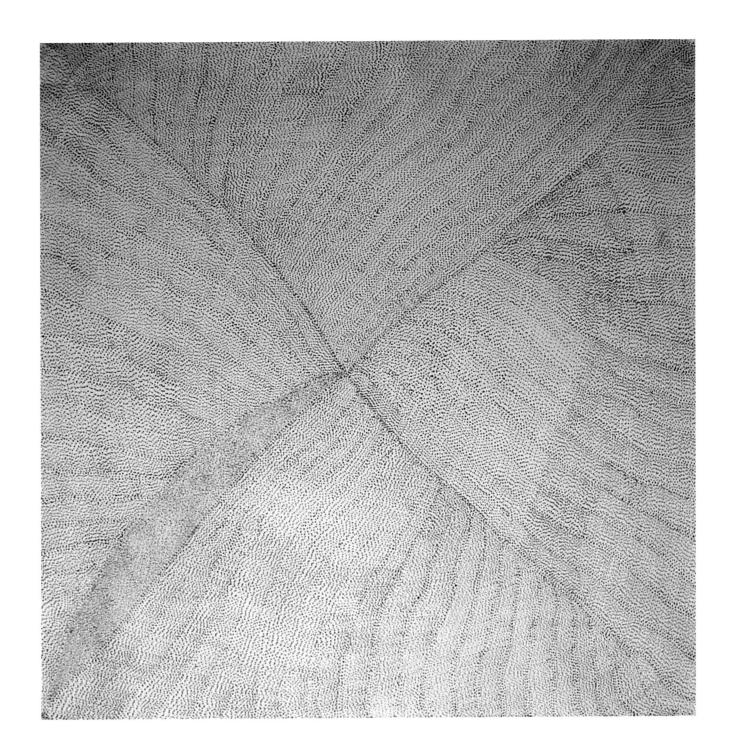

30
**Kathleen Petyarre**

*Arnkerrthe* (Mountain Devil Lizard), 2001
Acrylic on linen
47 1/4 x 47 1/4 in. (120 x 120 cm)
Private North Carolina Collection

# Abie Loy Kemarre

(born 1972)

UTOPIA

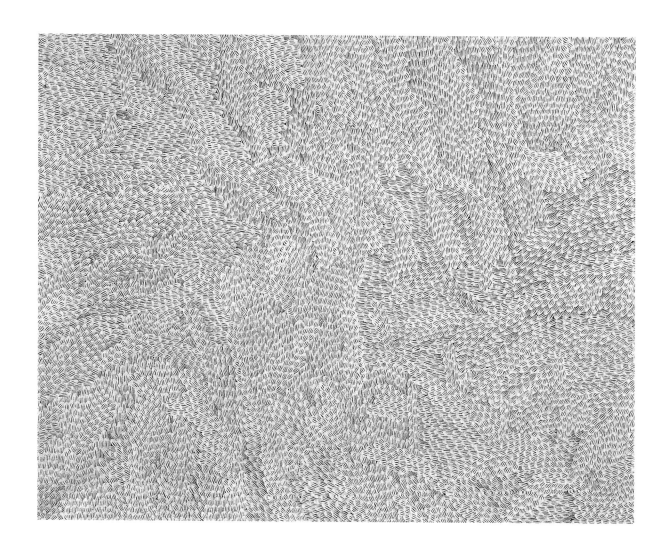

"This is my grandfather's story. This country is known as Artenya. The centre of this painting represents a dry water hole where only women can go. They hold ceremonies at this sacred site, which is west from Mosquito Bore. The Bush Leaves Dreaming Trail goes to Mosquito Bore and stops there. This Bush Hen travels through the country looking for bush plums and bush tomatoes that bear a yellow fruit called *arkitjira*. Bush plums are also found in this area and are eaten by both the people of this area and the Bush Hen."

—**Abie Loy Kemarre**

31
**Abie Loy Kemarre**

*Bush Leaves*, 2001
Acrylic on linen
35 4/5 x 48 in. (91 x 122 cm)
Collection of Margaret Levi and Robert Kaplan

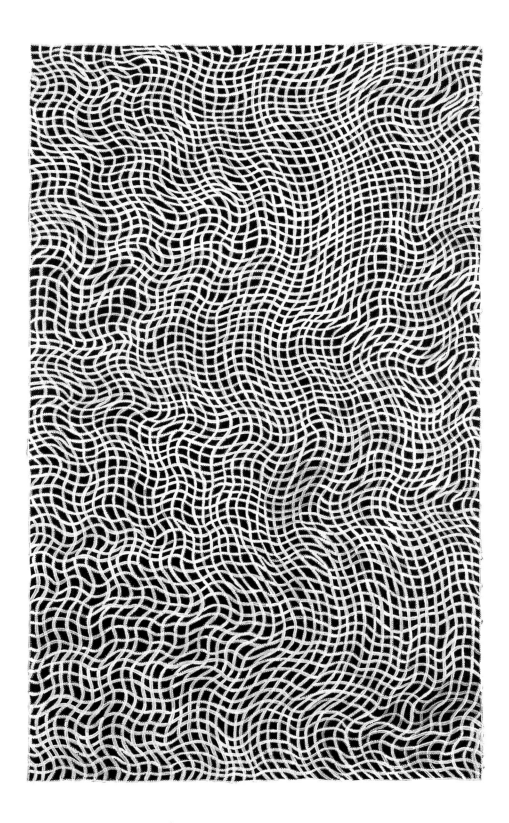

32
**Abie Loy Kemarre**

*Body Painting*, 2004
Acrylic on linen
59 4/5 x 36 1/5 in. (152 x 92 cm)
Collection of Margaret Levi and Robert Kaplan

# Ningura Napurrula

(born c. 1938)

WALUNGURRU (KINTORE)

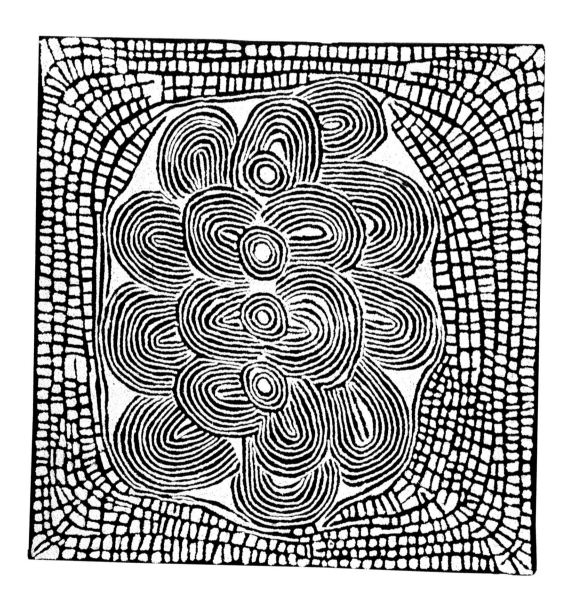

33
**Ningura Napurrula**

*Wanturrnga*, 2001
Acrylic on canvas
48 x 48 in. (122 x 122 cm)
On loan from Richard Klingler

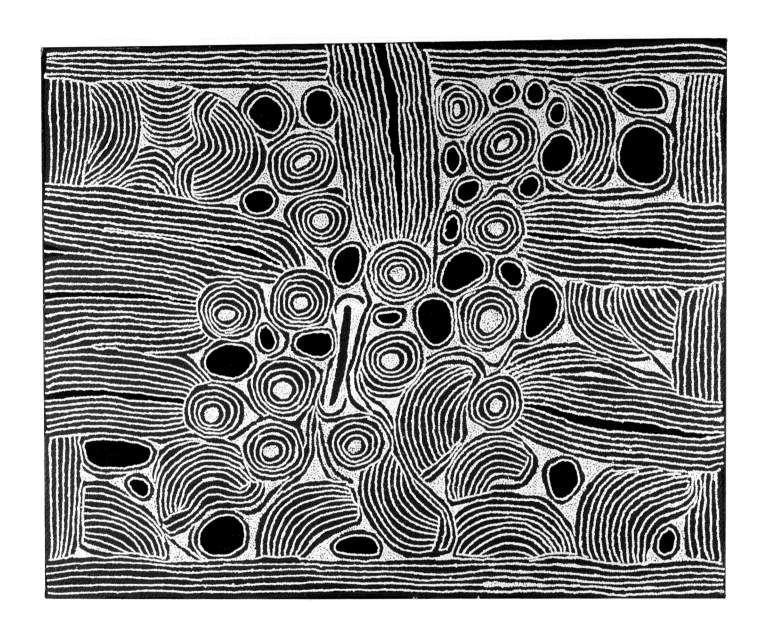

**34**
**Ningura Napurrula**

Untitled, 2005
Acrylic on canvas
48 x 60 1/5 in. (122 x 153 cm)
Laverty Collection, Sydney

The roundels in this painting depict Wirrulnga, a rock hole site east of the Kiwirrkura community in Western Australia. In mythological times, a group of ancestral women of the Napaltjarri and Napurrula kinship subsections camped at this location after traveling from the rock hole site of Ngaminya further west. Wirrulnga is associated with birth, and the lines adjacent to the roundels symbolize the extended shape of a pregnant woman. The parallel lines around the edges of the painting represent the nearby *tali* (sand hills) and the *karru* (creek). While at the site, the women also gathered the bush food known as *kampurarrpa*, or bush raisin, before continuing their travels northeast to Wilkinkarra (Lake Mackay).

# Inyuwa Nampitjinpa

(c. 1935–1999)

WALUNGURRU (KINTORE)

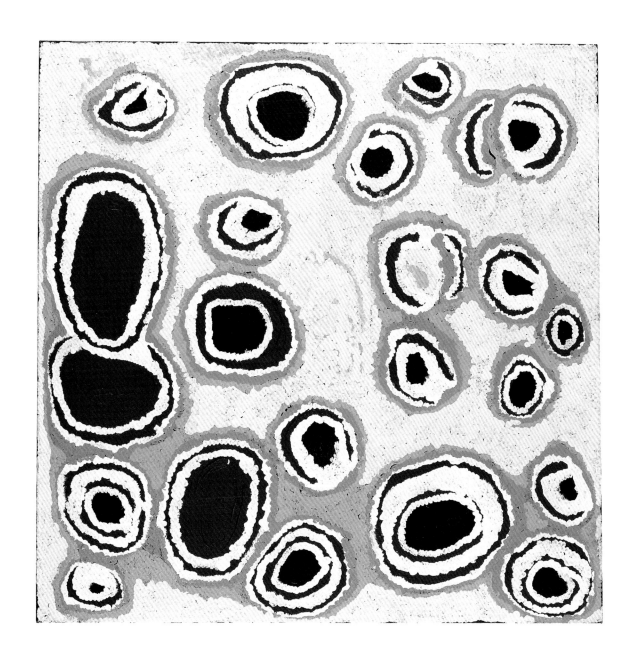

35
**Inyuwa Nampitjinpa**

*Pukanya*, 1999
Synthetic polymer paint on linen
35 4/5 x 35 4/5 in. (91 x 91 cm)
Laverty Collection, Sydney

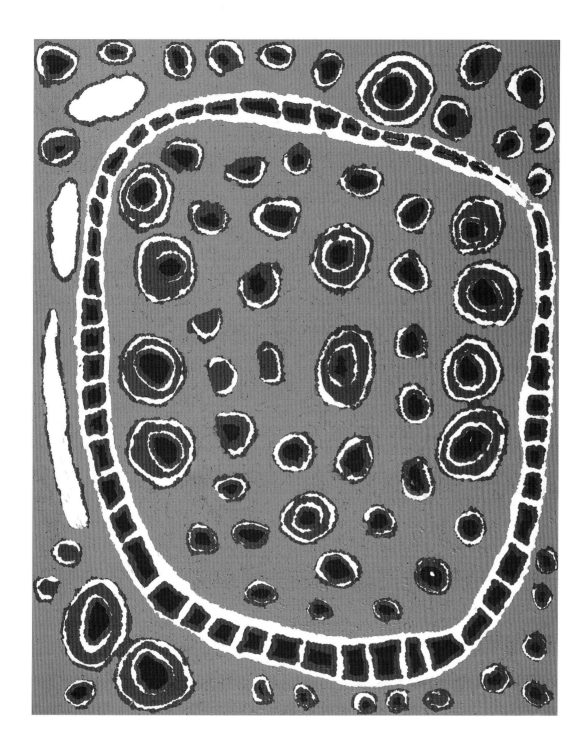

36

**Inyuwa Nampitjinpa**

*Travels of Kutungka Napanangka
from Papunga to Muruntji*, 1999
Acrylic on canvas
59 4/5 x 48 in. (152 x 122 cm)
On loan from Richard Klingler

This painting depicts designs associated with the travels of an old woman known as Kutungka Napanangka. She traveled from Papunga, west of Kintore, passing through several sites along the way and eventually arriving at the large permanent water site Muruntji, southwest of the Mount Liebig community. This old woman was considered a "devil-devil." While she rested, she was accosted by one of a group of boys. She chased and killed them, with the exception of the culprit, who managed to escape. She later cooked and ate his friends.

# Tatali Nangala

(c. 1925–2000)

WALUNGURRU (KINTORE)

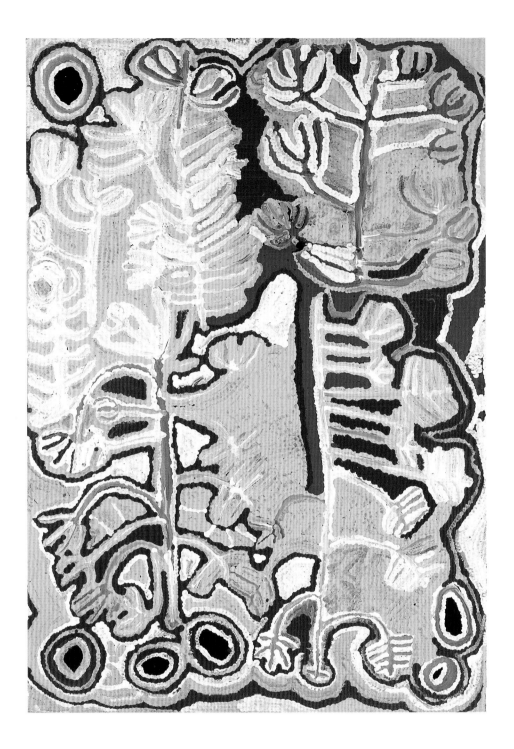

37
**Tatali Nangala**
Untitled, 1997
Acrylic on canvas
48 x 31 4/5 in. (122 x 81 cm)
Laverty Collection, Sydney

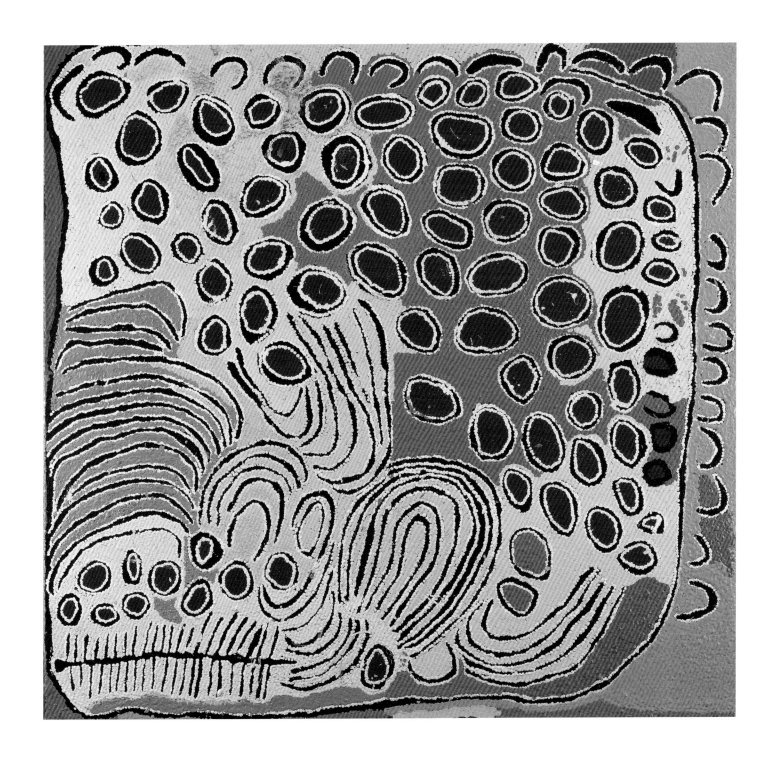

38
**Tatali Nangala**

*Two Women's Travels to the Rock Hole Site of Tjunpanya, South of Lake MacDonald*, 1999
Acrylic on canvas
48 x 48 in. (122 x 122 cm)
Laverty Collection, Sydney

In mythological times, the Two Women visited the rock hole site of Tjunpanya and traveled in the surrounding area, visiting Ngatankaritja, Tika Tika, Kurnkunya, and Putjana rock holes. The women gathered the *wangunu*, or woolly-butt seeds, from perennial grass. These seeds are ground into flour and mixed with water to create a thick paste, which is then cooked in hot sand and ashes to make a type of damper.

# Makinti Napanangka

(born 1930)

WALUNGURRU (KINTORE)

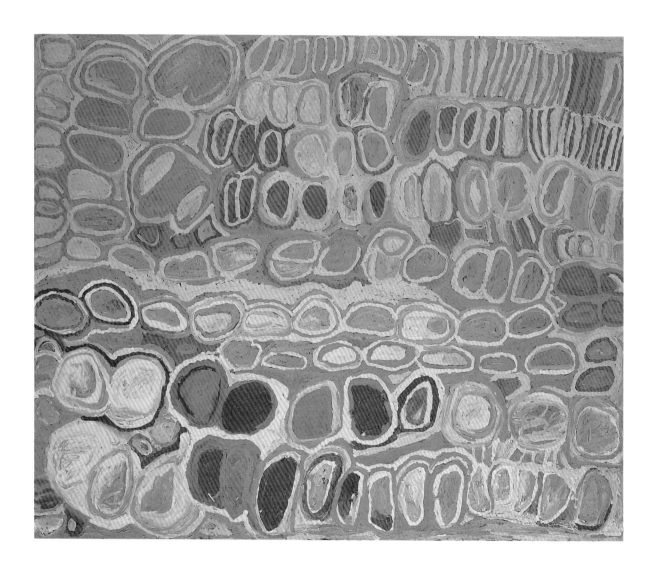

This composition is associated with the travels of the *Kungka Kutjarra* (Two Women) to a site located on the south side of Lake MacDonald. There, the women dug for the *kuningka* (western quoll), a small animal that usually lives in hollow logs or in the burrows—here represented by circles—of other animals, such as bettongs (a native marsupial) or rabbits. Afterward, the women continued their travels to the east.

39
**Makinti Napanangka**

*Kungka Kutjarra* (Two Women), 1999
Acrylic on canvas
48 x 60 in. (122 x 152.4 cm)
Collection of Margaret Levi and Robert Kaplan

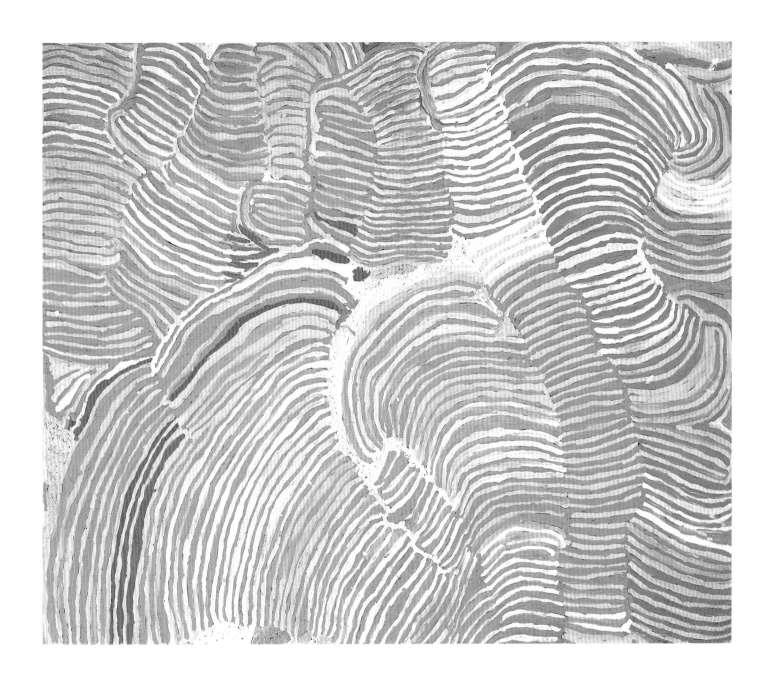

40
**Makinti Napanangka**

*Two Women*, 2001
Acrylic on linen
48 x 60 1/5 in. (122 x 153 cm)
On loan from Richard Klingler

# KIMBERLEY

KILOMETERS

0 20 40 60 80 100          200

MILES

0 20 40 60 80 100          200

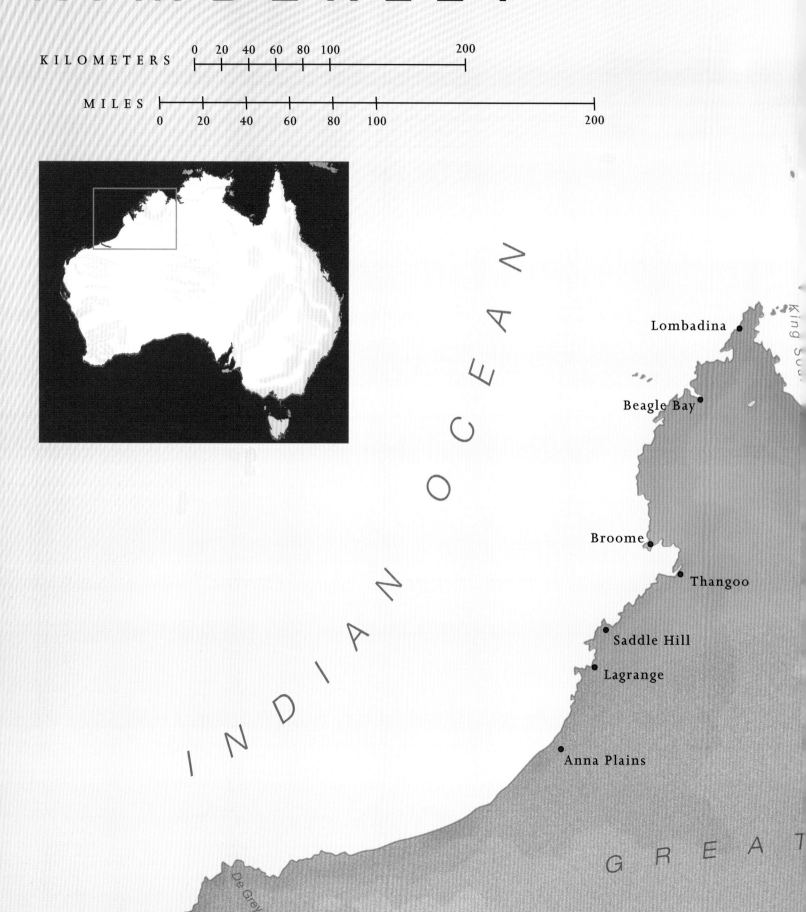

INDIAN OCEAN

King Sou

Lombadina

Beagle Bay

Broome

Thangoo

Saddle Hill

Lagrange

Anna Plains

De Grey R.

GREAT

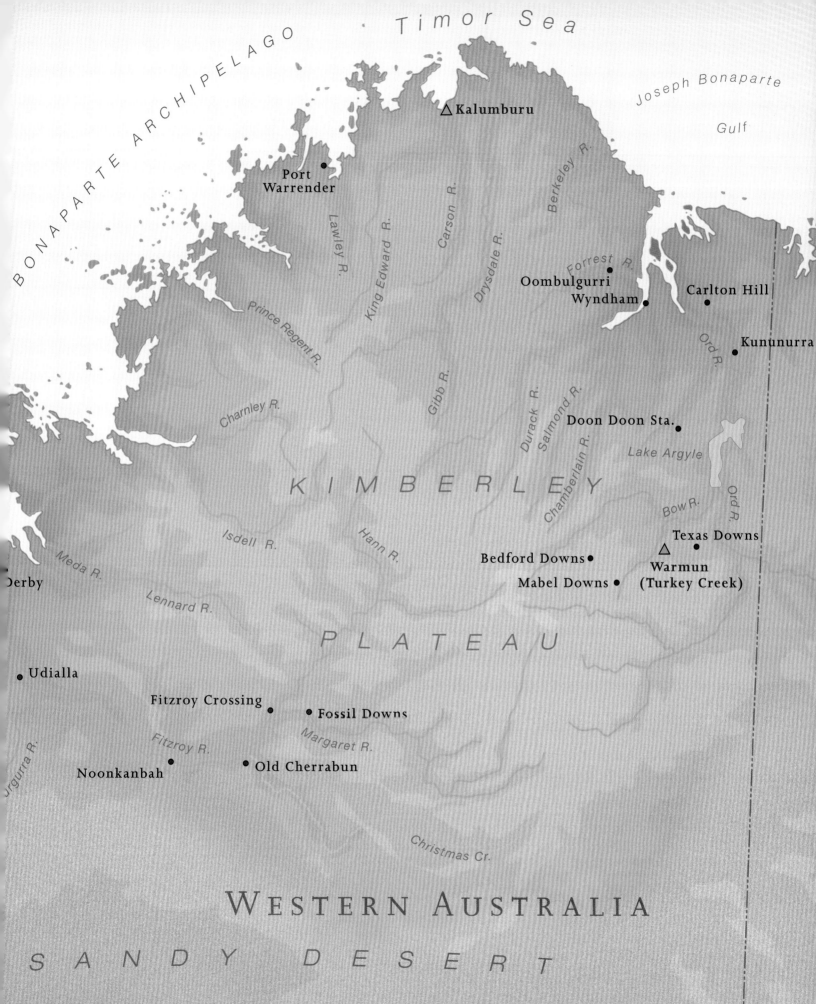

Timor Sea

BONAPARTE ARCHIPELAGO

Joseph Bonaparte Gulf

△ Kalumburu

Port Warrender •

*Lawley R.*

*King Edward R.*

*Carson R.*

*Drysdale R.*

*Berkeley R.*

*Forrest R.*

Oombulgurri
Wyndham •

Carlton Hill •

Kununurra •

*Ord R.*

*Prince Regent R.*

*Gibb R.*

*Durack R.*

*Salmond R.*

Doon Doon Sta. •

Lake Argyle

*Charnley R.*

K I M B E R L E Y

*Chamberlain R.*

*Bow R.*

*Ord R.*

*Isdell R.*

*Hann R.*

Texas Downs •

Bedford Downs •

△ Warmun
(Turkey Creek)

Derby

*Meda R.*

Mabel Downs •

P L A T E A U

*Lennard R.*

• Udialla

Fitzroy Crossing •

• Fossil Downs

*Fitzroy R.*

*Margaret R.*

*urgurra R.*

Noonkanbah •

• Old Cherrabun

*Christmas Cr.*

W E S T E R N   A U S T R A L I A

S A N D Y   D E S E R T

Lake Gregory

△ Balgo Hills
(Wirrimanu)

# KIMBERLEY

The Kimberley region is here represented by artists from the communities of Balgo Hills (Wirrimanu), Warmun (Turkey Creek), and Kalumburu. The artistic styles practiced in these areas differ widely, from exuberantly colored canvases to muted Western-style landscapes, to depictions of spirit figures from ancient times. **Balgo Hills** lies far to the south of the Kimberley Plateau, on the edge of the Great Sandy Desert in Western Australia. The artists' close relationship to their environment informs much of the work, which is characterized by extremely bright colors and a very free handling of paint.

Lucy Yukenbarri Napanangka used bold hues and heavily applied paint in simple compositions that represent topographical elements, including the sand dunes and water holes depicted in *Kunduwarra Rock Hole in the Great Sandy Desert* (1999; cat. 41). The work's dense pigmentation is created by the convergence of individual dots of paint. This technique, of Napanangka's own invention, is now known as *kıntı-kinti* (close-close). The later *Winpurpurla* (2001; cat. 42) demonstrates a lighter touch and a more complex composition. Napanangka was an important member of her community, for she held the rights to several Dreamings associated with local sources of food and water.

Currently the community's best-known artist is Eubena Nampitjin, who paints the land of her birth, far to the south of Balgo Hills. Nampitjin is an esteemed law woman and was taught traditional healing skills by her mother. She was raised in the lifestyle of a nomadic hunter, and she still spends large amounts of time in the bush. Her bold, opulent paintings display intense hues of red, orange, and pink—a signature style she arrived at in 1989.

In stark contrast to the striking color choices and loose handling of paint of Balgo artists are the paintings produced in **Warmun**, which predominantly display a subdued palette of ochres and natural pigments on canvas, sometimes with glue and sand for texture. In the most characteristic style, landscape is depicted using simple, undifferentiated shapes that are outlined with dots. Warmun artists are unique for their use of planar or multiple perspectives and their depiction of historical events.

Queenie McKenzie was the first well-known woman painter of east Kimberley. Her subjects range from important geographical sites and Christian themes to witnessed or historical events. In typical Warmun style, her subjects are presented against a background of geographical features that are arranged in rows or multiples. Because she had a white father, McKenzie narrowly escaped being taken away from her mother by force, and she worked on the old and new stations of Texas Downs as a cook for nearly forty years, until she moved to the Warmun community in the mid-1970s. Her friend Rover Thomas (c. 1926–1998), one of the best-known Australian Aboriginal artists, encouraged her to take up art, and eventually

McKenzie herself became an inspiration to many younger artists.

While Lena Nyadbi employs some elements typical of Warmun style, her works are original in their subtle shifts of color and form and in the repetition of abstract linear elements. Nyadbi did not start painting until 1998, at age sixty-one, and has since made it a full-time profession. The jagged and stony region of her father's country, Jimbala, informs much of her work.

The community of **Kalumburu** is located at the north tip of the Kimberley and is best known for its imagery of Wandjina, ancestral beings who are responsible for fertility, rain, and, in turn, food supply. Modern representations of these figures relate to ancient rock paintings, which have continuously eroded and been repainted since ancient times, a cycle that relates the eternal to the present.[1] Likewise, artists of this region still use traditional ochre pigments from creek beds and glue made from the sap of trees in their works. Lily Karedada, who belongs to a large family of artists, depicts Wandjina on canvas as well as on bark and in prints in a precise, flat manner using subtle tonal variations. The single or grouped figures are pictured against a dotted ground and are surrounded by small humans and animals such as snakes, turtles, and birds.

[1] Howard Morphy, *Aboriginal Art* (London: Phaidon, 1998), pp. 55–56.

# Lucy Yukenbarri Napanangka

(1934–2003)

BALGO HILLS (WIRRIMANU)

41
**Lucy Yukenbarri Napanangka**

*Kunduwarra Rock Hole in the Great Sandy Desert*, 1999
Acrylic on canvas
31 1/2 x 47 1/4 in. (80 x 120 cm)
Kluge-Ruhe Aboriginal Art Collection, University of Virginia, Charlottesville

42
**Lucy Yukenbarri Napanangka**

*Winpurpurla*, 2001
Acrylic on canvas
59 x 39 2/5 in. (150 x 100 cm)
Private North Carolina Collection

In this work, the artist depicted her grandmother's country, located far to the south of Balgo, in the Great Sandy Desert. The *Tjukurrpa* (Dreaming) for this country tells of ancestral women of the Nungurrayi, Nampitjin, and Napangardi skin groups who camped at Winpurpurla, a *tjurrnu* (soakwater) that is considered an *inta*, or "living water" place, because it always has potable water. The ancestral women made a fire close to the water and started dancing a sacred, secret dance. The dancing went all night, after which the women started walking a long way west. They came to Winpurpurla to collect the special food of the area, in particular the *murlanpa*, a flower harvested from the sugar tree and eaten raw, which is considered a great delicacy. The fine dot work depicts the abundance of *murlanpa*, while the U shapes represent the women collecting flowers with their *wanna* (digging sticks).

# Eubena Nampitjin

(born c. 1925)

BALGO HILLS (WIRRIMANU)

43
**Eubena Nampitjin**

*Walganbuggsa Rock Hole in the*
*Great Sandy Desert*, 1995
Acrylic on canvas
59 x 39 2/5 in. (150 x 100 cm)
Collection of Margaret Levi and Robert Kaplan

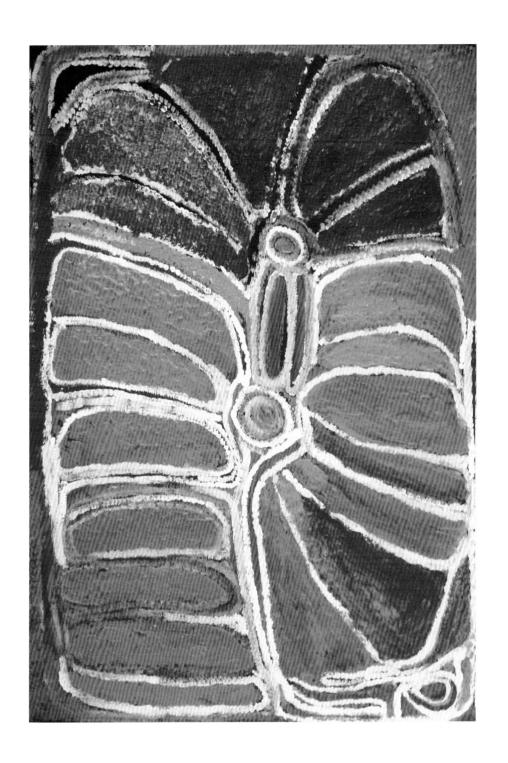

44
**Eubena Nampitjin**

*Minma*, 2000
Acrylic on linen
35 2/5 x 23 3/5 in. (90 x 60 cm)
Private North Carolina Collection

Minma is the name of part of the artist's traditional country, located far to the southwest of Balgo, in the Great Sandy Desert. In the center of the painting are two connected *waniri* (rock holes) called Kinyu and Witjiri. The *Tjukurrpa* (Dreaming) story for this area tells of *malu*, or kangaroos, which came out of the ground at this site. The animals' escape passages eventually formed the rock holes.

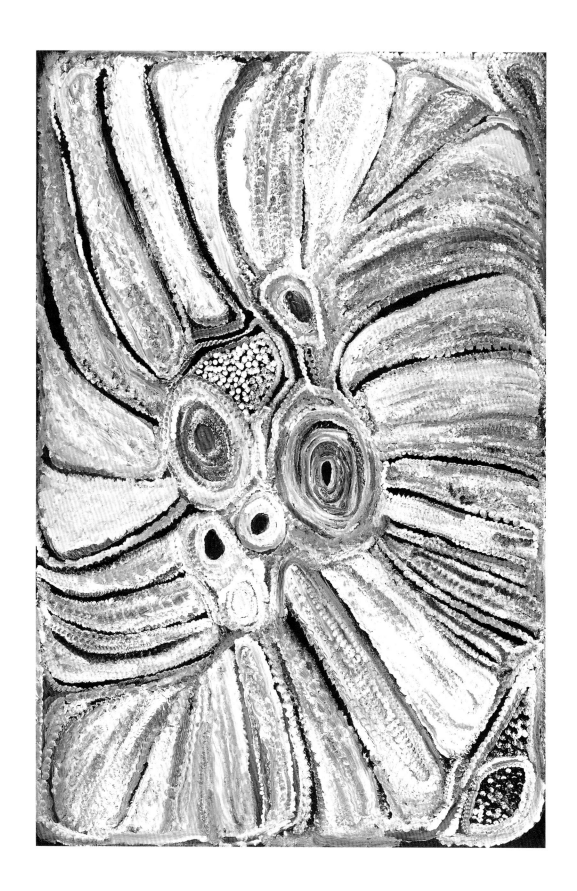

45
**Eubena Nampitjin**

*Tjintalpa*, 2004
Synthetic polymer paint on linen
59 x 39 2/5 in. (150 x 100 cm)
Laverty Collection, Sydney

# Queenie McKenzie

(c. 1930–1998)

WARMUN (TURKEY CREEK)

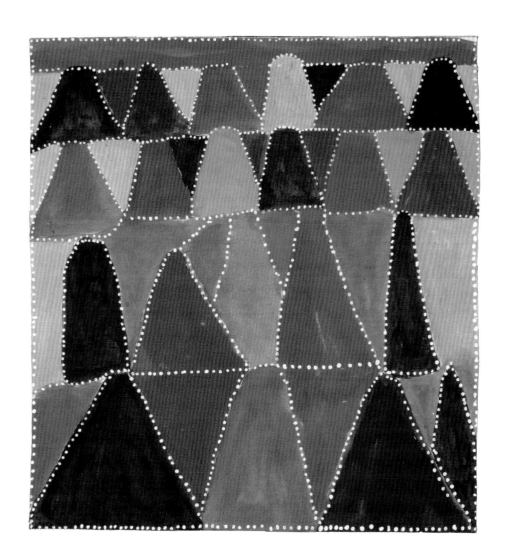

46
**Queenie McKenzie**

*Limestone Hills near Texas Downs*, 1991
Earth pigment and natural binder on canvas
37 3/8 x 35 3/8 in. (95 x 89.8 cm)
National Gallery of Victoria, Melbourne

"I like a do country. What you know country. And where you go to Sunday road, somewhere walkabout, you look hill like that. You take notice. 'Ah! I can draw this,' you say. You go back la camp. You camp might be that day. That morning you get up, just get your paint and run that hill where he sit down. I got to run 'em that Bow River hill yet. I'm going for that I tell you."

**–Queenie McKenzie**

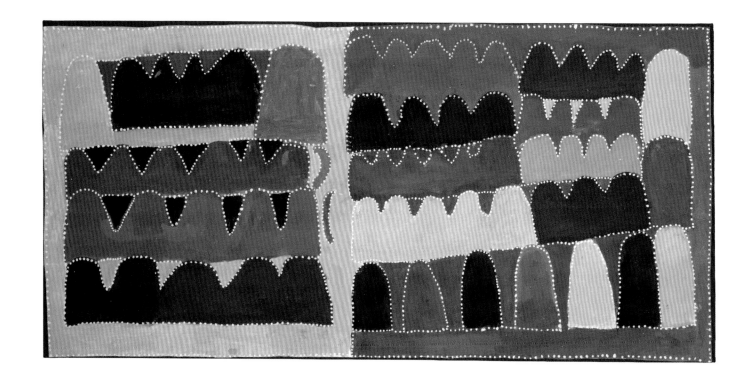

47
**Queenie McKenzie**

*Texas Country, Other Side*, 1994
Earth pigment on linen
40 1/2 x 83 3/8 in. (102.8 x 211.8 cm)
National Gallery of Victoria, Melbourne

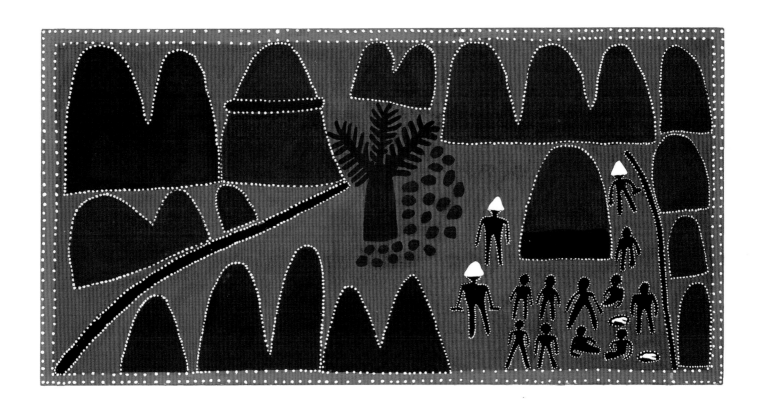

48

**Queenie McKenzie**

*Horso Creek Massacre*, 1997
Acrylic on canvas
35 2/5 x 65 in. (90 x 165 cm)
Collection of Margaret Levi and Robert Kaplan

# Lena Nyadbi

(born c. 1937)

WARMUN (TURKEY CREEK)

The sharp, stony land of Jimbala is the country of the artist's father. When hunting kangaroos in the hills, people wrapped their feet in paperbark or calico to keep the sharp stones from cutting them. *Jimbala* (spearheads) were traditionally made of stone and later made of glass. Many different colored stones can be found in this country, many of which were used to make *jimbala*. In the early days, people used to break these stones with a strong stick to create a sharp edge.

Near Doon Doon Station there is a hill with a white rock on top. In the *Ngarrangkarni* (Dreaming) this was a cave where *darbarun*, the pelican, hid *daiwul*, the barramundi (a native fish). The barramundi escaped and traveled south, although the fish are not normally found south of Doon Doon. The upside-down U shapes in the composition symbolize the *lilmim* (scales) of the barramundi, while the linear shapes stand for the spearheads.

49
**Lena Nyadbi**

*Lilmim and Jimbala* (Scales and spearheads), 2002
Ochre on linen
17 3/5 x 47 1/4 in. (45 x 120 cm)
Collection of Margaret Levi and Robert Kaplan

50
**Lena Nyadbi**

*Jimbala* (Spearheads), 2003
Ochre on linen
35 2/5 x 47 1/4 in. (90 x 120 cm)
Collection of Margaret Levi and Robert Kaplan

# Lily Karedada

(born c. 1935)

KALUMBURU

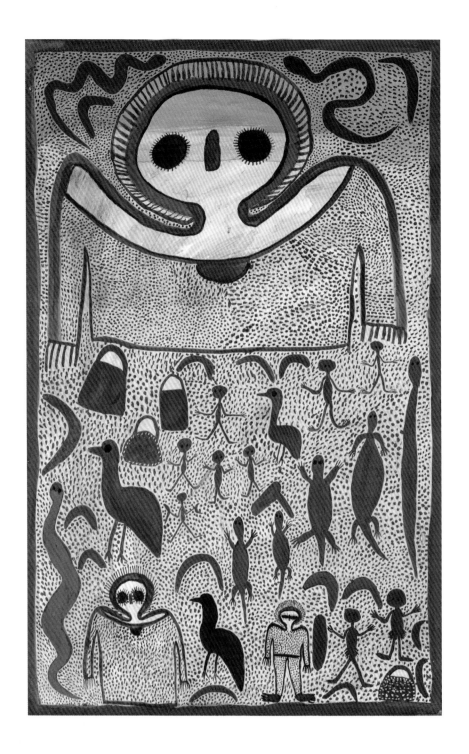

The Wandjina, powerful ancestors of the Woonambal tribe, are a key motif in the artist's paintings. They are spirits of the sky and are associated with rain, thunderstorms, and the coming of the wet season. Wandjina are often depicted in a veil of dots, signifying rain, with prominent eyes and no mouth. It is said that the Wandjina communicate through thought, and if they had mouths, it would never stop raining. The animals that surround the Wandjina also hold significance in the artist's totem.

51
**Lily Karedada**
*Wandjina*, 1990
Earth pigment and natural binder on canvas
43 2/5 x 27 3/5 in. (110 x 70 cm)
National Gallery of Victoria, Melbourne

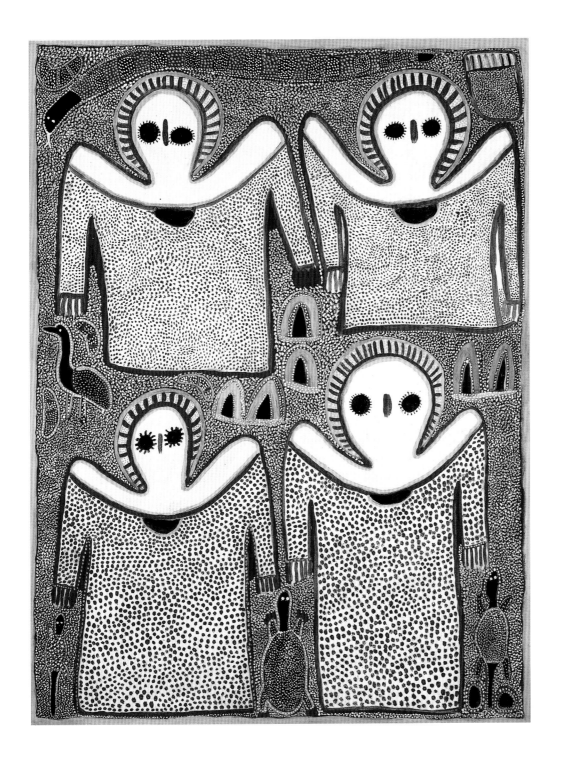

52
**Lily Karedada**

*Four Wandjina*, 1998
Natural pigment on canvas
48 x 36 in. (122 x 91.5 cm)
The Kelton Foundation

A r a f u r a   S e a

△ Melville Island

Cape
Fourcroy
△
**Bathurst Island**

Co

**Darwin** ● Howard
Springs
● Palmerston

**Noonamah** ●

Jabir

*Adelaide R.*

*Mary R.*

*S. Alligator R.*

*Timor Sea*

**Daly River** ●

△
**Peppimenarti**

*Joseph Bonaparte*

*Gulf*

● **Wadeye**

*Daly R.*

*Katherine R.*

**Maranboy** ●

*Fitzmaurice R.*

**Matarank**

**Wyndham** ●

*West Baines R.*

*Victoria R.*

N O R T H E R N

*Ord R.*

**Doon Doon Sta.** ●

*Lake Argyle*

**Warmun
(Turkey Creek)**
△  ● **Texas Downs**

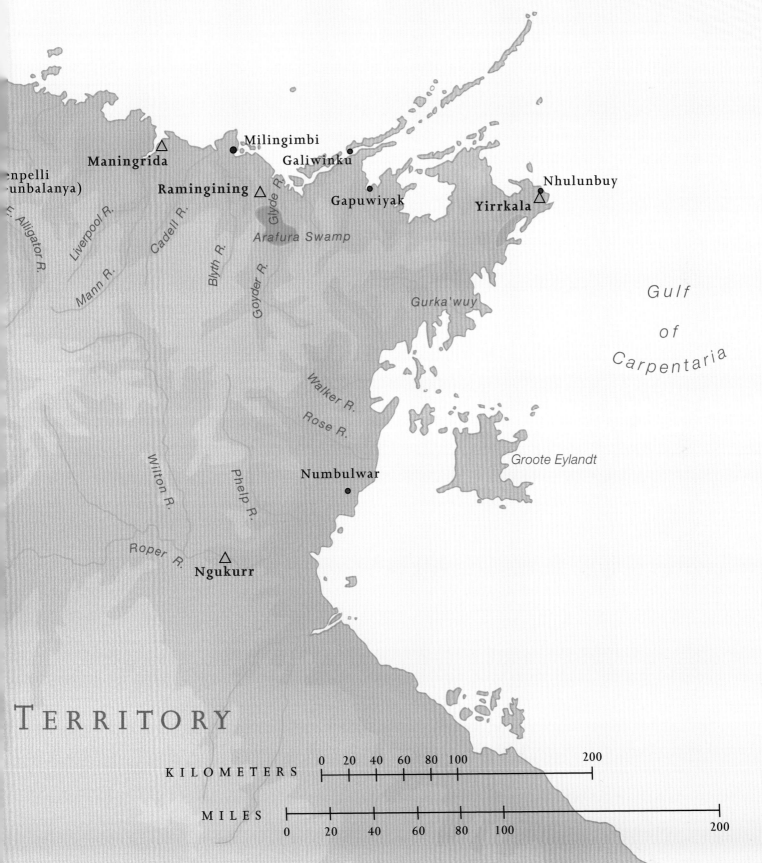

# ARNHEM LAND/
# NORTH AUSTRALIA

Maningrida

Milingimbi

Galiwinku

Nhulunbuy

npelli
unbalanya)

Ramingining

Gapuwiyak

Yirrkala

Cadell R.

Liverpool R.

Mann R.

Glyde R.

Blyth R.

Goyder R.

Arafura Swamp

Gurka'wuy

*Gulf*

*of*

*Carpentaria*

E. Alligator R.

Walker R.

Rose R.

*Groote Eylandt*

Wilton R.

Phelp R.

Numbulwar

Roper R.

Ngukurr

T E R R I T O R Y

KILOMETERS

0 20 40 60 80 100 200

MILES

0 20 40 60 80 100 200

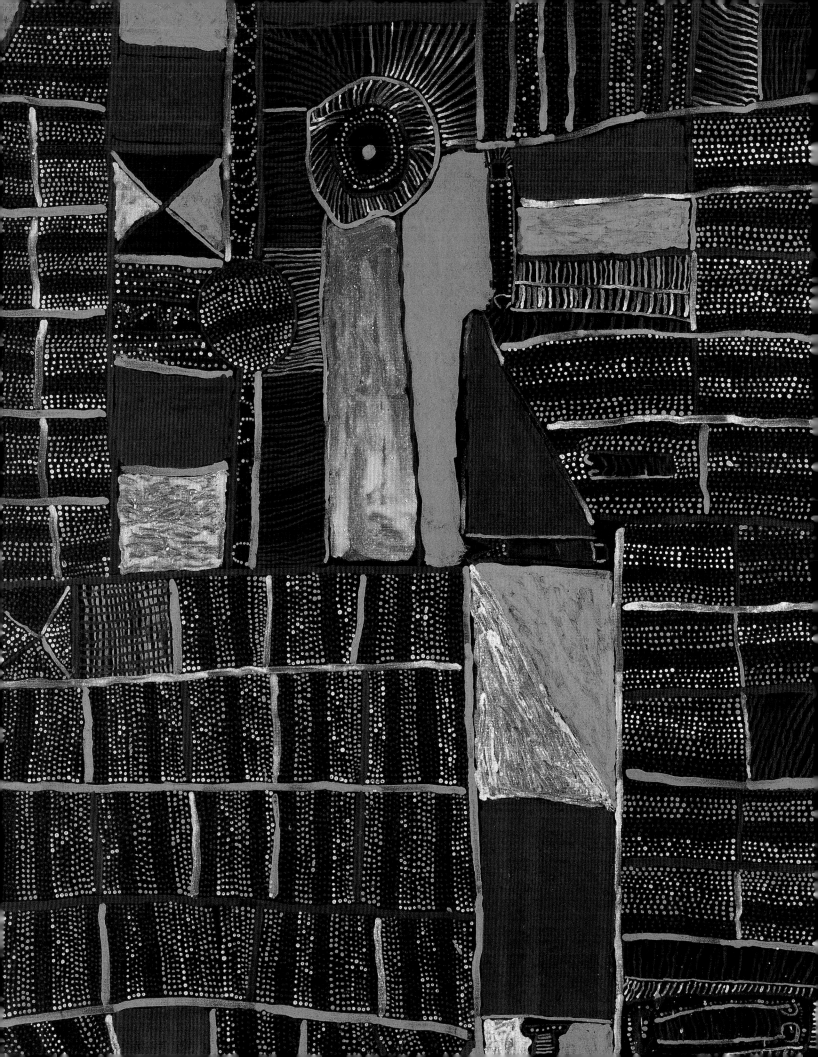

# ARNHEM LAND/ NORTH AUSTRALIA

Many Aboriginal communities in northern Australia are well known for their artistic expression. The majority of these are located within Arnhem Land and on Bathurst and Melville Islands. Due to the tropical climate and lush vegetation of Arnhem Land, the use of eucalyptus bark as a painting ground is widespread. Designs are painted in natural ochres and pigments and are either very intricate, stylized representations or abstract, complex compositions, all of which carry great spiritual significance. Kay Lindjuwanga lives near **Maningrida** in western Arnhem Land. She was taught to paint by her husband, acclaimed artist John Mawurndjul (born c. 1952), whom she has assisted since the 1980s. Employing a technique typical of Arnhem Land painters, Lindjuwanga uses a long-haired brush to apply layers of precise parallel strokes in a crosshatched pattern. Her images are abstract representations of significant sites in her Dreaming. Lindjuwanga also produces etchings, hollow logs, and carvings of *mimih*—mythical, mischievous creatures.

Art produced in Ramingining and Yirrkala strongly reflects social organization and the tradition of clans inheriting specific designs.[1] Barks from **Ramingining** possess a formal quality, as evidenced in the work of Dorothy Djukulul. Born into a family of prominent artists, Djukulul is one of a small number of women who were taught to paint by their fathers in the 1960s. In her 1989 painting *Warrnyu* (cat. 55), Djukulul employs her clan's design of crosshatching and solid colors in the

grid that encloses the hanging flying foxes. These are surrounded by the sacred pattern of flower- or star-like shapes, which are sometimes interpreted as guano. Daisy Manybunharrawuy, who was also among those taught by their fathers, depicts the story of the Wagilag Sisters in finely detailed and complex visual narratives.

**Yirrkala** barks are even more visually structured and layered in meaning than those from Ramingining. Galuma Maymuru's *Djarrakpi Landscape* (1996; cat. 59) relates to a Dreaming associated with the area surrounding Lake Djarrakpi. The composition centers on a double image of the ancestral woman Nyapililngu, around which Maymuru presents different points of the story, thus compartmentalizing it in episodic form. She was strongly encouraged as an artist by her father, Narritjin (c. 1914–1981), and belongs to the first generation of Yolngu women who became major artists. Howard Morphy eloquently describes the significance of art to Maymuru: "To Galuma, art is an act of memory and a process of transmission, in which she passes Manggalili law on to a new generation of her clan. Equally, it is a spiritual and aesthetic exploration of her homeland."[2]

With great control and deliberation, Wolpa Wanambi painstakingly administers strokes of paint to relate the narrative of the Marrakulu clan. The story recounts the beginning of the epic journey of the two Wagilag (or Wawilak) Sisters, who traveled through many different clan countries.

The Aboriginal communities on the tropical islands of Bathurst and Melville, located north of the continent, speak the Tiwi language and developed their art and traditions in relative isolation. Today their range of artistic creations is broad, including bark baskets, painting, printmaking, and textile design, as well as sculpture based on carved *Pukamani* (funeral poles) and figurative works. Art from **Bathurst and Melville Islands** relates strongly to sacred or significant sites and seasonal changes. Abstract, geometric designs underscore the importance of ceremony in social life, especially funeral rites. While the artists display great individual differences in their work, all of them use only natural pigments and ochres. Their designs are often set against a black background, which recalls ceremonial body painting.

One of the most acclaimed artists of her generation, Kitty Kantilla possessed strong compositional skills and an assuredness of design. Deftly balancing shape and color, and patterned and solid areas, her traditional images are incredibly refined and almost decorative. In 1997 Kantilla boldly reversed the Tiwi tradition of painting on black ground, painting on white instead. The resulting images are unusually delicate and airy, as can be seen in an untitled work from 1997 (cat. 63).

A slightly younger generation of Tiwi artists is here represented by Jean Baptist Apuatimi, who, aside from painting, is also renowned for her carved ironwood sculptures. Although based on a combination of mythical

and personal stories, *Yirrikapayi* (2005; cat. 67) displays the artist's sheer pleasure in inventing new combinations of traditional Tiwi design patterns. At the same time the design possibly relates to the skin of a crocodile.

On the mainland, **Ngukurr** is a remote township on the Roper River in southeast Arnhem Land. A number of this community's artists are known for painting lush and colorful landscapes. In another striking contrast to most Aboriginal art, Gertie Huddleston employs a horizontal, or planar, point of view when layering her exuberantly colored landscapes. These works are representational, not symbolic, yet they are equally complex compositions of intricate details. Huddleston spent her early life hunting and gathering with her family and was later educated at Roper River Mission, where she tended to animals, flowers, and other plants. She also learned the art of needlework, which is still reflected in the nature of her mark making.

The women artists of **Peppimenarti**, which is located in the wetlands southwest of Darwin, have a long upstanding tradition of richly colored weavings, including bags, baskets, fishnets, and mats. In the last five years, a group of women has taken inspiration from weaving patterns and began to paint on canvas. The resulting works feature intricate patterns of loops, lines, and dots in strong, vibrant colors. Regina Wilson's *String Design* (2002; cat. 70) is based on a traditional stitch used in coiling baskets from pandanus fiber.

[1] "Arnhem Land: Setting the Scene," in *Art from the Land: Dialogues with the Kluge-Ruhe Collection of Australian Aboriginal Art*, eds. Howard Morphy and Margo Smith Boles (Charlottesville: University of Virginia, 1999), p. 26.
[2] Howard Morphy, "Galuma Maymuru," in Hetti Kemerre Perkins and Howard Morphy, *Tradition Today: Indigenous Art in Australia* (Sydney: Art Gallery of New South Wales, 2004), p. 84.

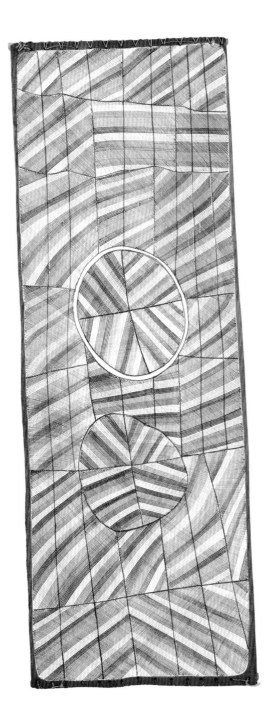

# Kay Lindjuwanga

(born 1957)

MANINGRIDA

This painting represents the artist's Dreaming, a site called Dadbe Bolhmeng, which in Kunwinjku means "the Deaf Adder ascended" out of the billabong (water hole). This billabong lies in the artist's country near Milmilgkan. The billabong at Dadbe Bolhmeng is covered with *kun-dark* (water lilies), which are symbolized by the large areas of *rarrk* cross-hatching in the composition. The central circle signifies the fount that supplies the billabong with water. Each of the water creatures and plants is considered a manifestation of *ngalyod*, the rainbow serpent.

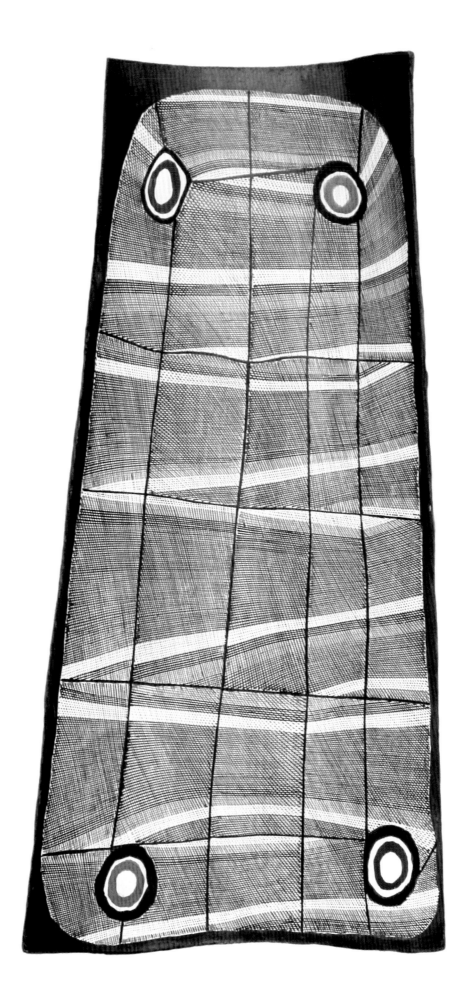

54
**Kay Lindjuwanga**

*Bilwoyinj*, 2004
Ochre on bark
39 4/5 x 20 1/5 in. (101 x 51 cm)
Private North Carolina Collection

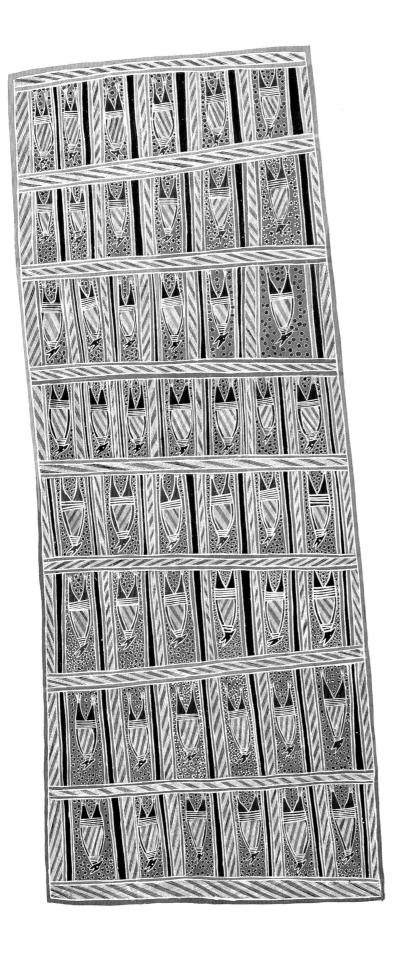

# Dorothy Djukulul

## (born 1942)

### RAMINGINING

55
**Dorothy Djukulul**

*Warrnyu* (Flying foxes), 1989
Natural pigment on eucalyptus bark
106 1/4 x 32 in. (269.9 x 81.3 cm)
Kluge-Ruhe Aboriginal Art Collection,
University of Virginia, Charlottesville

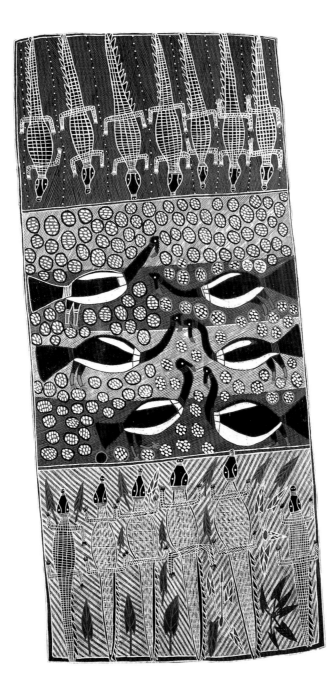

Magpie geese and crocodiles, which migrate along the coast and swamp region of the artist's country, are sacred totems to her clan. During the Dreaming, the Crocodile Man learned how to make fire sticks and started a bush fire, which burned his back and created scars like the marks of a crocodile. To escape the fire, he jumped into the water and became a crocodile. As he grew accustomed to his new form, he traveled north and west to Milingimbi, up the river and into the swamp, where he pushed up the earth to create a little island known as Mutyka. The eggs of magpie geese are used in ceremonies for new-borns and mothers, ensuring a healthy infancy and a plentiful supply of eggs. Magpie goose nests are considered resting places for souls.

56
**Dorothy Djukulul**

*Magpie Geese (Mutyka) and Crocodile*, c. 1990
Ochre on bark
87 1/2 x 39 1/2 in. (222.3 x 100.3 cm)
Kluge-Ruhe Aboriginal Art Collection,
University of Virginia, Charlottesville

# Daisy Manybunharrawuy
## (born c. 1950)
### RAMINGINING

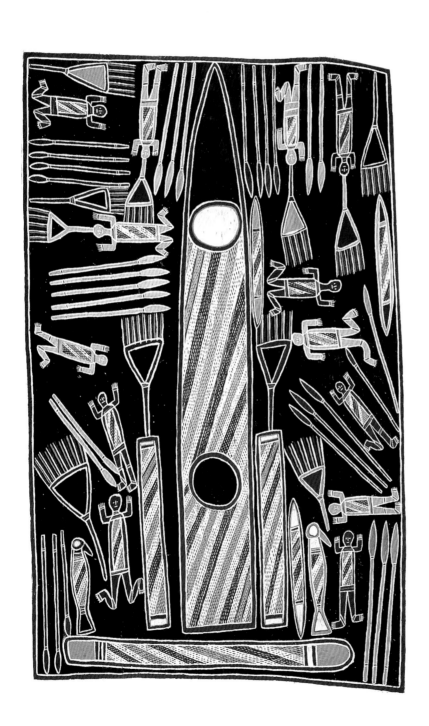

57
**Daisy Manybunharrawuy**
*Wagilag Sisters*, 1988–90
Natural pigment on eucalyptus bark
59 x 35 in. (150 x 89 cm)
Kluge-Ruhe Aboriginal Art Collection,
University of Virginia, Charlottesville

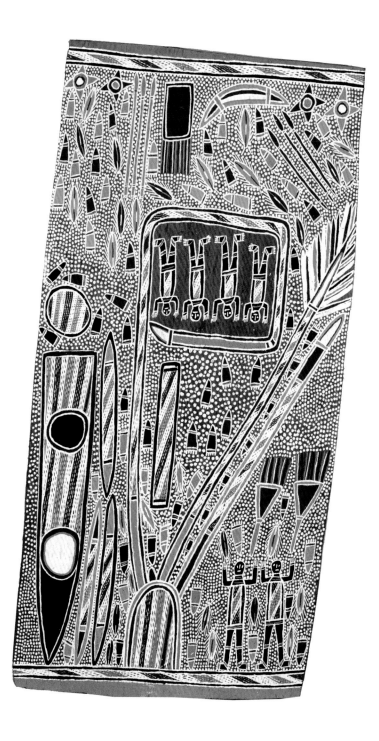

"I was born and lived at Ngarrawundhu at Milingimbi. . . . I still kept going at bark painting after I married Djembangu. My father used to tell me a story from the painting. My families were happy with that—all those old people. . . . I use white clay from the beach; black from the tree from the bush; red and yellow from the beach. We used to use *djalkurrk* [native orchid], that bush medicine. We call it bush medicine because you chew it before you use it. Glue came really when Mr. McLeay came. Alan Fidock used to use a spray—a hand spray, helping bush medicine."

—Daisy Manybunharrawuy

58
**Daisy Manybunharrawuy**

*Wagilag Creation Story*, 1990
Natural pigment on eucalyptus bark
54 5/8 x 27 1/4 in. (138.7 x 69.1 cm)
National Gallery of Victoria, Melbourne

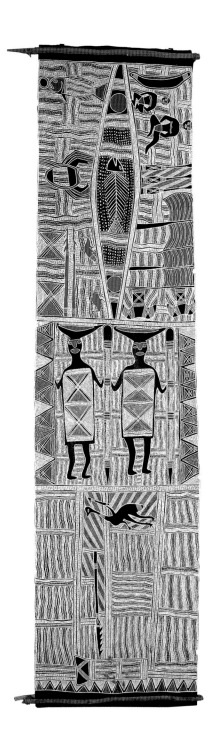

# Galuma Maymuru

(born 1951)

YIRRKALA

59
**Galuma Maymuru**

*Djarrakpi Landscape* (*Manggalili Dhawu*), 1996
Natural pigment on eucalyptus bark
116 1/4 x 30 1/4 in. (295.3 x 76.8 cm)
Kluge-Ruhe Aboriginal Art Collection,
University of Virginia, Charlottesville

The three panels on this bark show related events that occurred during the time of *Wangarr* (Dreamings) in the Manggalili homeland of Djarrakpi. The dominant *miny'tji*, or clan design, of wavy alternately colored bands of cross-hatching throughout the three panels generally represents the sand dunes of Djarrakpi. The top panel depicts a *yingapungapu*, a sand sculpture that keeps the contamination of death at bay. The middle panel displays two depictions of the ancestral woman Nyapililngu, who is portrayed both with her digging sticks and fruit-carrying baskets. She is a Manggalili symbol of fertility, knowledge, and power. The bottom panel shows the totemic emu using his spear to hit a special rock.

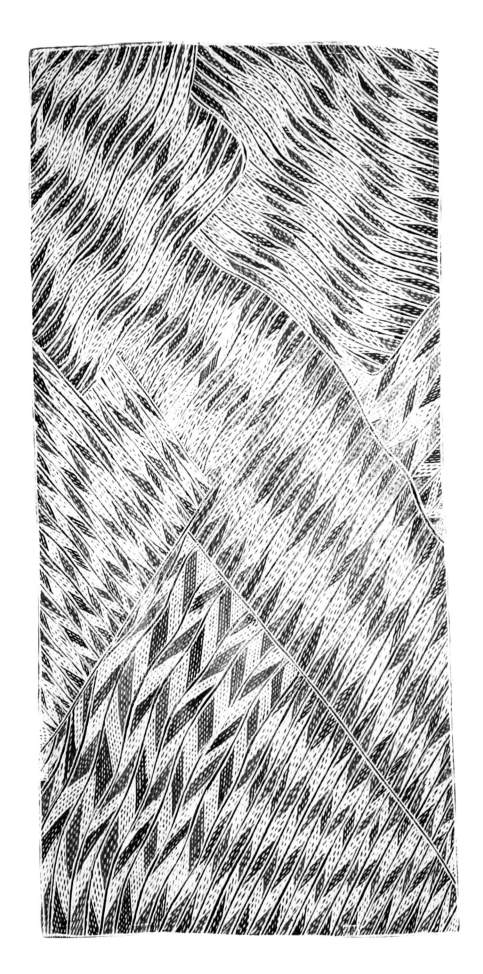

60
**Galuma Maymuru**

*Yirritja Dhuwa Gapu II*, 2004
Ochre on bark
36 1/5 x 18 1/5 in. (92 x 43 cm)
Private North Carolina Collection

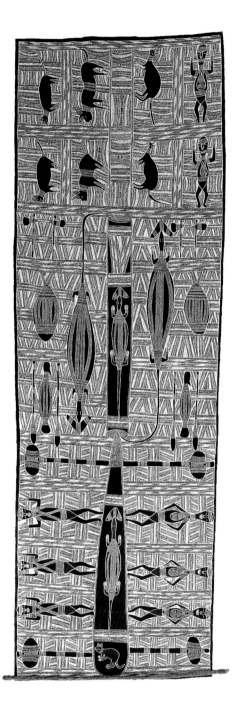

# Wolpa Wanambi

(born 1970)

YIRRKALA

61
**Wolpa Wanambi**
*Marrakulu Miny'tji*, 1996
Ochre on bark
112 1/4 x 38 1/2 in. (285.1 x 97.8 cm)
Kluge-Ruhe Aboriginal Art Collection,
University of Virginia, Charlottesville

This bark is associated with the early travels of the Wagilag Sisters through the Arnhem Land region. The top panel shows the sisters, in the form of wild cats, at the site of Yanawal. There they saw Wuyal, the honey man, cutting down trees in search of honey. One of the fallen trees crashed through the country, gouging out the bed of the Gurka'wuy River, which can be seen in the middle panel with two *djerrka* (lizards) playing on either side and another in the hollowed-out inside of the tree. The lower panel is the ceremonial site where dancers perform commemorative rituals and reenact the travels of the Wagilag Sisters.

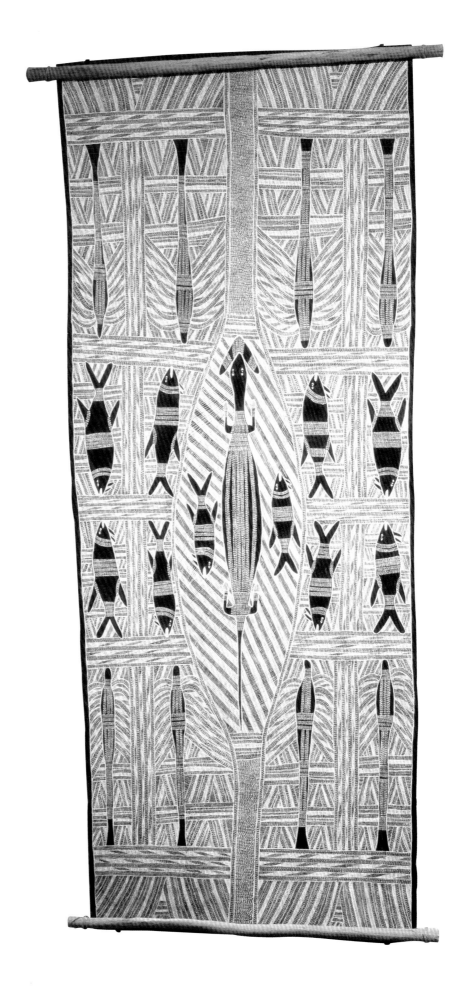

**Wolpa Wanambi**

*Marrakulu at the Goyder River*, 1997
Natural pigment on eucalyptus bark
92 1/2 x 37 in. (235 x 94 cm)
Seattle Art Museum, gift of Margaret Levi
and Robert Kaplan

# Kitty Kantilla

(c. 1928–2003)

## MELVILLE ISLAND

63
**Kitty Kantilla**

Untitled, 1997
Natural pigment on canvas
34 4/5 x 41 3/5 in. (88.5 x 105 cm)
Laverty Collection, Sydney

"It's from the old times."

–**Kitty Kantilla** speaking of her work

The imagery in the artist's paintings, like that of most Tiwi art, is derived from *jilimara*, or ceremonial body painting, and the decoration applied to *Pukamani* funeral poles and other ritual objects. Traditionally, participants in funeral ceremonies decorate themselves with a rich variety of ochre designs so as to conceal their true identity from malevolent *mapurtiti* (spirits of the dead). The decorative motif *mulypinyini amintiya pwanga* (lines and dots) forms a common basis for many of the abstract designs that are said to have no specific meaning. Thus, Tiwi art generally avoids direct references to totems, Dreamings, or stories connected with the *palaneri*, or Creation Era.

64
**Kitty Kantilla**
Untitled, 1998
Ochre on linen
45 3/5 x 30 1/2 in. (114 x 82 cm)
Laverty Collection, Sydney

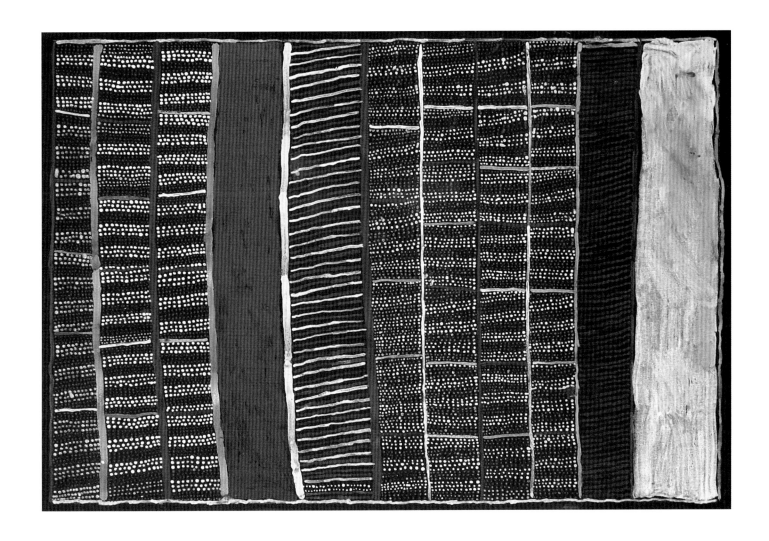

65
**Kitty Kantilla**

Untitled, 1999
Ochre on canvas
24 x 35 4/5 in. (61 x 91 cm)
Private North Carolina Collection

# Jean Baptist Apuatimi

(born 1940)

BATHURST ISLAND

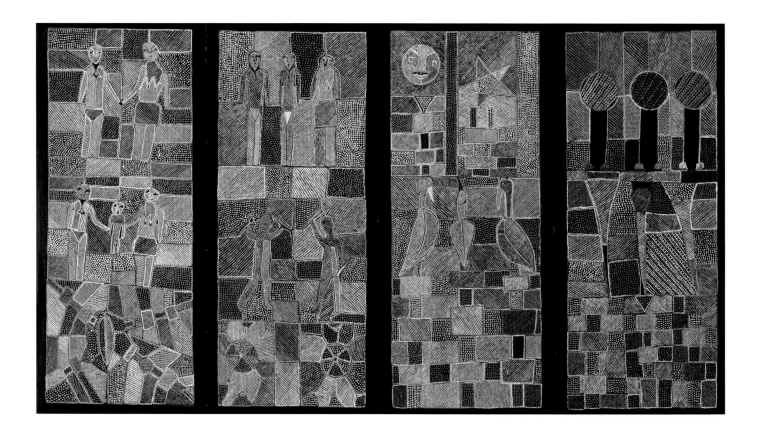

66

**Jean Baptist Apuatimi**

*Purukuparli ngirramini*, 1992
Earth pigment on canvas
4 panels; each 53 1/2 x 23 4/5 in. (136 x 60.7 cm)
National Gallery of Victoria, Melbourne

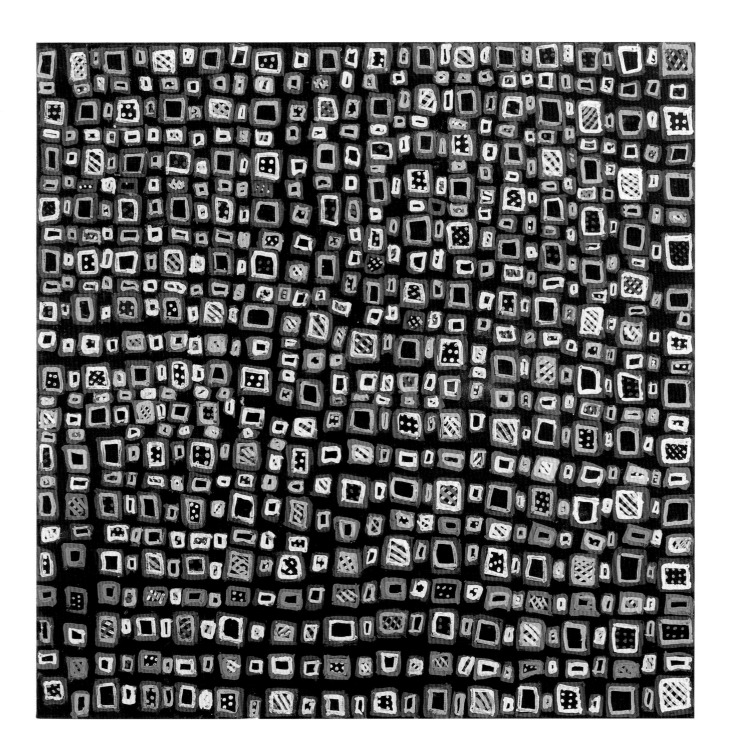

67
**Jean Baptist Apuatimi**

*Yirrikapayi* (Crocodile), 2005
Ochre on canvas
47 1/4 x 47 1/4 in. (120 x 120 cm)
Collection of Margaret Levi and Robert Kaplan

"Yirrikapayi was once a man who lived around Fourcroy. They been spear him. He crawled into the water and turned into a crocodile [*Yirrikapayi*]. Long ago my husband was hunting and fishing when a big crocodile jumped out of the water and grabbed his arm. He save himself. He grab that inside part and pulled. That crocodile let go and died. He didn't want to eat that crocodile. He been chuck him away. I had two girls at that time, Carmelina and Josette. My husband was a brave man."

—Jean Baptist Apuatimi

# Gertie Huddleston

(born c. 1933)

NGUKURR

"Oh goodness [flowers] make me happy inside.
Long time, when the missionaries were there
[at Roper River] we used to do fancywork you
know, tablecloth and needlework; big flowers,
Waratah flowers all the bush flowers. I was
champion for needlework and it looked like
that [one of her paintings]."

—Gertie Huddleston

68

**Gertie Huddleston**

Untitled, 1996
Synthetic polymer paint on canvas
24 1/8 x 38 in. (61.3 x 96.5 cm)
National Gallery of Victoria, Melbourne

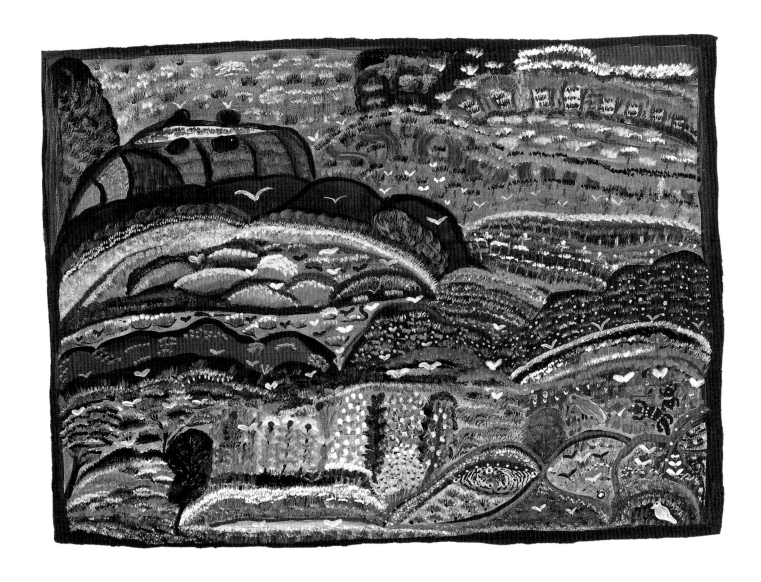

69
**Gertie Huddleston**

*Wet Season Billabong*, 1998
Acrylic on canvas
24 2/5 x 34 2/5 in. (62 x 87 cm)
Collection of Margaret Levi and Robert Kaplan

# Regina Wilson

(born 1945)

PEPPIMENARTI

70
**Regina Wilson**

*String Design*, 2002
Acrylic on canvas
48 x 50 in. (122 x 127 cm)
Collection of Margaret Levi and Robert Kaplan

71
**Regina Wilson**

*Message Sticks*, 2004
Acrylic on canvas
78 3/5 x 78 3/5 in. (200 x 200 cm)
Collection of Margaret Levi and Robert Kaplan

"Long time ago before the white man came for ceremony our ancestors used to use a message stick to let other tribe know when the other tribe had ceremony. By doing that they marked the stick to let them know when the next ceremony is being held and where. They knew which tribe sent the stick to follow on for the next ceremony if they went wrong they had to start again. They'd send the stick through wet dry. From one person who sent the stick they'd passed it on to another tribe from there it went on. Back in the old days we had no pen, paper we only had message stick. All the writing were marked on the stick by stone axe. Today in our days we use hot wire or file. They used pine tree to make the message stick."

–**Regina Wilson**

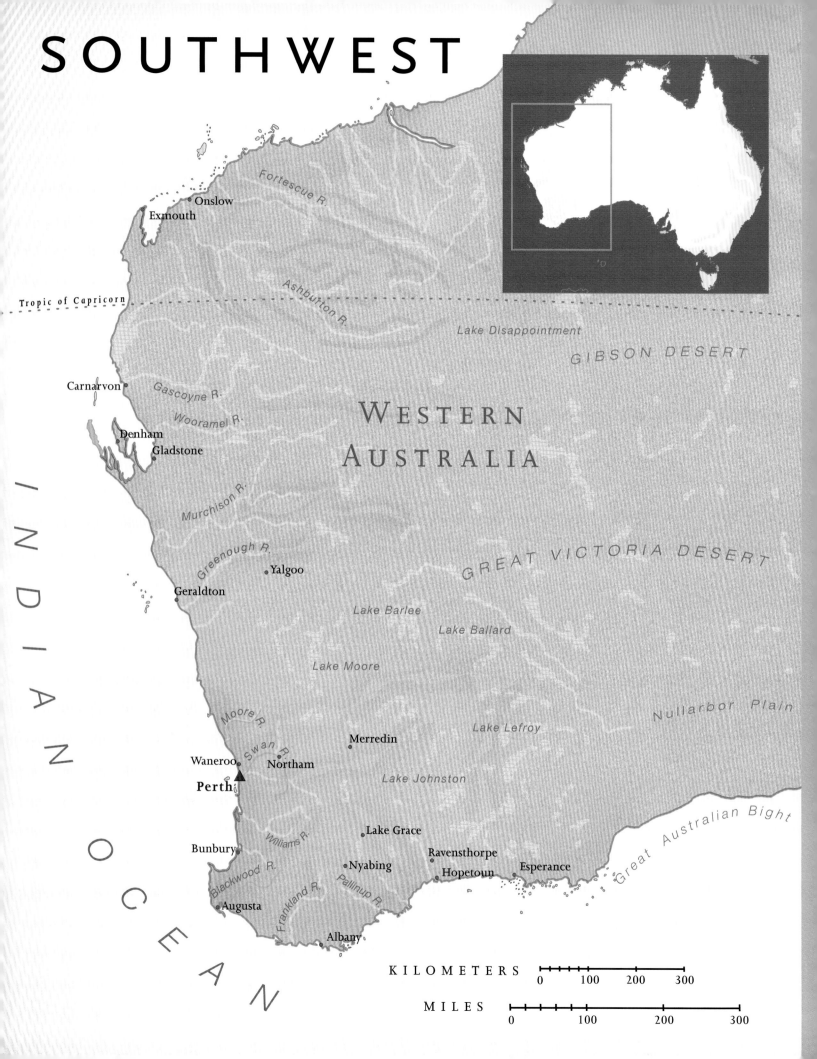

# SOUTHWEST

Tropic of Capricorn

INDIAN OCEAN

WESTERN
AUSTRALIA

GIBSON DESERT

GREAT VICTORIA DESERT

Nullarbor Plain

Great Australian Bight

Lake Disappointment

Fortescue R.

Ashburton R.

Gascoyne R.

Wooramel R.

Murchison R.

Greenough R.

Moore R.

Swan R.

Williams R.

Blackwood R.

Frankland R.

Pallinup R.

Lake Barlee

Lake Ballard

Lake Moore

Lake Lefroy

Lake Johnston

Onslow
Exmouth

Carnarvon

Denham
Gladstone

Yalgoo

Geraldton

Waneroo
**Perth**
Northam

Merredin

Lake Grace

Bunbury

Nyabing

Ravensthorpe
Hopetoun
Esperance

Augusta

Albany

KILOMETERS
0    100    200    300

MILES
0    100    200    300

# NORTHEAST

PAPUA NEW GUINEA

*Arafura Sea*

*Torres Strait*

Bamaga

Mapoon    Bramwell

*Wenlock R.*

Weipa

▲ Lockhart River

Aurukun

*Archer R.*

Coen

Ebagoola

## Cape York

*Mitchell R.*

*Gulf of Carpentaria*

KILOMETERS

0   100   200   300

MILES

0   100   200   300

*Coral Sea*

Cairns

*GREAT BARRIER REEF*

Normanton

Burketown

Croydon

*Flinders R.*

Gilbert River

Townsville

*Burdekin R.*

Dobbyn

Quamby

Richmond

Cloncurry

Malbon

Kynuna

Mackay

## QUEENSLAND

*GREAT DIVIDING RANGE*

*Fitzroy R.*

Tropic of Capricorn

Rockhampton

Gladstone

*Fraser I.*

Bundaberg

Maryborough

Brisbane ▲

Gold Coast

# NORTHEAST & SOUTHWEST

The northeast region of Australia is largely covered with tropical rain forest, which disrupts access to many communities during the wet season. **Lockhart River**, an extremely remote community on the east coast of Cape York, is home to the Lockhart River Art Gang, a group of young artists, male and female, of which Rosella Namok is the most acclaimed. Instead of using brushes or sticks, Namok paints with her fingers—usually on canvas, sometimes paper—a practice that is inspired by traditional sand drawing. She has developed a range of symbolic shapes (including rectangles and ovals) that she utilizes not only to evoke traditional Aboriginal culture, but also to address contemporary life in her community. Although Namok has been influenced by the modern and contemporary art she has viewed at art galleries, she claims that "it's listening to the old (Lockhart River) girls yarn that gives me the inspiration."[1] In *Para Way: other way* (2001; cat. 73), Namok evokes racial difference—*para* meaning white people.

In the more urban and now heavily populated coastal areas of Queensland and New South Wales, the continuity of Aboriginal ceremonial life was severely threatened by early, disruptive white settlement. Largely unnoticed by wider society, Aboriginal art and culture endured and adapted, and with great resilience, has now become a source of pride for many. Some Aboriginal artists currently living in these areas are still searching for connections to the land and their family. Their art explores what it means to be Aboriginal today and at times takes a social activist stance.

Raised in **Brisbane** in southeast Queensland, art-school trained painter/printmaker Judy Watson was one of the three Aboriginal women artists included in the 1997 Venice Biennale. Her work traces her ancestral roots back to her great-grandmother, and it also deals with women's and political issues, including the environment. Essentially, Watson creates visual parables of her Aboriginal heritage, showing especially how history is embedded in the land, wounding and scarring it.

Born in a suburb of **Perth** in the southwest region of Australia, art-school trained artist Julie Dowling is taking Aboriginal art in a completely new direction—portraiture in the Western sense. Drawing on her family and community history, she creates portraits from life or imagines the likenesses of her subjects. Of special renown are her self-portraits, in which she reclaims her maternal ancestors.

[1] Quoted in Georgina Safe, "Selling Out Paintings...But Not Her Heritage," *The Australian*, 11 February 2003, p. 3, Local.

# Rosella Namok

(born 1979)

## LOCKHART RIVER

72
**Rosella Namok**
*That Day: painful day*, 2001
Synthetic polymer paint on canvas
27 1/8 x 22 7/8 in. (69 x 58 cm)
National Gallery of Victoria, Melbourne

"I paint about country and people around me. . .
about traditional culture. . . about things that
happen, things we do. . . the weather. . .
our isolated community. My recent paintings
have been about how people live in our
community and about country."

**–Rosella Namok**

73
**Rosella Namok**

*Para Way: other way*, 2001
Acrylic on canvas
68 1/2 x 48 4/5 in. (174 x 124 cm)
Ann Lewis, AM, Sydney

# Judy Watson

(born 1959)

BRISBANE

74
**Judy Watson**

*suture*, 1995
Ink, pastel, and acrylic on canvas
47 x 73 1/2 in. (119.4 x 186.7 cm)
Saint Louis Art Museum

"I get inspirations from my grandmother; I'm very close to her and very connected with her story through the matrilineal side of my family that's the Aboriginal side. And also country, just country everywhere, but particularly up in North West Queensland which is our area. I get really inspired and enriched by looking at collections in museums and art galleries around the place and by looking at other Aboriginal artists work too; they're doing so much deadly stuff out there."

**–Judy Watson**

75
**Judy Watson**

*waterline*, 2001
Pigment on linen
88 1/5 x 46 1/2 in. (224 x 118 cm)
Ann Lewis, AM, Sydney

NORTHEAST AND SOUTHWEST REGIONS

76
**Judy Watson**

*Two Halves with Conch Shell*, 2002
Acrylic, pigment, pastel, and watercolor
on canvas
76 2/5 x 40 1/5 in. (194 x 103 cm)
Private North Carolina Collection

# Julie Dowling

(born 1969)

PERTH

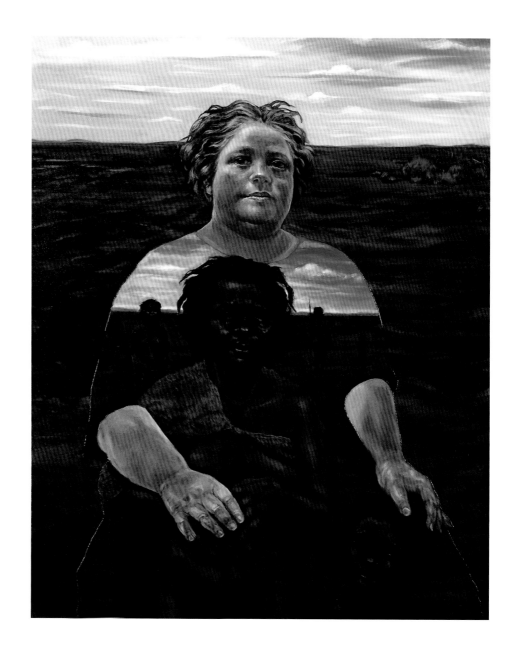

77
**Julie Dowling**

*Self-portrait: in our country*, 2002
Synthetic polymer paint, oil,
and red ochre on canvas
47 1/4 x 39 2/5 in. (120 x 100 cm)
National Gallery of Australia, Canberra

"I painted this self-portrait to express my feelings about returning to my grandmother's country, which is located near a small town called Yalgoo. My great uncle George Latham told me the story of when white people asked my ancestors to describe gold and where to find it. They said that gold looked like Yalgoo, which is the Badimaya/Budimia word for the fat deposits around the belly of a large goanna [lizard] found in that area.

Yalgoo became one of the many mining towns in the area during the 1870s gold rush. My ancestors were moved off this land into stations or missions. The faces depicted in my body are of my ancestor women. I wanted to express to the viewer the feeling of connection with their spirits. Yalgoo is marked by many fences and is now almost a ghost town with only a few houses left.

My family holds this area as being very significant. Our family is the only claimant for this country and is currently involved in the Native Title process. The group inside my body consists of a family group on a hunting party with the two small children carried on hips or walking alongside their mothers and grandmother. I am situated as a member of this group with time not separating our mutual connection to this country."

—**Julie Dowling**

78
**Julie Dowling**

*Playing dead*, 2003
Synthetic polymer paint and red ochre on canvas
35 4/5 x 48 in. (91 x 122 cm)
National Gallery of Australia, Canberra

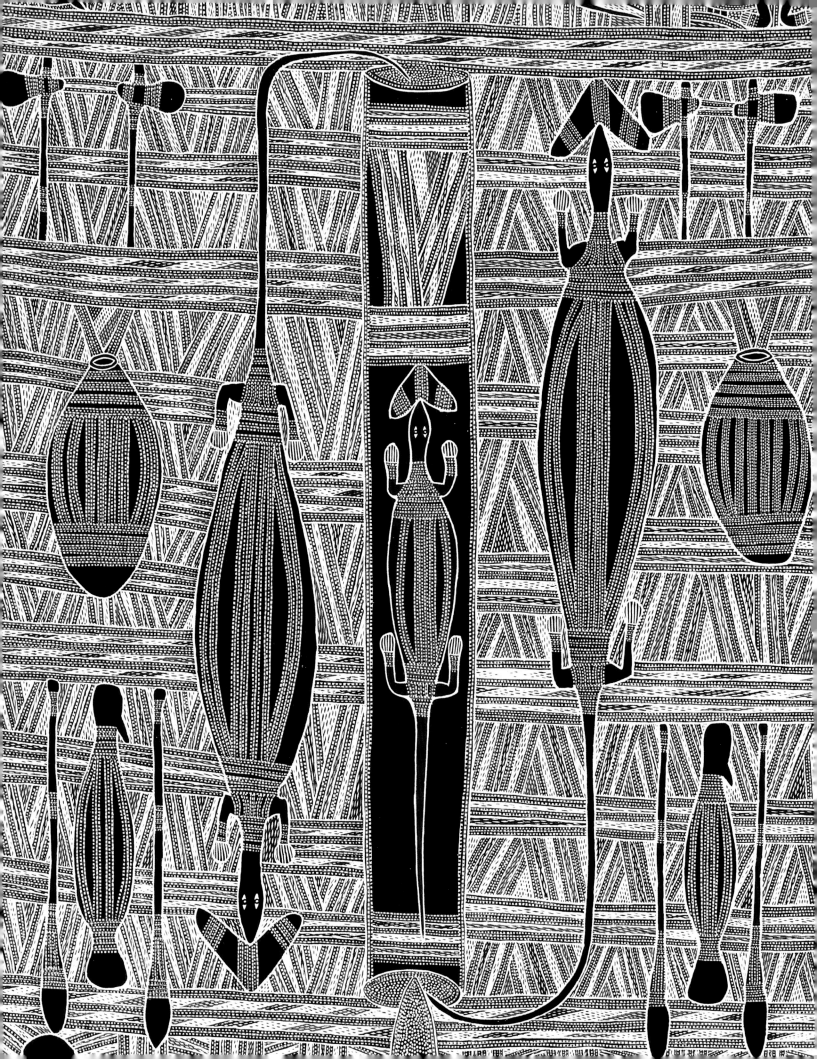

# Artist Profiles

*Note to the Reader: For each artist, only selected exhibitions and collections are listed.*

### Jean Baptist Apuatimi

born 1940

Community: Nguiu, Bathurst Island, Northern Territory

Language: Tiwi

Exhibitions:

    2001 *Across the Clarence Strait: Art of the Tiwi*, Ancient Earth Indigenous Art Gallery, Cairns

    2001 *Islands in the Sun*, National Gallery of Australia, Canberra

    2000 *Jean Baptist Apuatimi*, Solo Exhibition, Aboriginal and Pacific Art Gallery, Sydney

    1999 *Jean Baptist Apuatimi*, Solo Exhibition, Sutton Gallery, Melbourne

    1994 *Power of the Land: Masterpieces of Aboriginal Art*, National Gallery of Victoria, Melbourne

Collections:

    National Gallery of Australia, Canberra

    National Gallery of Victoria, Melbourne

    Art Gallery of South Australia, Adelaide

    Museum and Art Gallery of the Northern Territory, Darwin

    Museum of Victoria, Melbourne

    Collection of Margaret Levi and Richard Kaplan

Representation:

    Tiwi Designs (www.tiwiart.com/tiwi/tiwi.htm)

### Dorothy Djukulul

born 1942

Community: Ramingining, Northern Territory

Language: Ganalbingu

Exhibitions:

    1995 *The Best Face Value for Autumn*, Wollongong City Art Gallery

    1994 *Power of the Land: Masterpieces of Aboriginal Art*, National Gallery of Victoria, Melbourne

    1994 *Yiribana*, Art Gallery of New South Wales, Sydney

    1991 *Aboriginal Women's Exhibition*, Art Gallery of New South Wales, Sydney

Collections:

    National Gallery of Australia, Canberra

    National Gallery of Victoria, Melbourne

    Art Gallery of New South Wales, Sydney

    Museum of Contemporary Art, Sydney

    Art Gallery of South Australia, Adelaide

    Museum and Art Gallery of the Northern Territory, Darwin

    Flinders University Art Museum, Adelaide

    Kluge-Ruhe Aboriginal Art Collection, University of Virginia, Charlottesville

Representation:

    Bula'bula Arts Aboriginal Corporation (www.bulabula-arts.com)

## Julie Dowling

born 1969

Community: Perth, Western Australia

Language: Badimaya-Yamatji-Noongar

Awards:

2002  Finalist, Archibald Portrait Prize, Art Gallery of New South Wales, Sydney

2001  Winner, People's Choice Award, 18th Telstra National Aboriginal and Torres Strait Islander Art Award

2001  Finalist, Archibald Portrait Prize, Art Gallery of New South Wales, Sydney

2000  Winner, General Painting Award, 17th Telstra National Aboriginal and Torres Strait Islander Art Award

2000  Finalist, Doug Moran National Portrait Prize, Sydney

Exhibitions:

2004  *Warridah Sovereignty*, Solo Exhibition, Artplace, Perth

2002  *Big Womanhead*, Solo Exhibition, Artplace, Perth

1999  *People, Places, Pastimes: Challenging Perspectives of Ipswich*, Global Arts Link, Ipswich, Australia

1998  *Ceremony, Identity, and Community*, Flinders University Art Museum, Adelaide

1995  *Secrets about Being Strong*, Solo Exhibition, Fremantle Arts Centre

Collections:

National Gallery of Australia, Canberra

National Gallery of Victoria, Melbourne

Art Gallery of Western Australia, Perth

Art Gallery of South Australia, Adelaide

Museum and Art Gallery of the Northern Territory, Darwin

University of Southern Queensland, Toowoomba

The Kelton Foundation

Representation:

ArtPlace (www.artplace.com.au)

## Lorna Napurrula Fencer

born c. 1925

Community: Lajamanu, Northern Territory

Language: Warlpiri

Awards:

1997  Conrad Jupiters Casino, Gold Coast City Art Award, Australia

Exhibitions:

2002  *Lorna Fencer: Inner Spring—New Works from the Tanami*, Solo Exhibition, Mary Place Gallery, Paddington, Australia

2002  *Lorna Napurrula Fencer: The Big Picture*, Solo Exhibition, Vivien Anderson Gallery, Melbourne

2002  *Lorna Napurrula Fencer*, Solo Exhibition, Japingka Gallery, Fremantle, Australia

2001  *Little Gems*, Japingka Gallery, Fremantle, Australia

2000  *Opening of Yuwayi Art Centre*, Yuwayi Gallery, Sydney

1999  *Spirit Country: Contemporary Australian Aboriginal Art*, Fine Arts Museums of San Francisco; Melbourne Museum

Collections:

National Gallery of Victoria, Melbourne

Museum and Art Gallery of the Northern Territory, Darwin

Holmes à Court Collection, Perth

Laverty Collection, Sydney

Kerry Stokes Collection, Perth

Collection of Margaret Levi and Robert Kaplan

Representation:

Mimi Arts and Crafts (www.mimiarts.com)

## Gertie Huddleston

born c. 1933

Community: Ngukurr, Northern Territory

Language: Mara

Awards:

1999  Winner, General Painting Award, 16th Telstra National Aboriginal and Torres Strait Islander Art Award

Exhibitions:

2002  *Sisters: Gertie Huddleston and Angelina George*, Art Mob Gallery, Hobart, Tasmania

2002  *New Acquisitions*, Macquarie University Art Gallery, Sydney

2000  *Adelaide Biennial of Contemporary Australian Art*, Art Gallery of South Australia, Adelaide

1999  *Spirit Country: Contemporary Australian Aboriginal Art*, Fine Arts Museums of San Francisco; Melbourne Museum

1996  Rebecca Hossack Gallery, London

Collections:

National Gallery of Victoria, Melbourne

Art Mob Gallery, Hobart, Tasmania

Macquarie University Art Gallery, Sydney

Collection of Margaret Levi and Robert Kaplan

Representation:

Ngukurr Arts (www.ngukurrarts.com)

## Kitty Kantilla

c. 1928–2003

Community: Milikapiti, Melville Island, Northern Territory

Language: Tiwi

Awards:

2002  Winner, Work on Paper Award, 19th Telstra National Aboriginal and Torres Strait Islander Art Award

Exhibitions:

2000  *Kitty Kantilla: New Works on Paper and Canvas*, Solo Exhibition, Aboriginal and Pacific Arts, Sydney

1999  *Great Icons of Aboriginal Art*, National Gallery of Victoria, Melbourne

1997  *Dreamings*, Spazio Pitti Arte, Florence

1995  *Kitty Kantilla*, Solo Exhibition, Aboriginal and South Pacific Gallery, Sydney

1993  *Kitty Kantilla*, Solo Exhibition, Aboriginal and South Pacific Gallery, Sydney

Collections:

National Gallery of Australia, Canberra

National Gallery of Victoria, Melbourne

Art Gallery of New South Wales, Sydney

Art Gallery of South Australia, Adelaide

Museum of Victoria, Melbourne

National Maritime Museum, Darling Harbour, Sydney

Musée des Arts, Afrique d'Oceanie, Paris

Laverty Collection, Sydney

Private North Carolina Collection

## Lily Karedada

born c. 1935

Community: Kalumburu, Western Australia

Language: Tjarintjin-Wunumbal

Exhibitions:

2000 *Lily Karedada*, Solo Exhibition, Niagara Galleries, Melbourne

1999 *Opening Exhibition*, Ochre Gallery, Melbourne

1994 *Power of the Land: Masterpieces of Aboriginal Art*, National Gallery of Victoria, Melbourne

1991 *Aboriginal Women's Exhibition*, Art Gallery of New South Wales, Sydney

Collections:

National Gallery of Australia, Canberra

National Gallery of Victoria, Melbourne

Art Gallery of South Australia, Adelaide

Queensland Art Gallery, Brisbane

The Kelton Foundation

Representation:

Waringarri Aboriginal Arts (www.waringarriarts.com.au)

## Abie Loy Kemarre

born 1972

Community: Utopia, Northern Territory

Language: Eastern Anmatyerre

Awards:

2003 Special Runner-Up, Adelaide Critics Circle Awards

2001 Finalist, 18th Telstra National Aboriginal and Torres Strait Islander Art Award

1997 Finalist, 14th Telstra National Aboriginal and Torres Strait Islander Art Award

Exhibitions:

2004 *Abie Loy Kemarre*, Solo Exhibition, Gadfly Gallery, Perth

2003 *Abie Loy Kemarre*, Solo Exhibition, Alcaston Gallery, Melbourne

2002 *Abie Loy and Violet Petyarre: Recent Paintings*, Mary Place Gallery, Paddington, Australia

Collections:

National Gallery of Victoria, Melbourne

Art Gallery of South Australia, Adelaide

Kerry Stokes Collection, Perth

Collection of Margaret Levi and Robert Kaplan

The Kelton Foundation

Representation:

Gallerie Australis (www.gallerieaustralis.com)

# Emily Kame Kngwarreye

1916–1996

Community: Utopia, Northern Territory

Language: Anmatyerre

Awards:

    1992  Australian Artists Creative Fellowship

Exhibitions:

    1999  *Spirit Country: Contemporary Australian Aboriginal Art*, Fine Arts Museums of San Francisco; Melbourne Museum

    1998  *Emily Kame Kngwarreye—Alhalkere—Paintings from Utopia*, Solo Exhibition, Queensland Art Gallery, Brisbane; Art Gallery of New South Wales, Sydney; National Gallery of Victoria, Melbourne

    1997  *Emily Kame Kngwarreye*, Solo Exhibition, Robert Steele Gallery, New York

    1997  *Fluent: Emily Kame Kngwarreye, Yvonne Koolmatrie, Judy Watson*, 47th Biennale di Venezia, Venice

    1996  *Emily Kame Kngwarreye*, Solo Exhibition, Niagara Galleries, Melbourne

    1996  *Eye of the Storm: Eight Contemporary Indigenous Australian Artists*, National Gallery of Australia, Canberra

    1994  *Emily Kame Kngwarreye: Utopia*, Solo Exhibition, Rebecca Hossack Gallery, London

    1993  *Recent Paintings by Emily Kame Kngwarreye*, Solo Exhibition, Gallery Gabrielle Pizzi, Melbourne

    1992  *Alkalhere*, Solo Exhibition, Utopia Art, Sydney

    1991  *Emily Kame Kngwarreye*, Solo Exhibition, Hogarth Galleries, Sydney

    1991  *Aboriginal Women's Exhibition*, Art Gallery of New South Wales, Sydney

    1990  *Emily Kame Kngwarreye*, Solo Exhibition, Utopia Art, Sydney

Collections:

    National Gallery of Australia, Canberra

    National Gallery of Victoria, Melbourne

    Art Gallery of New South Wales, Sydney

    Art Gallery of South Australia, Adelaide

    Art Gallery of Western Australia, Perth

    Queensland Art Gallery, Brisbane

    Museum and Art Gallery of the Northern Territory, Darwin

    Seattle Art Museum, Seattle

    Vatican Collection, Rome

    Kluge-Ruhe Aboriginal Art Collection, University of Virginia, Charlottesville

    Laverty Collection, Sydney

    Ann Lewis, AM, Sydney

    The Wolfensohn Family Foundation

## Kay Lindjuwanga

born 1957

Community: Maningrida, Northern Territory

Language: Kunwinjku

Awards:

2004 Winner, Bark Painting Award, 21st Telstra National Aboriginal and Torres Strait Islander Art Award

Exhibitions:

2006 *Oceanic Art*, Galerie Dad, Mantes-la-Jolie, France

2005 *New Prints from the Maningrida Region*, Maningrida Arts and Culture Darwin

2004 *Crossing Country*, Art Gallery of New South Wales, Sydney

Collections:

Art Gallery of New South Wales, Sydney

Kluge-Ruhe Aboriginal Art Collection, University of Virginia, Charlottesville

Private North Carolina Collection

Representation:

Maningrida Arts and Culture (www.maningrida.com)

## Daisy Manybunharrawuy

born c. 1950

Community: Ramingining, Northern Territory

Language: Liyagalawumirr

Exhibitions:

1994 *Power of the Land: Masterpieces of Aboriginal Art*, National Gallery of Victoria, Melbourne

1993 *Aratjara: Art of the First Australians*, Kunstammlung Nordrhein-Westfalen, Düsseldorf; Hayward Gallery, London; Louisiana Museum, Humlebaek, Denmark

1991 *Aboriginal Women's Exhibition*, Art Gallery of New South Wales, Sydney

1990 *Spirit in Land: Bark Paintings from Arnhem Land*, National Gallery of Victoria, Melbourne

Collections:

National Gallery of Australia, Canberra

National Gallery of Victoria, Melbourne

Kluge-Ruhe Aboriginal Art Collection, University of Virginia, Charlottesville

Representation:

Milingimbi Art Centre (www.milingimbiarts.com)

## Galuma Maymuru

born 1951

Community: Yirrkala, Northern Territory

Language: Manggalili

Awards:

2003  Winner, Best Bark Award, 20th Telstra National Aboriginal and Torres Strait Islander Art Award

Exhibitions:

2005  *Yäkumipri: People Who Have a Name—Yirrkala Barks*, Holmes à Court Gallery, Perth

2005  *The Year in Art*, National Trust of Australia, Sydney

2004  *Blak Insights*, Queensland Art Gallery, Brisbane

2003  *Invisibility*, Annandale Galleries, Sydney

1999  *Spirit Country: Contemporary Australian Aboriginal Art*, Fine Arts Museums of San Francisco; Melbourne Museum

Collections:

Art Gallery of New South Wales, Sydney

Queensland Art Gallery, Brisbane

Holmes à Court Collection, Perth

Kluge-Ruhe Aboriginal Art Collection, University of Virginia, Charlottesville

Private North Carolina Collection

Representation:

Buku Larrnggay Mulka Art Centre (www.yirrkala.com)

## Queenie McKenzie

c. 1930–1998

Community: Warmun (Turkey Creek), Western Australia

Language: Gija

Exhibitions:

1997  *Queenie McKenzie Nakarra*, Solo Exhibition, William Mora Galleries, Melbourne

1996  *Figures in the Land*, National Gallery of Victoria, Melbourne

1994  *Bush Women*, Fremantle Arts Centre

1993  *Images of Power: Aboriginal Art of the Kimberley*, National Gallery of Victoria, Melbourne

1991  *Aboriginal Women's Exhibition*, Art Gallery of New South Wales, Sydney

Collections:

National Gallery of Australia, Canberra

National Gallery of Victoria, Melbourne

Art Gallery of South Australia, Adelaide

Art Gallery of Western Australia, Perth

Berndt Museum of Anthropology, University of Western Australia, Perth

Flinders University Art Museum, Adelaide

Collection of Margaret Levi and Robert Kaplan

## Rosella Namok

born 1979
Community: Lockhart River, Queensland
Language: Aangkum
Awards:

2003  Winner, High Court of Australia Centenary Art Prize

1999  Lin Onus Youth Award, National Indigenous Heritage Art Awards

1997  Rena Ellen Jones Award, Warrnambool Art Gallery, Victoria

Exhibitions:

2004  *Intelligence Now!*, October Gallery, London

2004  *Land/Space + Family/Place*, Art Gallery of Western Australia, Perth

2003  *Rosella Namok*, Solo Exhibition, Niagara Galleries, Melbourne

2001  *mepla sarbie paint*, Solo Exhibition, Andrew Baker Art Dealer, Brisbane

2000  *Uncommon World: Aspects of Contemporary Australian Art*, National Gallery of Australia, Canberra

Collections:

National Gallery of Australia, Canberra

National Gallery of Victoria, Melbourne

Art Gallery of New South Wales, Sydney

Queensland Art Gallery, Brisbane

Kluge-Ruhe Aboriginal Art Collection, University of Virginia, Charlottesville

Ann Lewis, AM, Sydney

Representation:

Lockhart River Art Centre (www.artgang.com.au)

## Eubena Nampitjin

born c. 1925
Community: Balgo Hills (Wirrimanu), Western Australia
Language: Kukatja
Awards:

1998  Winner, Open Painting Award, 15th Telstra National Aboriginal and Torres Strait Islander Art Award

Exhibitions:

2002  *Eubena Nampitjin*, Solo Exhibition, Alcaston Gallery, Melbourne

2002  *Balgo Hills*, Gallery Gabrielle Pizzi, Melbourne

1999  *Spirit Country: Contemporary Australian Aboriginal Art*, Fine Arts Museums of San Francisco; Melbourne Museum

1998  *Kinyarri: My Country*, Solo Exhibition, Alcaston Gallery, Melbourne

1991  *Aboriginal Women's Exhibition*, Art Gallery of New South Wales, Sydney

Collections:

National Gallery of Australia, Canberra

National Gallery of Victoria, Melbourne

Art Gallery of New South Wales, Sydney

Art Gallery of Western Australia, Perth

Museum and Art Gallery of the Northern Territory, Darwin

Collection of Margaret Levi and Robert Kaplan

Laverty Collection, Sydney

Private North Carolina Collection

Representation:

Warlayirti Artists (www.balgoart.org.au)

## Alice Nampitjinpa

born c. 1943

Community: Ikuntji (Haasts Bluff), Northern Territory

Language: Pintupi

Exhibitions:

      2004  Red Dot Gallery, Singapore

      2001  *Mythology and Reality*, Palazzo Bricherasio, Turin; AAM Utrecht; Monash University, Victoria

      2001  *Our Country: Pintupi Women from Haasts Bluff*, Raft Artspace, Darwin

      2000  *Alice Nampitjinpa*, Solo Exhibition, Gallery Gabrielle Pizzi, Melbourne

Collections:

      National Gallery of Victoria, Melbourne

      Araluen Centre Galleries, Alice Springs

      Supreme Court of the Northern Territory, Darwin

      Griffith University, Brisbane

      M. H. de Young Memorial Museum, Fine Arts Museums of San Francisco

      Private North Carolina Collection

Representation:

      Ikuntji Art Centre (www.ikuntji.com.au)

## Inyuwa Nampitjinpa

c. 1935–1999

Community: Walungurru (Kintore), Northern Territory

Language: Pintupi

Exhibitions:

      2002  *Images and Identity*, Iserlohn Academy, Germany

      2001  *Desert Art*, Palazzo Bricherasio, Turin

      2000  *Papunya Tula: Genesis and Genius*, Art Gallery of New South Wales, Sydney

      1999  *Recent Paintings by Inyuwa Nampitjinpa*, Solo Exhibition, Gallery Gabrielle Pizzi, Melbourne

Collections:

      National Gallery of Victoria, Melbourne

      Art Gallery of New South Wales, Sydney

      Queensland Art Gallery, Brisbane

      Laverty Collection, Sydney

      Collection of Richard Klingler

## Tatali Nangala

c. 1925–2000

Community: Walungurru (Kintore), Northern Territory

Language: Pintupi

Exhibitions:

      2003  *Big Country: Works from the Flinders University Art Museum Collection*, Flinders University Art Museum, Adelaide

      2001  *Mythology and Reality*, Palazzo Bricherasio, Turin; AAM Utrecht; Monash University, Victoria

      2000  *Papunya Tula: Genesis and Genius*, Art Gallery of New South Wales, Sydney

      1999  *Spirit Country: Contemporary Australian Aboriginal Art*, Fine Arts Museums of San Francisco; Melbourne Museum

Collections:

      National Gallery of Victoria, Melbourne

      Art Gallery of New South Wales, Sydney

      Flinders University Art Museum, Adelaide

      The Kelton Foundation

## Lucy Yukenbarri Napanangka

1934–2003

Community: Balgo Hills (Wirrimanu), Western Australia

Language: Kukatja

Awards:

>2000 Highly Commended, Alice Prize, Alice Springs

>1999 Waringarri Arts Award, East Kimberley Art Awards, Kununurra Arts Council

Exhibitions:

>2002 *Art from Balgo*, Gallery Gondwana, Alice Springs

>2000 *Dreaming in Color: Australian Aboriginal Art from Balgo*, Kluge-Ruhe Aboriginal Art Collection, University of Virginia, Charlottesville

>1999 *Tjurrnu: Living Water*, Solo Exhibition, Alcaston Gallery, Melbourne

>1997 *Daughters of the Dreaming: Sisters Together Strong*, Art Gallery of Western Australia, Perth

Collections:

>National Gallery of Australia, Canberra

>National Gallery of Victoria, Melbourne

>Art Gallery of New South Wales, Sydney

>Araluen Centre Galleries, Alice Springs

>Kluge-Ruhe Aboriginal Art Collection, University of Virginia, Charlottesville

>Private North Carolina Collection

## Makinti Napanangka

born 1930

Community: Walungurru (Kintore), Northern Territory

Language: Pintupi

Awards:

>2003 Finalist, Clemenger Art Award, National Gallery of Victoria, Melbourne

Exhibitions:

>2005 *Luminous: Contemporary Art from the Australian Desert*, Manly Art Gallery and Museum, Sydney

>2004 *Colour Power: Aboriginal Art Post 1984*, National Gallery of Victoria, Melbourne

>2001 *Makinti Napanangka: New Paintings*, Solo Exhibition, Utopia Art, Sydney

>2000 *New Vision*, Solo Exhibition, Utopia Art, Sydney

>1999 *Spirit Country: Contemporary Australian Aboriginal Art*, Fine Arts Museums of San Francisco; Melbourne Museum

Collections:

>National Gallery of Victoria, Melbourne

>Art Gallery of New South Wales, Sydney

>Museum and Art Gallery of the Northern Territory, Darwin

>Queensland Art Gallery, Brisbane

>Collection of Margaret Levi and Robert Kaplan

>Collection of Richard Klingler

Representation:

>Papunya Tula Artists Pty. Ltd. (www.papunyatula.com)

## Pansy Napangati

born c. 1948

Community: Papunya, Northern Territory

Language: Luritja-Warlpiri

Awards:

      1993  Winner, Northern Territory Art Award

      1989  Winner, 6th National Aboriginal Art Award

Exhibitions:

      2001  *Mythology and Reality*, Palazzo Bricherasio, Turin; AAM Utrecht; Monash University, Victoria

      2000  *Papunya Tula: Genesis and Genius*, Art Gallery of New South Wales, Sydney

      1991  *Pansy Napangati*, Solo Exhibition, Gallery Gabrielle Pizzi, Melbourne

      1991  *Aboriginal Women's Exhibition*, Art Gallery of New South Wales, Sydney

      1988  *Pansy Napangati*, Solo Exhibition, Sydney Opera House

Collections:

      National Gallery of Australia, Canberra

      National Gallery of Victoria, Melbourne

      Museum and Art Gallery of the Northern Territory, Darwin

      Queensland Art Gallery, Brisbane

      Australian National University, Canberra

      The Kelton Foundation

      Private North Carolina Collection

Representation:

      Papunya Tula Artists Pty. Ltd. (www.papunyatula.com)

## Mitjili Napurrula

born c. 1945

Community: Ikuntji (Haasts Bluff), Northern Territory

Language: Pintupi

Awards:

      1999  Alice Prize, Alice Springs

      1997  Finalist, 14th Telstra National Aboriginal and Torres Strait Islander Art Award

Exhibitions:

      2000  *Mitjili Napurrula*, Solo Exhibition, Niagara Galleries, Melbourne

      2000  *Adelaide Biennial of Australian Art: Beyond the Pale*, Art Gallery of South Australia, Adelaide

      1999  *Spirit Country: Contemporary Australian Aboriginal Art*, Fine Arts Museums of San Francisco; Melbourne Museum

      1998  *Mitjili Napurrula*, Solo Exhibition, Niagara Galleries, Melbourne

Collections:

      National Gallery of Australia, Canberra

      National Gallery of Victoria, Melbourne

      Art Gallery of New South Wales, Sydney

      Museum and Art Gallery of the Northern Territory, Darwin

      Flinders University Art Museum, Adelaide

      Private North Carolina Collection

Representation:

      Ikuntji Art Centre (www.ikuntji.com.au)

## Ningura Napurrula

born c. 1938

Community: Walungurru (Kintore), Northern Territory

Language: Pintupi

Awards:

2002  Highly Recommended, Alice Prize, Alice Springs

2001  Finalist, 18th Telstra National Aboriginal and Torres Strait Islander Art Award

Exhibitions:

2005  *Papunya Tula Artists*, Gallery Gabrielle Pizzi, Melbourne

2003  *Masterpieces from the Western Desert*, Gavin Graham Gallery, London

2002  *Next Generation: Aboriginal Art 2002*, Art House Gallery, Sydney

2000  *Ningura Napurrula*, Solo Exhibition, William Mora Galleries, Melbourne

Collections:

National Gallery of Australia, Canberra

Art Gallery of New South Wales, Sydney

Museum and Art Gallery of the Northern Territory, Darwin

Laverty Collection, Sydney

Collection of Richard Klingler

Representation:

Papunya Tula Artists Pty. Ltd. (www.papunyatula.com)

## Gabriella Possum Nungurrayi

born 1967

Community: Alice Springs, Northern Territory

Language: Anmatyerre

Awards:

1983  Alice Prize, Alice Springs

Exhibitions:

2001  Mia Mia Gallery, Melbourne

2000  United Nations, New York

1999  Flinders University Art Museum, Adelaide

1999  Aboriginal Art Galleries of Australia, Melbourne

1998  *Sztuka Aborygenow (Art of the Aborigines)*, Warsaw, Poland

Collections:

National Gallery of Australia, Canberra

Museum and Art Gallery of the Northern Territory, Darwin

Flinders University Art Museum, Adelaide

Araluen Centre Galleries, Alice Springs

The Kelton Foundation

Private North Carolina Collection

Representation:

Boomerang Art-Aboriginal Art Gallery (www.boomerangart.com.au)

## Lena Nyadbi

born c. 1937

Community: Warmun (Turkey Creek), Western Australia

Language: Gija

Exhibitions:

    2005 *Lena Nyadbi*, Solo Exhibition, Niagara Galleries, Melbourne

    2000 *Adelaide Biennial of Australian Art: Beyond the Pale*, Art Gallery of South Australia, Adelaide

    1999 Short Street Gallery, Broome

    1999 Gallery Gabrielle Pizzi, Melbourne

Collections:

    Art Gallery of Western Australia, Perth

    Museum and Art Gallery of the Northern Territory, Darwin

    Kerry Stokes Collection, Perth

    Collection of Margaret Levi and Robert Kaplan

Representation:

    Warmun Art Centre (www.warmunart.com)

## Gloria Tamerre Petyarre

born c. 1948

Community: Utopia, Northern Territory

Language: Anmatyerre

Awards:

    1999 Wynne Prize, Art Gallery of New South Wales, Sydney

    1994 Tapestry Commission for the Law Courts, Brisbane

    1993 Tapestry Commission for Victorian Tapestry Workshop, Melbourne

    1993 Mural Commission for Kansas City Zoo

Exhibitions:

    2005 *Summer in the Desert*, Hogarth Galleries, Sydney

    2003 *New Works by Gloria Petyarre*, Solo Exhibition, Indigenart, Subiaco, Australia; National Gallery of Victoria, Melbourne

    2002 *Leaves You Thinking: World Vision of Australia*, Walkabout Gallery, Sydney

    1999 *Gloria Petyarre: A Survey*, Solo Exhibition, New England Regional Art Museum, Armidale, Australia

    1999 *Spirit Country: Contemporary Australian Aboriginal Art*, Fine Arts Museums of San Francisco; Melbourne Museum

    1998 *Gloria Tamerre Petyarre*, Solo Exhibition, Campbelltown Bicentennial Art Gallery

Collections:

    National Gallery of Australia, Canberra

    National Gallery of Victoria, Melbourne

    Art Gallery of New South Wales, Sydney

    Queensland Art Gallery, Brisbane

    Parliament House Art Collection, Canberra

    Wadsworth Atheneum, Hartford

    Kluge-Ruhe Aboriginal Art Collection, University of Virginia, Charlottesville

    Collection of Margaret Levi and Robert Kaplan

    The Wolfensohn Family Foundation

Representation:

    Utopia Art Sydney (utopiaartsydney@ozemail.com)

## Kathleen Petyarre

born c. 1930

Community: Utopia, Northern Territory

Language: Eastern Anmatyerre

Awards:

1998 Finalist, Visual Art; Winner, People's Choice Award, Seppelts Contemporary Art Award, Museum of Contemporary Art, Sydney

1997 Overall Winner of the Visy Board Art Prize, Barossa Vintage Festival Art Show, Nurioopta, Australia

1996 First Prize, 13th Telstra National Aboriginal and Torres Strait Islander Art Award

Exhibitions:

2002 *Sisters/Yakkananna*, Kahui Mareikura Exhibition, Tandanya, Adelaide

2001 *Genius of Place: The Work of Kathleen Petyarre*, Solo Exhibition, Museum of Contemporary Art, Sydney

2000 *Adelaide Biennial of Australian Art: Beyond the Pale*, Art Gallery of South Australia, Adelaide

1999 *Raiki Wara: Long Cloth from Aboriginal Australia and the Torres Strait*, Art Gallery of New South Wales, Sydney

1999 *Recent Paintings by Kathleen Petyarre*, Solo Exhibition, Coo-ee Gallery, Sydney

1998 *Arnkerrthe: My Dreaming*, Solo Exhibition, Alcaston Gallery, Melbourne

Collections:

National Gallery of Victoria, Melbourne

Art Gallery of South Australia, Adelaide

University of South Australia Art Museum, Adelaide

Peabody Essex Museum, Harvard University, Salem

Kluge-Ruhe Aboriginal Art Collection, University of Virginia, Charlottesville

Collection of Margaret Levi and Robert Kaplan

Private North Carolina Collection

Representation:

Gallerie Australis (www.gallerieaustralis.com)

## Dorothy Napangardi Robinson

born c. 1956

Community: Yuendumu; residence Alice Springs, Northern Territory

Language: Warlpiri

Awards:

2001 First Prize, 18th Telstra National Aboriginal and Torres Strait Islander Art Award

1999 Highly Commended, 16th Telstra National Aboriginal and Torres Strait Islander Art Award

1998 Northern Territory Art Award, Alice Springs

1991 Best Painting in European Media, 8th National Aboriginal and Torres Strait Islander Art Award

Exhibitions:

2004 *Ngati Jinta (One Mother)*, Gallery Gondwana, Sydney

2003 *Indecorous Abstraction 2*, New Contemporaries Gallery, Sydney

2001 *Dorothy Napangardi: New Paintings*, Solo Exhibition, Vivien Anderson Gallery,  Melbourne

1999 *Recent Works by Dorothy Napangardi*, Solo Exhibition, Chapman Gallery, Canberra

Collections:

National Gallery of Australia, Canberra

National Gallery of Victoria, Melbourne

Art Gallery of South Australia, Adelaide

Queensland Museum, Brisbane

The Australia Council Collection, Sydney

Kerry Stokes Collection, Perth

The Kelton Foundation

Collection of Margaret Levi and Robert Kaplan

The LeWitt Collection, Chester, Connecticut

Representation:

Gallery Gondwana (www.gallerygondwana.com.au)

## Bessie Nakamarra Sims

born c. 1932

Community: Yuendumu, Northern Territory

Language: Warlpiri

Exhibitions:

1994 *Desert Tracks*, Berchem Cultural Center, Amsterdam

1993 *Aratjara: Art of the First Australians*, Kunstammlung Nordrhein-Westfalen, Düsseldorf; Hayward Gallery, London; Louisiana Museum, Humlebaek, Denmark

1993 *Jukurrpa: Desert Dreamings*, Art Gallery of Western Australia, Perth

Collections:

National Gallery of Australia, Canberra

Art Gallery of Western Australia, Perth

South Australian Museum, Adelaide

Collection of Margaret Levi and Robert Kaplan

Private North Carolina Collection

Representation:

Warlukurlangu Artists (www.warlu.com)

## Linda Syddick (Tjungkaya Napaltjarri)

born 1941

Community: Papunya, Northern Territory

Language: Pintupi-Luritja

Awards:

2000 Joint Runner-Up Prize, National Heritage Art Award, Canberra

1997 Two Year Visual Arts Fellowship, Australia Council for the Arts

1996 Northern Territory Award, Alice Springs

Exhibitions:

2000 *Transitions: 17 Years of the Aboriginal and Torres Strait Islander Art Award*, Museum and Art Gallery of the Northern Territory, Darwin; Melbourne Museum; Tandanya National Aboriginal Cultural Institute, Adelaide; Australian National University Drill Hall Gallery, Canberra; Customs House Circular Quay, Sydney

1999 *Appreciation to Appropriation*, Flinders University Art Museum, Adelaide

1999 *Spirit Country: Contemporary Australian Aboriginal Art*, Fine Arts Museums of San Francisco; Melbourne Museum

1998 *Linda Syddick*, Solo Exhibition, Vivien Anderson Gallery, Melbourne

1996 *Exploring Two Worlds*, Solo Exhibition, Hogarth Galleries, Sydney

Collections:

>Collections:

National Gallery of Australia, Canberra

Art Gallery of New South Wales, Sydney

Art Gallery of Victoria, Melbourne

Museum and Art Gallery of the Northern Territory, Darwin

The Kelton Foundation

## Wolpa Wanambi

born 1970

Community: Yirrkala, Northern Territory

Language: Marrakulu

Awards:

2000 National Indigenous Heritage Art Award

Exhibitions:

2005 *Yakumirri: Artists of East Arnhem*, Raft Artspace, Darwin

2002 *Wolpa Wanambi*, Solo Exhibition, Niagara Galleries, Melbourne

2001 *Wall, Floor, Ceiling*, Niagara Galleries, Melbourne

2001 *Yolnu Bark*, Ben Grady Gallery, Canberra

Collections:

National Gallery of Australia, Canberra

Seattle Art Museum

Kluge-Ruhe Aboriginal Art Collection, University of Virginia, Charlottesville

Laverty Collection, Sydney

Representation:

Buku Larrnggay Mulka Centre (www.yirrkala.com)

## Judy Watson

born 1959

Community: Brisbane, Queensland

Language: Waanyi

Awards:

1995 Moët and Chandon Fellowship

Exhibitions:

1997 *Fluent: Emily Kame Kngwarreye, Yvonne Koolmatrie, Judy Watson*, 47th Biennale di Venezia, Venice

1995 *In the Company of Women*, Perth Institute of Contemporary Arts, Perth

1994 *Judy Watson*, Solo Exhibition, Edith Cowan University, Perth

1993 *The Artist's Studio*, Solo Exhibition, Art Gallery of New South Wales, Sydney

1991 *Aboriginal Women's Exhibition*, Art Gallery of New South Wales, Sydney

1988 *Bloodline*, Solo Exhibition, Aboriginal Artists Gallery, Sydney

Collections:

   National Gallery of Australia, Canberra

   National Gallery of Victoria, Melbourne

   Art Gallery of New South Wales, Sydney

   Art Gallery of South Australia, Adelaide

   Art Gallery of Western Australia, Perth

   Queensland Art Gallery, Brisbane

   Saint Louis Art Museum

   Ann Lewis, AM, Sydney

   Private North Carolina Collection

Representation:

   Tolarno Galleries (www.tolarnogalleries.com)

## Regina Wilson

born 1945

Community: Peppimenarti, Northern Territory

Language: Marathiel

Awards:

   2003  Winner, General Painting Award, 20th Telstra National Aboriginal and Torres Strait Islander Art Award

Exhibitions:

   2005  *Peppimenarti Show*, Artabout Gallery, Armadale, Australia

   2004  *Peppimenarti: Transcending Tradition*, Sherman Galleries, Sydney

Collections:

   Art Gallery of New South Wales, Sydney

   Collection of Margaret Levi and Robert Kaplan

Representation:

   Agathon Gallery (www.agathongallery.com)

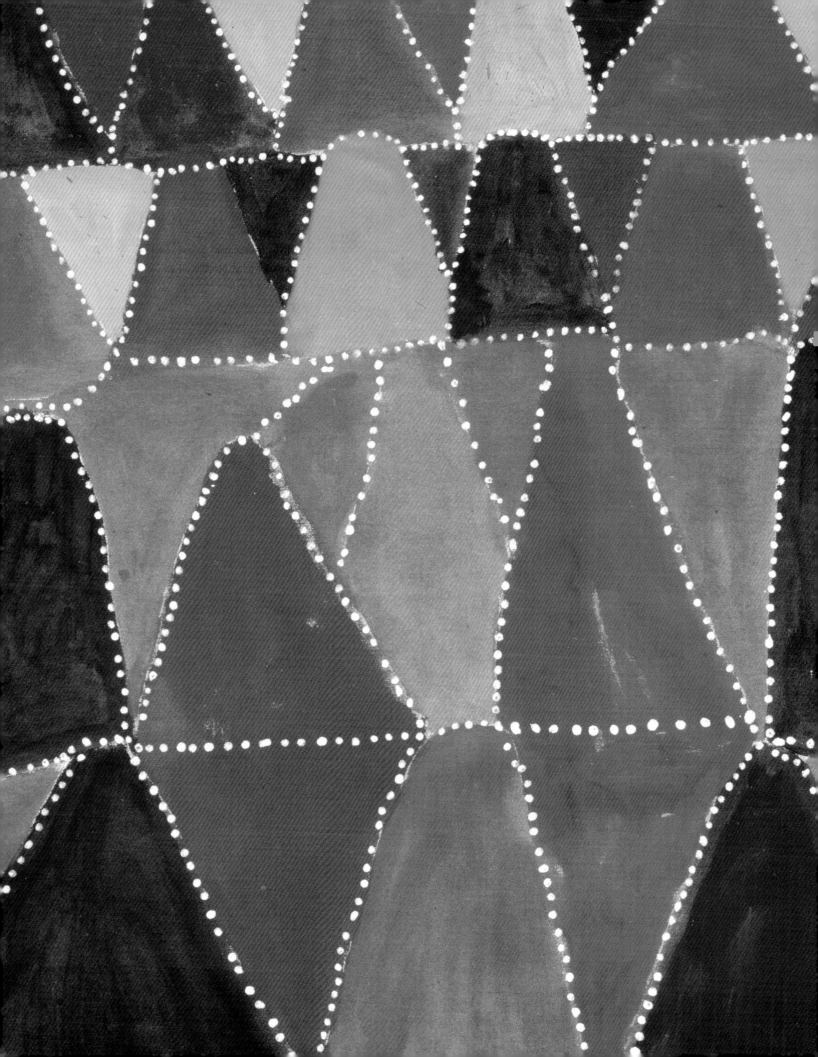

# Checklist

*Note to the Reader: Many of the paintings show an aerial view of the land, thus their orientation can vary.*
*The checklist will change slightly at each venue.*

1
Pansy Napangati
*Kungka Kutjarra at Kampurarrpa*
(Two Women at Kampurarrpa), 1991
Acrylic on canvas
54 x 36 in. (137 x 91.5 cm)
The Kelton Foundation

2
Pansy Napangati
*Women's Ceremony at Pikilyi*, 1991
Acrylic on canvas
63 x 36 in. (160 x 91.5 cm)
The Kelton Foundation

3
Pansy Napangati
*Winbaree*, 2001
Acrylic on canvas
48 x 35 4/5 in. (122 x 91 cm)
Private North Carolina Collection

4
Linda Syddick (Tjungkaya Napaltjarri)
*ET Going Home*, 1995
Acrylic on canvas
22 1/2 x 18 in. (57.2 x 45.7 cm)
The Kelton Foundation

5
Linda Syddick (Tjungkaya Napaltjarri)
*Spirits at the Gap*, 1999
Acrylic on canvas
26 x 30 in. (66 x 76.2 cm)
The Kelton Foundation

6
Dorothy Napangardi Robinson
*Bush Plum Dreaming*, 1996
Acrylic on canvas
34 1/4 x 49 1/4 in. (80 x 125.1 cm)
The Kelton Foundation

7
Dorothy Napangardi Robinson
*Salt on Mina Mina*, 2002
Acrylic on linen
79 x 48 1/8 in. (200.7 x 122.2 cm)
The LeWitt Collection, Chester, Connecticut

8
Dorothy Napangardi Robinson
*Mina Mina*, 2005
Acrylic on canvas
78 x 48 in. (198 x 122 cm)
Collection of Margaret Levi and Robert Kaplan

9
Bessie Nakamarra Sims
*Yarla Jukurrpa* (Bush Potato Dreaming), 1996
Acrylic on canvas
71 3/5 x 23 3/5 in. (182 x 60 cm)
Private North Carolina Collection

10
Bessie Nakamarra Sims
*Yarla Jukurrpa* (Bush Potato Dreaming), 2000
Acrylic on linen
72 x 36 1/5 in. (183 x 92 cm)
Collection of Margaret Levi and Robert Kaplan

11
Alice Nampitjinpa
*Tali at Talaapi* (Sand hills at Talaapi), 2001
Synthetic polymer paint on canvas
54 x 36 1/5 in. (137 x 92 cm)
National Gallery of Victoria, Melbourne,
presented through the NGV Foundation by
an anonymous donor, 2003

12
Alice Nampitjinpa
*Tali at Talaalpi* (Sand hills at Talaalpi), 2001
Acrylic on linen
54 1/2 x 36 in. (138.5 x 91.5 cm)
Private North Carolina Collection

13
Mitjili Napurrula
*Nullanulla and alcatjari, Ualki*
(Spear grass and bush sultanas), 1994
Synthetic polymer paint on canvas
35 4/5 x 54 in. (91 x 137 cm)
Art Gallery of New South Wales, Sydney,
purchased 1994

14
Mitjili Napurrula
*Uwalki: Watiya Tjuta* (Trees), 2000
Acrylic on canvas
48 x 24 in. (122 x 61 cm)
Private North Carolina Collection

15
Gabriella Possum Nungurrayi
*Goanna Dreaming*, 1991
Acrylic on canvas
57 x 35 in. (144.8 x 88.9 cm)
The Kelton Foundation

16
Gabriella Possum Nungurrayi
*Milky Way Seven Sisters Dreaming*, 1998
Acrylic on canvas
39 4/5 x 25 4/5 in. (101 x 65.5 cm)
Private North Carolina Collection

17
Lorna Napurrula Fencer
*Ngapa, Warna Manu Ngurlu Jukurrpa*
(Water, Snake, and Seeds Dreaming), 1996
Synthetic polymer paint on canvas
76 1/8 x 39 7/8 in. (193.4 x 101.2 cm)
National Gallery of Victoria, Melbourne,
purchased 1997

18
Lorna Napurrula Fencer
*Bush Potato*, 1998
Acrylic on canvas
39 1/5 x 29 3/5 in. (99.5 x 75.5 cm)
Collection of Margaret Levi and Robert Kaplan

19
Emily Kame Kngwarreye
*Hungry Emus,* 1990
Acrylic on canvas
47 1/4 x 70 1/2 in. (120 x 179 cm)
Kluge-Ruhe Aboriginal Art Collection,
University of Virginia, Charlottesville

20
Emily Kame Kngwarreye
*Untitled (Wild Tomato and Yam II)*, 1991
Acrylic on canvas
47 3/5 x 23 3/5 in. (121 x 60 cm)
Laverty Collection, Sydney

21
Emily Kame Kngwarreye
*Alhalkere (My Country)*, 1991
Synthetic polymer paint on canvas
47 3/5 x 118 in. (121 x 300 cm)
Ann Lewis, AM, Sydney

22
Emily Kame Kngwarreye
*Soakage Bore*, 1995
Acrylic on canvas
12 panels; each 15 x 20 in. (38 x 50.8 cm)
The Wolfensohn Family Foundation

23
Emily Kame Kngwarreye
*Anooralya* (Wild Yam Dreaming), 1995
Acrylic on canvas
59 4/5 x 48 in. (152 x 122 cm)
Seattle Art Museum, gift of Margaret Levi and
Robert Kaplan

24
Emily Kame Kngwarreye
Untitled, 1996
Acrylic on canvas
5 panels; each 47 3/5 x 35 4/5 in. (121 x 91 cm)
Ann Lewis, AM, Sydney

25
Gloria Tamerre Petyarre
*Emu Ancestor*, 1992–93
Acrylic on canvas
67 1/2 x 149 1/2 in. (171.5 x 379.7 cm)
Kluge-Ruhe Aboriginal Art Collection,
University of Virginia, Charlottesville

26
Gloria Tamerre Petyarre
*Untitled (Leaves)*, 1996
Acrylic on canvas
40 1/2 x 22 1/2 in. (102.9 x 57.2 cm)
The Wolfensohn Family Foundation

27
Gloria Tamerre Petyarre
*Leaves*, 2002
Acrylic on canvas
70 4/5 x 157 1/2 in. (180 x 400 cm)
Collection of Margaret Levi and Robert Kaplan,
pledged to Seattle Art Museum in honor of
Virginia and Bagley Wright

28
Kathleen Petyarre
*Thorny Devil Lizard Dreaming*
*(after Sandstorm)*, 1995
Acrylic on canvas
60 x 120 in. (152.4 x 304.8 cm)
Kluge-Ruhe Aboriginal Art Collection,
University of Virginia, Charlottesville

29
Kathleen Petyarre
*My Country—Bush Seeds*, 1998
Synthetic polymer on linen
60 x 60 in. (152.4 x 152.4 cm)
Collection of Margaret Levi and Robert Kaplan

30
Kathleen Petyarre
*Arnkerrthe* (Mountain Devil Lizard), 2001
Acrylic on linen
47 1/4 x 47 1/4 in. (120 x 120 cm)
Private North Carolina Collection

31
Abie Loy Kemarre
*Bush Leaves*, 2001
Acrylic on linen
35 4/5 x 48 in. (91 x 122 cm)
Collection of Margaret Levi and Robert Kaplan

32
Abie Loy Kemarre
*Body Painting*, 2004
Acrylic on linen
59 4/5 x 36 1/5 in. (152 x 92 cm)
Collection of Margaret Levi and Robert Kaplan

33
Ningura Napurrula
*Wanturrnga*, 2001
Acrylic on canvas
48 x 48 in. (122 x 122 cm)
On loan from Richard Klingler

34
Ningura Napurrula
Untitled, 2005
Acrylic on canvas
48 x 60 1/5 in. (122 x 153 cm)
Laverty Collection, Sydney

35
Inyuwa Nampitjinpa
*Pukanya*, 1999
Synthetic polymer paint on linen
35 4/5 x 35 4/5 in. (91 x 91 cm)
Laverty Collection, Sydney

36
Inyuwa Nampitjinpa
*Travels of Kutungka Napanangka
from Papunga to Muruntji*, 1999
Acrylic on canvas
59 4/5 x 48 in. (152 x 122 cm)
On loan from Richard Klingler

37
Tatali Nangala
Untitled, 1997
Acrylic on canvas
48 x 31 4/5 in. (122 x 81 cm)
Laverty Collection, Sydney

38
Tatali Nangala
*Two Women's Travels to the Rock Hole Site of
Tjunpanya, South of Lake MacDonald*, 1999
Acrylic on canvas
48 x 48 in. (122 x 122 cm)
Laverty Collection, Sydney

39
Makinti Napanangka
*Kungka Kutjarra* (Two Women), 1999
Acrylic on canvas
48 x 60 in. (122 x 152.4 cm)
Collection of Margaret Levi and Robert Kaplan

40
Makinti Napanangka
*Two Women*, 2001
Acrylic on linen
48 x 60 1/5 in. (122 x 153 cm)
On loan from Richard Klingler

41
Lucy Yukenbarri Napanangka
*Kunduwarra Rock Hole in the Great Sandy
Desert*, 1999
Acrylic on canvas
31 1/2 x 47 1/4 in. (80 x 120 cm)
Kluge-Ruhe Aboriginal Art Collection,
University of Virginia, Charlottesville

42
Lucy Yukenbarri Napanangka
*Winpurpurla*, 2001
Acrylic on canvas
59 x 39 2/5 in. (150 x 100 cm)
Private North Carolina Collection

43
Eubena Nampitjin
*Walganbuggsa Rock Hole in the Great Sandy
Desert*, 1995
Acrylic on canvas
59 x 39 2/5 in. (150 x 100 cm)
Collection of Margaret Levi and Robert Kaplan

44
Eubena Nampitjin
*Minma*, 2000
Acrylic on linen
35 2/5 x 23 3/5 in. (90 x 60 cm)
Private North Carolina Collection

45
Eubena Nampitjin
*Tjintalpa*, 2004
Synthetic polymer paint on linen
59 x 39 2/5 in. (150 x 100 cm)
Laverty Collection, Sydney

46
Queenie McKenzie
*Limestone Hills near Texas Downs*, 1991
Earth pigment and natural binder on canvas
37 3/8 x 35 3/8 in. (95 x 89.8 cm)
National Gallery of Victoria, Melbourne,
purchased through The Art Foundation of Victoria
with the assistance of Alcoa Foundation,
Governor, 1991

47
Queenie McKenzie
*Texas Country, Other Side*, 1994
Earth pigment on linen
40 1/2 x 83 3/8 in. (102.8 x 211.8 cm)
National Gallery of Victoria, Melbourne,
purchased through The Art Foundation of Victoria
with the assistance of Alcoa Foundation,
Governor, 1994

48
Queenie McKenzie
*Horse Creek Massacre*, 1997
Acrylic on canvas
35 2/5 x 65 in. (90 x 165 cm)
Collection of Margaret Levi and Robert Kaplan

49
Lena Nyadbi
*Lilmim and Jimbala* (Scales and spearheads),
2002
Ochre on linen
17 3/5 x 47 1/4 in. (45 x 120 cm)
Collection of Margaret Levi and Robert Kaplan

50
Lena Nyadbi
*Jimbala* (Spearheads), 2003
Ochre on linen
35 2/5 x 47 1/4 in. (90 x 120 cm)
Collection of Margaret Levi and Robert Kaplan

51
Lily Karedada
*Wandjina*, 1990
Earth pigment and natural binder on canvas
43 2/5 x 27 3/5 in. (110 x 70 cm)
National Gallery of Victoria, Melbourne,
purchased through The Art Foundation of Victoria
with the assistance of the Marjory and Alexander
Lynch Endowment, Governors, 1990

52
Lily Karedada
*Four Wandjina*, 1998
Natural pigment on canvas
48 x 36 in. (122 x 91.5 cm)
The Kelton Foundation

53
Kay Lindjuwanga
*Billabong at Milmilgkan*, n.d.
Ochre on eucalyptus bark
55 1/2 x 19 1/2 in. (141 x 49.5 cm)
Kluge-Ruhe Aboriginal Art Collection,
University of Virginia, Charlottesville

54
Kay Lindjuwanga
*Bilwoyinj*, 2004
Ochre on bark
39 4/5 x 20 1/5 in. (101 x 51 cm)
Private North Carolina Collection

55
Dorothy Djukulul
*Warrnyu* (Flying foxes), 1989
Natural pigment on eucalyptus bark
106 1/4 x 32 in. (269.9 x 81.3 cm)
Kluge-Ruhe Aboriginal Art Collection,
University of Virginia, Charlottesville

56
Dorothy Djukulul
*Magpie Geese (Mutyka) and Crocodile*, c. 1990
Ochre on bark
87 1/2 x 39 1/2 in. (222.3 x 100.3 cm)
Kluge-Ruhe Aboriginal Art Collection,
University of Virginia, Charlottesville

57
Daisy Manybunharrawuy
*Wagilag Sisters*, 1988–90
Natural pigment on eucalyptus bark
59 x 35 in. (150 x 89 cm)
Kluge-Ruhe Aboriginal Art Collection,
University of Virginia, Charlottesville

58
Daisy Manybunharrawuy
*Wagilag Creation Story*, 1990
Natural pigment on eucalyptus bark
54 5/8 x 27 1/4 in. (138.7 x 69.1 cm)
National Gallery of Victoria, Melbourne,
purchased from Admission Funds, 1990

59
Galuma Maymuru
*Djarrakpi Landscape (Manggalili Dhawu)*, 1996
Natural pigment on eucalyptus bark
116 1/4 x 30 1/4 in. (295.3 x 76.8 cm)
Kluge-Ruhe Aboriginal Art Collection,
University of Virginia, Charlottesville

60
Galuma Maymuru
*Yirritja Dhuwa Gapu II*, 2004
Ochre on bark
36 1/5 x 18 1/5 in. (92 x 43 cm)
Private North Carolina Collection

61
Wolpa Wanambi
*Marrakulu Miny'tji*, 1996
Ochre on bark
112 1/4 x 38 1/2 in. (285.1 x 97.8 cm)
Kluge-Ruhe Aboriginal Art Collection,
University of Virginia, Charlottesville

62
Wolpa Wanambi
*Marrakulu at the Goyder River*, 1997
Natural pigment on eucalyptus bark
92 1/2 x 37 in. (235 x 94 cm)
Seattle Art Museum, gift of Margaret Levi and
Robert Kaplan

63
Kitty Kantilla
Untitled, 1997
Natural pigment on canvas
34 4/5 x 41 3/5 in. (88.5 x 105 cm)
Laverty Collection, Sydney

64
Kitty Kantilla
Untitled, 1998
Ochre on linen
45 3/5 x 30 1/2 in. (114 x 82 cm)
Laverty Collection, Sydney

65
Kitty Kantilla
Untitled, 1999
Ochre on canvas
24 x 35 4/5 in. (61 x 91 cm)
Private North Carolina Collection

66
Jean Baptist Apuatimi
*Purukuparli ngirramini*, 1992
Earth pigment on canvas
4 panels; each 53 1/2 x 23 4/5 in. (136 x 60.7 cm)
National Gallery of Victoria, Melbourne,
purchased from Admission Funds, 1992

67
Jean Baptist Apuatimi
*Yirrikapayi* (Crocodile), 2005
Ochre on canvas
47 1/4 x 47 1/4 in. (120 x 120 cm)
Collection of Margaret Levi and Robert Kaplan

68
Gertie Huddleston
Untitled, 1996
Synthetic polymer paint on canvas
24 1/8 x 38 in. (61.3 x 96.5 cm)
National Gallery of Victoria, Melbourne,
purchased 1997

69
Gertie Huddleston
*Wet Season Billabong*, 1998
Acrylic on canvas
24 2/5 x 34 2/5 in. (62 x 87 cm)
Collection of Margaret Levi and Robert Kaplan

70
Regina Wilson
*String Design*, 2002
Acrylic on canvas
48 x 50 in. (122 x 127 cm)
Collection of Margaret Levi and Robert Kaplan

71
Regina Wilson
*Message Sticks*, 2004
Acrylic on canvas
78 3/5 x 78 3/5 in. (200 x 200 cm)
Collection of Margaret Levi and Robert Kaplan

72
Rosella Namok
*That Day: painful day*, 2001
Synthetic polymer paint on canvas
27 1/8 x 22 7/8 in. (69 x 58 cm)
National Gallery of Victoria, Melbourne,
purchased with assistance from the Supporters
and Patrons of Aboriginal Art, 2002

73
Rosella Namok
*Para Way: other way*, 2001
Acrylic on canvas
68 1/2 x 48 4/5 in. (174 x 124 cm)
Ann Lewis, AM, Sydney

74
Judy Watson
*suture*, 1995
Ink, pastel, and acrylic on canvas
47 x 73 1/2 in. (119.4 x 186.7 cm)
Saint Louis Art Museum, funds given by Mr. and
Mrs. Kenneth S. Kranzberg and Museum Purchase

75
Judy Watson
*waterline*, 2001
Pigment on linen
88 1/5 x 46 1/2 in. (224 x 118 cm)
Ann Lewis, AM, Sydney

76
Judy Watson
*Two Halves with Conch Shell*, 2002
Acrylic, pigment, pastel, and watercolor
on canvas
76 2/5 x 40 1/5 in. (194 x 103 cm)
Private North Carolina Collection

77
Julie Dowling
*Self-portrait: in our country*, 2002
Synthetic polymer paint, oil, and
red ochre on canvas
47 1/4 x 39 2/5 in. (120 x 100 cm)
National Gallery of Australia, Canberra,
purchased 2003

78
Julie Dowling
*Playing dead*, 2003
Synthetic polymer paint and red ochre on canvas
35 4/5 x 48 in. (91 x 122 cm)
National Gallery of Australia, Canberra,
purchased 2003

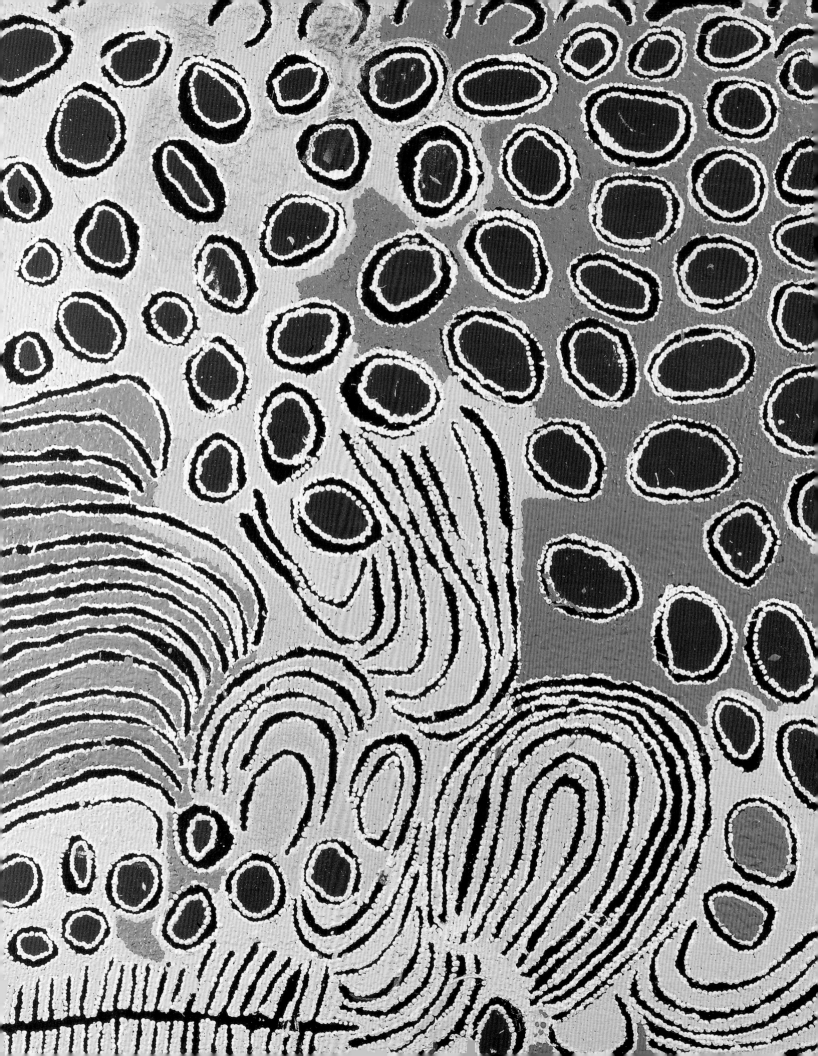

# Selected Bibliography

Bardon, Geoffrey. *Papunya: A Place Made after the Story: Beginnings of the Western Desert Painting Movement*. Carlton, Vic.: Miegunyah Press, 2004.

Bell, Diane. *Daughters of the Dreaming*. 3rd ed. Melbourne: Spinifex Press Pty. Ltd., 2002.

Boulter, Michael. *The Art of Utopia: A New Direction in Contemporary Aboriginal Art*. Roseville East, Australia: Craftsman House, 1991; reprint, 1993.

Caruana, Wally. *Aboriginal Art*. New York: Thames & Hudson, 1993; reprint, 2000.

Caruana, Wally and Nigel Lendon, eds. *The Painters of The Wagilag Sisters Story 1937–1997*. Exh. cat. Canberra: National Gallery of Australia, 1997.

Croft, Brenda, and Janda Gooding. *Southwest Central: Indigenous Art from South Western Australia, 1833–2002*. Exh. cat. Perth: Art Gallery of Western Australia, 2003.

Dowling, Carol Moorditji Djurapin. "Strong Love," in *Winyarn Budjarri (Sorry Birth): Birth's End*. Exh. cat. Perth: Artplace, 2005.

Dowling, Julie. "Moorditj Marbarn (Strong Magic)," in *Colour Power: Aboriginal Art Post 1984*, edited by Judith Ryan. Exh. cat. Melbourne: National Gallery of Victoria, 2004.

Dussart, Françoise. "Women's Acrylic Paintings from Yuendumu," in *The Inspired Dream: Life as Art in Aboriginal Australia*, edited by Margie K. C. West. Exh. cat. South Brisbane: The Gallery, 1988.

Dussart. "What an Acrylic Can Mean: On the Meta-ritualistic Resonances of a Central Desert Painting." In *Art From the Land: Dialogues with the Kluge-Ruhe Collection of Australian Aboriginal Art*, edited by Howard Morphy and Margo Smith Boles. Charlottesville: University of Virginia, 1999.

Isaacs, Jennifer. *Spirit Country: Contemporary Australian Aboriginal Art*. Exh. cat. South Yarr, Vic.: Hardie Grant, 1999.

Kleinert, Sylvia, and Margo Neale, eds. *The Oxford Companion to Aboriginal Art and Culture*. Melbourne: Oxford University Press, 2000.

McCulloch, Susan. *Contemporary Aboriginal Art: A Guide to the Rebirth of an Ancient Culture*. Honolulu: University of Hawaii Press, 1999.

Mellor, Doreen, ed. *Valuing Art, Respecting Culture: Protocols for Working with the Australian Indigenous Visual Art and Craft Sector*. Potts Point, Australia: National Association for the Visual Arts, 2001.

Mellor, Doreen, and Anna Haebich, eds. *Many Voices: Reflections on Experiences of Indigenous Child Separation*. Canberra: National Library of Australia, 2002.

Míllénaíre, Jouvence. *Art Aborigène*. Lausanne, Switzerland: Musée Olympique, 2002.

Morgan, Sally. *My Place*. Fremantle: Fremantle Arts Centre Press, 2000.

Morphy, Howard. *Ancestral Connections: Art and an Aboriginal System of Knowledge*. Chicago: University of Chicago Press, 1991.

Morphy. *Aboriginal Art*. London: Phaidon Press, 1998; reprint, 1999.

Morphy, Howard, and Margo Smith Boles, eds. *Art from the Land: Dialogues with the Kluge-Ruhe Collection of Australian Aboriginal Art*. Charlottesville: University of Virginia, 1999.

Munn, Nancy D. *Walbiri Iconography: Graphic Representation and Cultural Symbolism in a Central Australian Society*. Chicago: University of Chicago Press, 1973.

Myers, Fred. *Painting Culture: The Making of an Aboriginal High Art*. Durham: Duke University Press, 2002.

Perkins, Hetti. *Aboriginal Women's Exhibition*. Exh. cat. Sydney: Art Gallery of New South Wales, 1991.

Perkins. *Papunya: Genesis and Genius*. Exh. cat. Sydney: Art Gallery of New South Wales, 2000.

Perkins, Hetti, and Brenda Croft. *Fluent Australia: Emily Kame Kngwarreye, Yvonne Koolmatrie, Judy Watson*. Exh. cat. Sydney: Art Gallery of New South Wales, 1997.

Purcell, Leah. *Black Chicks Talking*. Sydney: Hodder Headline Australia, 2002.

Reed, A. W. *Aboriginal Myths, Legends, and Fables*. Sydney: Reed New Holland, 1999.

Ryan, Judith. *Mythscapes: Aboriginal Art of the Desert from the National Gallery of Victoria*. Exh. cat. Melbourne: National Gallery of Victoria, 1990.

Ryan. *Indigenous Australian Art in the National Gallery of Victoria*. Melbourne: National Gallery of Victoria, 2002.

Singh, Sarina, David Andrew, Bryan Andy, et al. *Aboriginal Australia and the Torres Strait Island: Guide to Indigenous Australia*. Footscray, Australia: Lonely Planet Publications, 2001.

Sutton, Peter, ed. *Dreamings: The Art of Aboriginal Australia*. New York: The Asia Society Galleries and George Braziller, Inc., 1988; reprint, 2001.

Watson, Christine. *Piercing the Ground: Balgo Women's Image Making and Relationships to Country*. Fremantle: Fremantle Arts Centre Press, 2003.

# Index of Artists and Works

*Page numbers that are boldface indicate illustrations.*

# Permissions

## Smith Essay

**Fig. 1** © NPY Women's Council, Alice Springs. Photo: Thisbe Purich. **Fig. 2** © Jutta Malnic. **Fig. 3** © Buku Larrnggay Mulka Centre, Yirrkala. **Fig. 4** © Galuma Maymuru, Buku Larrnggay Mulka Centre. **Fig. 5** © Narritjin Maymuru, Buku Larrnggay Mulka Centre, Yirrkala. Image courtesy the National Museum of Australia, Canberra. **Fig. 6** © Warlukurlangu Artists Aboriginal Association, Yuendumu. **Fig. 7** © 2006 Artists Rights Society (ARS), New York / VISCOPY, Australia.

## Konau Essay

**Fig. 1** © Powerhouse Museum, Sydney, Australia. Photo: Sue Stafford. **Fig. 2** © Tracey Moffatt, Roslyn Oxley9 Gallery, Sydney. **Fig. 3** © 2006 Artists Rights Society (ARS), New York / VISCOPY, Australia. **Fig. 4** © Sally Morgan. **Fig. 5** Photo courtesy Fiona Foley and Roslyn Oxley9 Gallery, Sydney.

## Artworks Section

**Cats. 1–2** © Pansy Napangati, Licensed by Aboriginal Artists Agency 2006. Photos © 2006 The Kelton Foundation. **Cat. 3** © Pansy Napangati, Licensed by Aboriginal Artists Agency 2006. Photo by Will Owen. **Cats. 4–5, 52** © 2006 Artists Rights Society (ARS), New York / VISCOPY, Australia. Photos © 2006 The Kelton Foundation. **Cat. 6** © Dorothy Napangardi Robinson, Gallery Gondwana. Photo © 2006 The Kelton Foundation. **Cat. 7** © Dorothy Napangardi Robinson, Gallery Gondwana. Photo by John Groo Photography for NMWA. **Cat. 8** © Dorothy Napangardi Robinson, Gallery Gondwana. Photo by Paul Macapia for NMWA. **Cats. 9, 42, 44, 76** © 2006 Artists Rights Society (ARS), New York / VISCOPY, Australia. Photos by Will Owen. **Cats. 10, 27, 39, 43, 48–50** © 2006 Artists Rights Society (ARS), New York / VISCOPY, Australia. Photos by Paul Macapia for NMWA. **Cat. 11** © Alice Nampitjinpa, Licensed by Aboriginal Artists Agency. Photo courtesy of National Gallery of Victoria, Melbourne. **Cat. 12** © Alice Nampitjinpa, Licensed by Aboriginal Artists Agency. Photo by Will Owen. **Cat. 13** © Mitjili Napurrula courtesy Aboriginal Desert Art Gallery. Photo by Suzie Ireland. **Cat. 14** © Mitjili Napurrula courtesy Aboriginal Desert Art Gallery. Photo by Will Owen. **Cat. 15** © Gabriella Possum Nungurrayi, Licensed by Aboriginal Artists Agency. Photo © 2006 The Kelton Foundation. **Cat. 16** © Gabriella Possum Nungurrayi, Licensed by Aboriginal Artists Agency. Photo by Will Owen. **Cat. 17** © Lorna Napurrula Fencer, Mimi Arts and Crafts–Aboriginal Corporation. Photo courtesy of National Gallery of Victoria, Melbourne. **Cat. 18** © Lorna Napurrula Fencer, Mimi Arts and Crafts–Aboriginal Corporation. Photo by Paul Macapia for NMWA. **Cats. 19, 25, 41, 55–57** © 2006 Artists Rights Society (ARS), New York / VISCOPY, Australia. Photos courtesy of Kluge-Ruhe Aboriginal Art Collection, University of Virginia, Charlottesville. **Cat. 20** © 2006 Artists Rights Society (ARS), New York / VISCOPY, Australia. Photo by Paul Green for NMWA. **Cat. 21** © 2006 Artists Rights Society (ARS), New York / VISCOPY, Australia. Photo by Ashley Mackevicius Photography. **Cat. 22** © 2006 Artists Rights Society (ARS), New York / VISCOPY, Australia. **Cat. 23** © 2006 Artists Rights Society (ARS), New York / VISCOPY, Australia. Photo by Paul Macapia for Seattle Art Museum. **Cat. 24** © 2006 Artists Rights Society (ARS), New York / VISCOPY, Australia. Photo by James Dee for NMWA. **Cats. 26, 40** © 2006 Artists Rights Society (ARS), New York / VISCOPY, Australia. Photos by Lee Stalsworth for NMWA. **Cat. 28** © Kathleen Petyarre, Gallery Australis, Adelaide, South Australia. Photo courtesy of Kluge-Ruhe Aboriginal Art Collection, University of Virginia, Charlottesville. **Cat. 29** © Kathleen Petyarre, Gallery Australis, Adelaide, South Australia. Photo courtesy of Gallery Australis. **Cat. 30** © Kathleen Petyarre, Gallery Australis, Adelaide, South Australia. Photo by Will Owen. **Cats. 31–32** © 2006 Artists Rights Society (ARS), New York / VISCOPY, Australia. Images courtesy of Gallery Australis. **Cat. 33** © Ningura Napurrula, Licensed by Aboriginal Artists Agency. Photo by Lee Stalsworth for NMWA. **Cat. 34** © Ningura Napurrula, Licensed by Aboriginal Artists Agency. Photo by Paul Green for NMWA. **Cat. 35** © Inyuwa Nampitjinpa, Licensed by Aboriginal Artists Agency. Photo by Paul Green for NMWA. **Cat. 36** © Inyuwa Nampitjinpa, Licensed by Aboriginal Artists Agency. Photo by Lee Stalsworth for NMWA. **Cat. 37–38** © Tatali Nangala, Licensed by Aboriginal Artists Agency. Photo by Paul Green for NMWA. **Cat. 45** © 2006 Artists Rights Society (ARS), New York / VISCOPY, Australia. Photo by Paul Green for NMWA. **Cats. 46–47, 51, 58** © 2006 Artists Rights Society (ARS), New York / VISCOPY, Australia. Images courtesy of National Gallery of Victoria, Melbourne. **Cat. 53** © Kay Lindjuwanga, courtesy Maningrida Arts & Culture. Photo courtesy of Kluge-Ruhe Aboriginal Art Collection, University of Virginia, Charlottesville. **Cat. 54** © Kay Lindjuwanga, courtesy Maningrida Arts & Culture. Photo by Will Owen. **Cat. 59** © Galuma Maymuru, Buku Larrnggay Mulka Centre. Photo courtesy of Kluge-Ruhe Aboriginal Art Collection, University of Virginia, Charlottesville. **Cat. 60** © Galuma Maymuru, Buku Larrnggay Mulka Centre. Photo by Will Owen. **Cat. 61** © Wolpa Wanambi, Buku Larrnggay Mulka Centre. Photo courtesy of Kluge-Ruhe Aboriginal Art Collection, University of Virginia, Charlottesville. **Cat. 62** © Wolpa Wanambi, Buku Larrnggay Mulka Centre. Photo by Paul Macapia for Seattle Art Museum. **Cats. 63–64** Estate of Kitty Kantilla, courtesy of Jilamara Arts & Crafts Association. Photos by Paul Green for NMWA. **Cat. 65** Estate of Kitty Kantilla, courtesy of Jilamara Arts & Crafts Association. Photo by Will Owen. **Cat. 66** © Jean Baptist Apuatimi, Licensed by Aboriginal Artists Agency. Photo courtesy of National Gallery of Victoria, Melbourne. **Cat. 67** © Jean Baptist Apuatimi, Licensed by Aboriginal Artists Agency. Photo by Paul Macapia for NMWA. **Cat. 68** © Gertie Huddleston. Photo courtesy of National Gallery of Victoria, Melbourne. **Cat. 69** © Gertie Huddleston. Photo by Paul Macapia for NMWA. **Cats. 70–71** Courtesy of Agathon Gallery and the artist. Photos by Paul Macapia for NMWA. **Cat. 72** © Rosella Namok, Lockhart River Arts Centre. Photo courtesy of National Gallery of Victoria, Melbourne. **Cat. 73** © Rosella Namok, Lockhart River Arts Centre. Photo by Ashley Mackevicius Photography. **Cat. 74** © 2006 Artists Rights Society (ARS), New York / VISCOPY, Australia. Photo courtesy of St. Louis Art Museum. **Cat. 75** © 2006 Artists Rights Society (ARS), New York / VISCOPY, Australia. Photo courtesy of Tolarno Galleries, Melbourne. **Cats. 77–78** © 2006 Artists Rights Society (ARS), New York / VISCOPY, Australia. Photos courtesy of National Gallery of Australia, Canberra.

## Literary Sources

**Page 9:** Jill Milroy's text was reprinted with permission from *The Art of Sally Morgan* (Ringwood, Vic.: Penguin, 1996). **Page 42:** Excerpt taken from Papunya Tula Artists Pty., Ltd. documentation. © Papunya Tula Artists Pty. Ltd. **Page 46:** Excerpt taken from documentation on artwork provided by the Kelton Foundation. © 2000 The Kelton Foundation. **Page 49:** Excerpt taken from Gallery Gondwana documentation. © Gallery Gondwana and the artists. **Page 51:** Excerpt taken from Warlukurlangu Artists Aboriginal Association documentation. © Warlukurlangu Artists Aboriginal Association, Inc. **Page 53:** Excerpt taken from Ikuntji Art Centre documentation. © Ikuntji Art Centre and the artist. **Page 55:** Edited excerpt from Jennifer Isaacs, *Spirit Country: Contemporary Australian Aboriginal Art* (South Yarra: Hardie Grant, 1999), p. 70. **Page 56:** Quotation taken from Vivien Johnson and Jane Hylton, *Dreamings of the Desert: Aboriginal Dot Paintings of the Western Desert* (Adelaide: Art Gallery of South Australia, 1996), p. 129. **Page 59:** Excerpt taken from Coo-ee Aboriginal Art Gallery documentation. © Coo-ee Aboriginal Art Gallery. **Page 61:** Quotation taken from Margo Neale, ed., *Emily Kame Kngwarreye—Alhalkere: Paintings from Utopia* (Brisbane: Queensland Art Gallery/Macmillan, 1997), p. 10. **Page 66:** Quotation taken from Sylvia Kleinert and Margo Neale, eds., *The Oxford Companion to Aboriginal Art and Culture.* (Melbourne: Oxford University Press, 2000), p. 671. Excerpt on women's Emu ceremony taken from documentation on artwork provided by Kluge-Ruhe Aboriginal Art Collection, University of Virginia, Charlottesville. **Page 69:** Quotation taken from *Paintings by Kathleen Petyarre* (Adelaide: Gallery Australis, 1999), p. 4. **Pages 70, 72:** Excerpt taken from Gallery Australis documentation. © Gallery Australis. **Pages 75, 77, 79, 80:** Excerpt taken from Papunya Tula Artists Pty. Ltd. documentation. © Papunya Tula Artists Pty., Ltd. **Pages 87, 89:** Excerpt taken from Warlayirti Artists Aboriginal Corporation documentation. © Warlayirti Artists Aboriginal Corporation. **Page 91:** Quotation taken from Judith Ryan, *Images of Power: Aboriginal Art of the Kimberley*, (Melbourne: National Gallery of Victoria, 1993), pp. 43–44. **Page 94:** Excerpt taken from Warmun Art Centre documentation. © Warmun Art Centre and the artist. **Page 96:** Edited excerpt from Jennifer Isaacs, *Spirit Country: Contemporary Australian Aboriginal Art* (South Yarra: Hardie Grant, 1999), p. 118. **Page 103:** Excerpt taken from Maningrida Arts and Culture documentation. © 2001 Maningrida Arts and Culture and the artist. **Page 106:** Excerpt taken from exhibition proposal material presented to John W. Kluge, compiled by Djon Mundine, 1989. Documentation on file at Kluge-Ruhe Aboriginal Art Collection, University of Virginia, Charlottesville. **Page 108:** Quotations taken from Wally Caruana and Nigel Lendon, eds., *The Painters of the Wagilag Sisters Story, 1937–1997* (Canberra: National Gallery of Australia, 1997), p. 156. **Page 109:** Excerpt taken from Buku Larrnggay Mulka Centre documentation. © Buku Larrnggay Mulka Centre with the artist. **Page 111:** Edited excerpt from Howard Morphy, "Life Through Art: Religion and Society in Eastern Arnhem Land," in Howard Morphy and Margo Smith Boles, eds., *Art From the Land: Dialogues with the Kluge-Ruhe Collection of Australian Aboriginal Art* (Charlottesville: University of Virginia, 1999), pp. 68–69. **Page 113:** Quotation taken from Dawn Mendham and Margie West, *Contemporary Territory* (Darwin: Museum & Art Gallery of the Northern Territory, 1994), http://gallery.discoverymedia.com.au/xroads/xroads_single.asp?xartist_id='12' (accessed November 10, 2005). **Page 114:** Edited excerpt taken from "Kitty Kantilla Documentation," Art Gallery of New South Wales, 2002, http://collection.artgallery.nsw.gov.au/collection/results.do?view=detail&search=aboriginal%2Fpaintings%2Fsearch&dept=aboriginal%2Fpaintings&db=object&id=31923 (accessed January 4, 2006). **Page 117:** Excerpt taken from Tiwi Design documentation. © Tiwi Design and the artist. **Page 118:** Quotation from interview between the artist and Margie West, 1998, from Sylvia Kleinert and Margo Neale, eds., *The Oxford Companion to Aboriginal Art and Culture* (Melbourne: Oxford University Press, 2000), p. 606. **Page 121:** Quotation taken from Karen Brown Gallery documentation. © Karen Brown Gallery and the artist. **Page 125:** Quotation taken from Rosella Namok, *Rosella Namok: mepla sarbie paint* (Brisbane: Andrew Baker Art Dealer, 2001), p. 1. **Page 127:** Quotation taken from Nanica Guivarra, "*Message Sticks 2003–Sydney Opera House: Judy Watson.*" Message Sticks, Aboriginal and Torres Strait Islander Online. April 21, 2003. http://www.abc.net.au/message/radio/awaye/ms_opera/visual_judywatson.htm (accessed November 15, 2005). **Page 130:** Excerpt from National Gallery of Australia, "Julie Dowling—Self-portrait: in our country 2002," http://www.nga.gov.au/NewAcquisitions/200